CREATIVE **!** SOLUTIONS

BRO CHU RES

BROCHURES: MAKING A STRONG IMPRESSION

85 Strategies for Message-Driven Design Jenny Sullivan

GLOUCESTER MASSACHUSETTS

ROCKPORT PUBLISHERS

First published in the United States of America by
Rockport Publishers, Inc.
33 Commercial Street
Gloucester, Massachusetts 01930-5089
Telephone: (978) 282-9590
Fax: (978) 283-2742
www.rockpub.com

Library of Congress Cataloging-in-Publication Data

Sullivan, Jenny, [date]
 Brochures : making a strong impression : 85 strategies for message-driven design
/ Jenny Sullivan.
 p. cm.
 Includes bibliographical references and index.
 ISBN 1-59253-041-9
 1. Pamphlets—Design. I. Title.
Z246.S79 2004
686.2'252—dc22 2003026367
 CIP

ISBN 1-59253-041-9

10 9 8 7 6 5 4 3 2 1

Book Design: Chen Design Associates, San Franciso, CA
Cover Design: Chen Design Associates, San Franciso, CA
Book Production: *tabula rasa* graphic design
Copyeditor: Pamela Elizian
Proofreader: Stacey Ann Follin

Printed in China

CONTENTS

Butterfield
&Robinson

(base london)

motivate decisions?

INTRODUCTION

Examining the brochure as an isolated entity is sort of like dissecting an arm or foot without considering the body and brain to which it is attached. In fact, nearly all the works featured in the following pages are appendages of larger strategic plans. Some are hybrids that double as posters, catalogs, promotions, point-of-purchase materials, advertising inserts, or invitations. But publishing a design book requires setting your margins somewhere, hence, our focus on the brochure—a perennial workhorse in the communications arsenal.

Like all forms of graphic design, brochures are cultural and historical mirrors, and the pieces here are no exception. This book comes at a time when sustainable design is no longer a fashion statement, but an eco-imperative for many (although still too few). Meanwhile, budgets have dwindled in a worldwide economic downturn, forcing designers to mete their resources more shrewdly. This task isn't so much a matter of sacrificing quality as weeding out superfluous indulgences, reconsidering trim sizes, and maximizing every centimeter of available space on a press form.

With Web communication now indelibly woven into our everyday vernacular, print has grown more tactile. Today's brochures create richer, more sensory experiences with mixed paper stocks, embossing, engraving, die cuts, and alternative substrates, such as plastic and cardboard. Old-school techniques, such as letterpress and serigraphy, are making a comeback, as are authentic touches, such as hand-stitched and hand-glued bindery, tip-ons, and belly wraps. Craftsmanship has regained considerable currency in an otherwise pixel-twisted world. We crave things that feel tangible and real.

That said, this book does its best to dwell in the real—in a design world where superstar budgets and untethered creative freedom seldom exist and working within specific parameters is always a struggle. We've done our best to include a cross section of big-ticket brochures as well as smaller projects, with insights into the creative noodling, wrong turns, dead ends, production acrobatics, and eureka moments that made each one a success.

CHAPTER ONE:
Arts and Entertainment

So much art, so many entertainment options, so little time. Eighty percent of success is showing up (in front of the right audience, no less), but then there's the matter of getting the time of day. The pressure is on for brochures of this ilk to delight the senses of would-be patrons with dramatically different motifs and constructs.

OCTAGON
Picture This

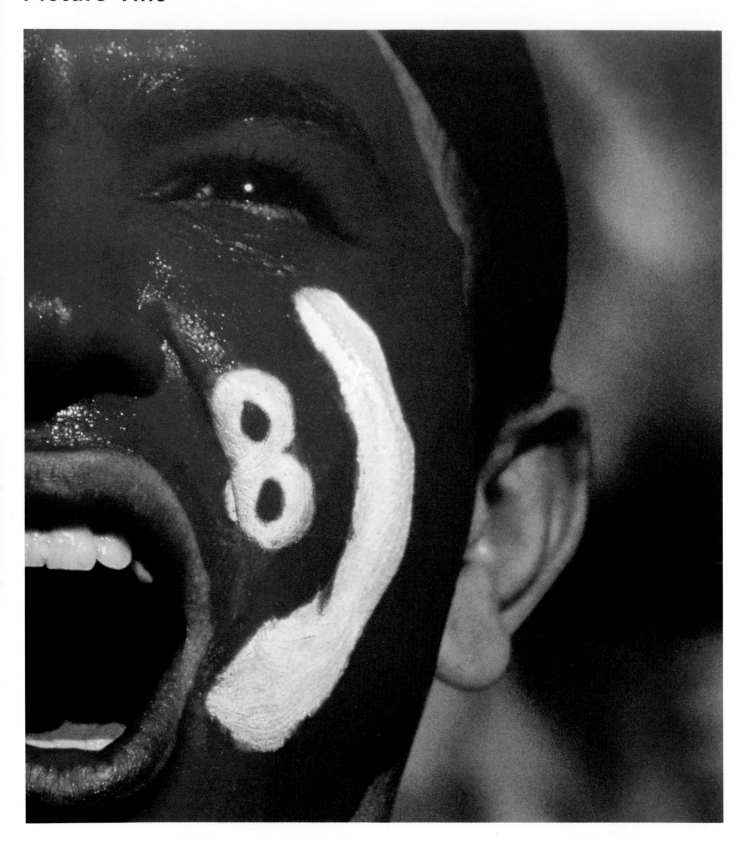

CLIENT: Octagon is a worldwide sports marketing company that deals in athlete representation, consulting, event management, property representation, TV rights, sales and distribution, TV production/archiving, licensing, and merchandising. FIRM: Carter Wong Tomlin ART DIRECTOR: Phil Carter
DESIGNERS: Neil Hedger and Phil Carter PHOTOGRAPHY: John Millar and others

FACING PAGE: No need for copy on the cover. One fan's face communicates the big message—that humanity's love affair with sports is universal, and that Octagon gets the connection.

THIS PAGE: For brand consistency, the design team at Carter Wong Tomlin maintained allegiance to the language of Octagon's corporate identity, incorporating visual elements such as the company's trademark red and repeated use of square grids as a layout device. The square motif is reiterated in the shape of the mini-brochure. Frutiger is the typeface used throughout.

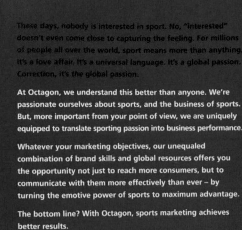

These days, nobody is interested in sport. No, "interested" doesn't even come close to capturing the feeling. For millions of people all over the world, sport means more than anything. It's a love affair. It's a universal language. It's a global passion. Correction, it's *the* global passion.

At Octagon, we understand this better than anyone. We're passionate ourselves about sports, and the business of sports. But, more important from your point of view, we are uniquely equipped to translate sporting passion into business performance.

Whatever your marketing objectives, our unequaled combination of brand skills and global resources offers you the opportunity not just to reach more consumers, but to communicate with them more effectively than ever – by turning the emotive power of sports to maximum advantage.

The bottom line? With Octagon, sports marketing achieves better results.

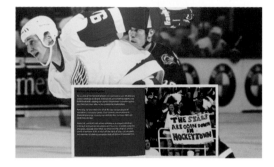

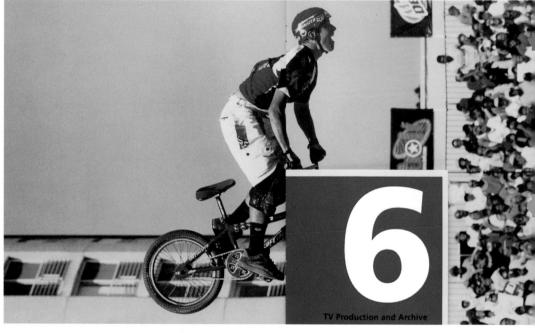

The Challenge

Octagon's game plan was direct: create a dynamic brochure in keeping with the dynamic nature of sports. And nothing conveys the power and passion of sports like photography. So for the design team at Carter Wong Tomlin, the challenge was to give action-packed photos plenty of play, while somehow fitting in copy in an unobtrusive way.

The Solution

How do you overlay copy on a rich, double-page bleed of the perfect slide tackle, a Formula One Ferrari at full speed, or a tennis champion in mid-swing? According to the creative team at Carter Wong Tomlin, you don't. In this case, at least, a

better alternative existed: a brochure within a brochure. Octagon's capabilities are succinctly chronicled in a small booklet, which allowed dramatic photo spreads of athletes to remain largely copy-free. Printed on Parilux glossy paper for contrast, the mini-brochure is collated inside the larger brochure of matte Monadnock Astrolite Smooth stock. "We wanted a distinct, tactile contrast in the papers, and the gloss stock was kept deliberately lightweight so as not to bulk up the inside of the brochure and create a lump across its lower half," notes art director Phil Carter. "We knew we would be challenging our printers and finishers to get the desired result, but then again, if you never challenge the status quo, you never create something

innovative. The finishers suggested pretrimming the small brochure so it could be collated before the main brochure was trimmed in line. This ensured that the white borders on the mini-brochure remained constant throughout."

In addition to providing textural contrast, the mini-brochure complements the narrative of the main piece by juxtaposing small images of fans against the larger spreads of athletes in motion. Photography, of course, was the critical ingredient throughout. The project took four months from brief to print, with a considerable chunk of creative time devoted to collecting magical, compelling images.

MUSEUM OF SCIENCE AND INDUSTRY
Taste the Experience

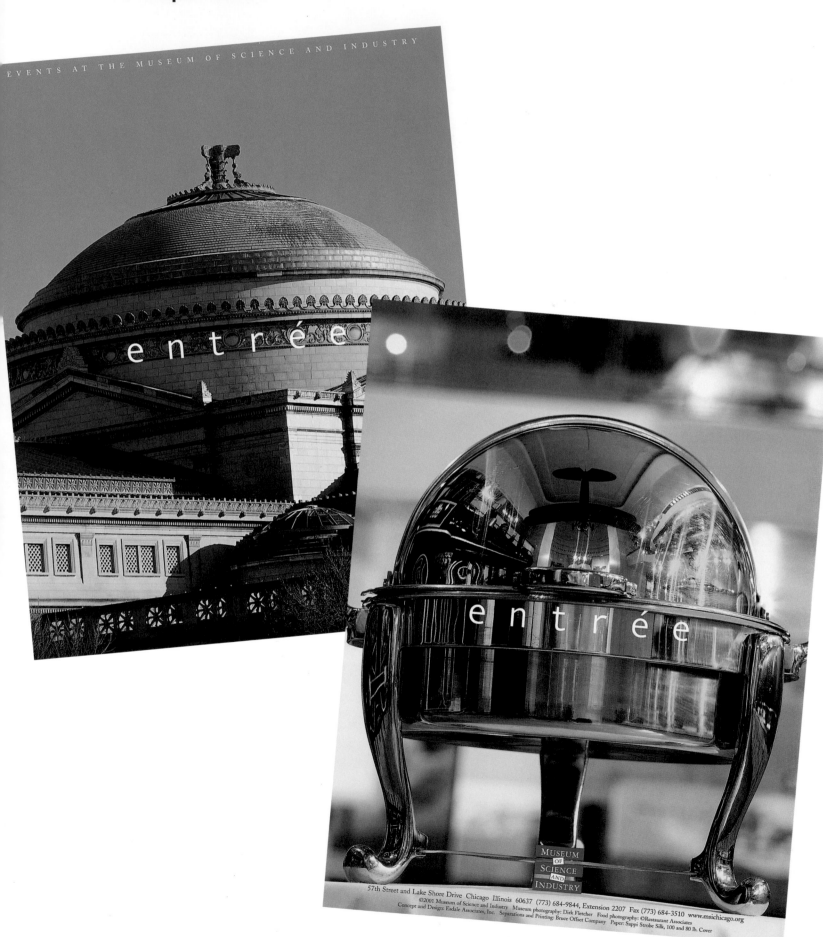

CLIENT: The Museum of Science and Industry draws exhibits on everything from coral reefs to monster trucks to railroad history. **FIRM:** Esdale Associates **CREATIVE DIRECTOR:** Donna Somerville **COPYWRITER:** Susan Esdale **PHOTOGRAPHY:** Dirk Fletcher **PRINTER:** Wallace Bruce Offset

FACING PAGE: Copy works as a double entendre on the brochure's front and back covers and beckons the reader to come inside.

ABOVE RIGHT: Mouthwatering photos create a sense of space—and taste.

BELOW RIGHT: Color plays a critical role and was, therefore, a priority. The piece was printed CMYK plus three spot colors and satin varnish. Sappi Strobe Silk, a dull-coated stock, was the perfect paper choice for an elegant finish.

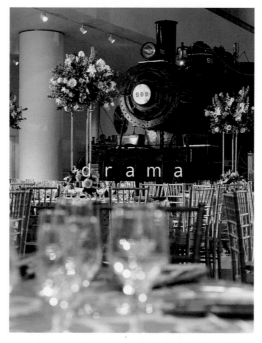

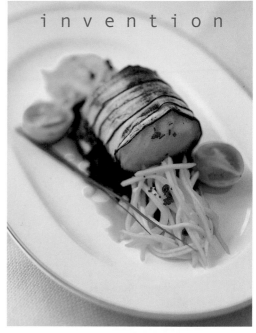

The Challenge

With its dramatic interiors and captivating industrial artifacts, Chicago's Museum of Science and Industry is a great venue for special events. Who wouldn't get a kick out of dining in the shadow of a massive steam engine or under the canopy of a helicopter suspended in midair? To ensure that its food service was on par with its decor, the museum partnered with the upscale culinary firm Restaurant Associates to promise a delectable experience. Sales materials were needed to give the target audience—corporate event planners—a taste of the new offerings.

The Solution

The project budget and time frame (three months) were tight. Fortunately, the team had little question about where to stage photo shoots. "Because the space offers such a spectacular backdrop for parties and corporate events, and the food by Restaurant Associates is so visually appealing, we felt from the start that the main brochure needed to be driven by this imagery, with strong but minimal supporting copy," says Susan Esdale, whose eponymous firm handled the brochure design. Clean, simple fonts and blocks of solid color complement rich, full-bleed photos in each layout.

EL ZANJON
Digging for Buried Treasure

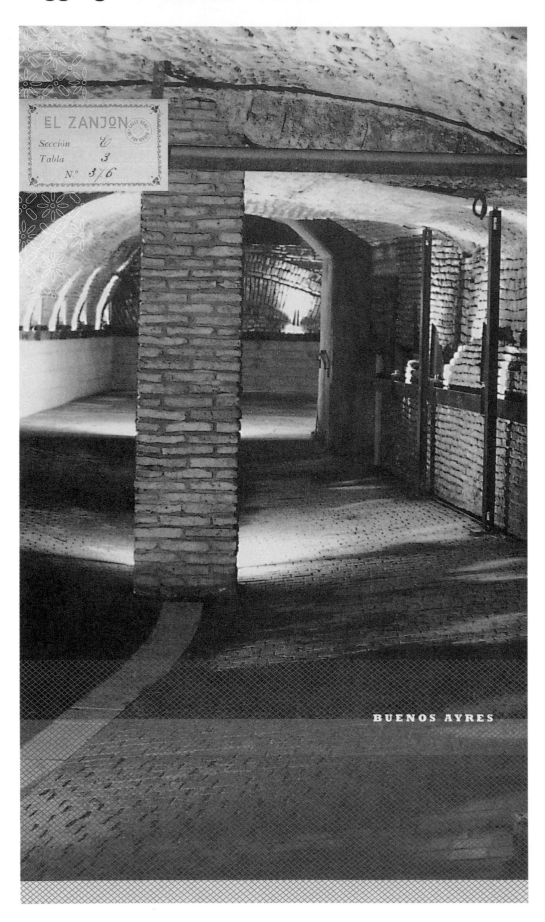

CLIENT: El Zanjon is a historic landmark in Buenos Aires, Argentina. **FIRM**: Bløk Design **CREATIVE DIRECTOR**: Vanessa Eckstein **DESIGNERS**: Vanessa Eckstein, Frances Chen, and Stephanie Yung **COPYWRITER**: JE **PHOTOGRAPHY**: Ernesto Dipietro

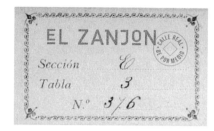

FACING PAGE AND ABOVE: Black-and-white photographs shot on location are overlaid with decorative tile motifs and sheer bands of earthy pigment. Others are delicately framed by sleek, contemporary rules. The resulting aesthetic is a densely textured layering of soil and rock, foundation and edifice, history and modernity.

RIGHT: Imagery was gathered from a variety of sources, including the first magazine ever published in Buenos Aires, books on Spanish imported tiles, and archival photographs documenting the building restoration.

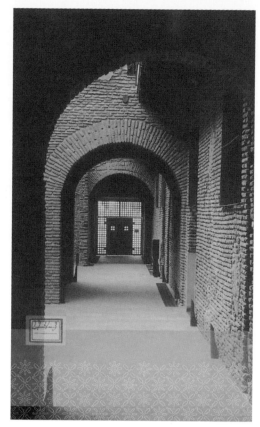

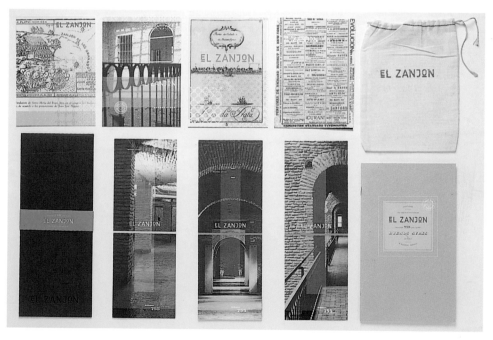

The Challenge

Some historians point to the "Zanjon de Granados" as the site of the first settlement of Buenos Aires, in 1536. A section of the old Zanjon was discovered under a historic 19th-century building, and, after 16 years of detailed obsession, the mansion was restored. In the process, other sections of the Zanjon were unearthed, including ruins of foundations, old walls, floors, water wells, and sewage pits that were built and destroyed between 1730 and 1865. When the historic site opened to the public in 2002, Bløk Design was hired to create an entire identity, including a collection of tourism brochures that could be used together or as stand-alone pieces. The print materials needed to convey the same rich complexity and archaeological layering as the site itself.

The Solution

A trip to Buenos Aires was imperative. "There, we discovered and uncovered history through imagery, literature, and an unimaginable private collection of books dating from the 1750s, which guided our designs," says creative director Vanessa Eckstein.

Referencing both contemporary and historic imagery, Bløk constructed an intricate visual vocabulary. Elements were borrowed from old city maps, architectural renderings of the building in various stages of development, and pattern designs inspired by Spanish imported tiles, circa 1860.

"The process of restoration was as important to feature as the end product," says Eckstein. "Instead of going for a stylistic solution that reflected a single point in history, we used real elements from the past and present, working in layers to reinforce the notion of an archaeological dig."

USA SWIMMING
A Splash of Creativity

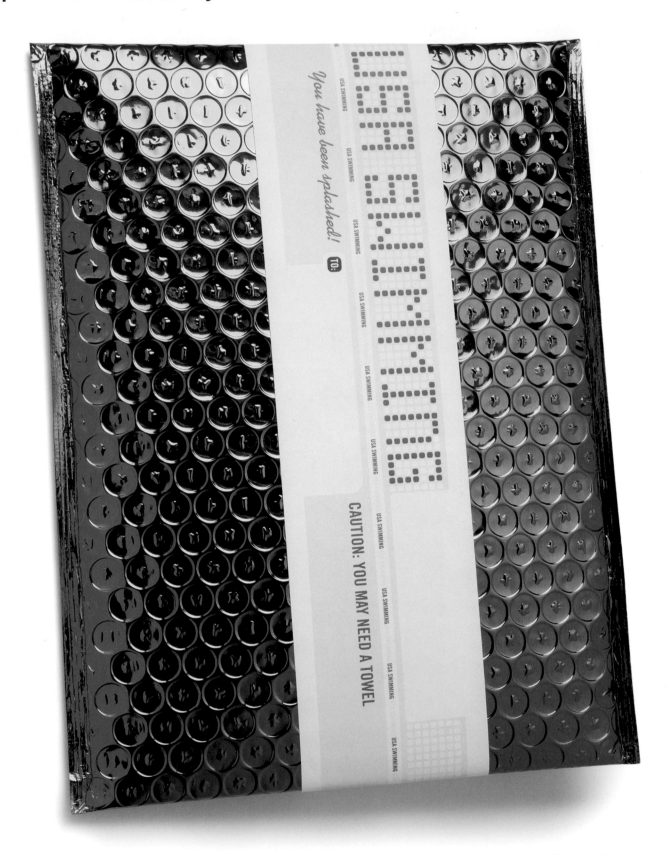

CAUTION: YOU MAY NEED A TOWEL

You have been splashed!

CLIENT: USA Swimming, the national governing body for the sport of swimming, administers competitive swimming in accordance with the Amateur Sports Act and promotes swimming in both amateur and competitive venues. **FIRM:** Dean Johnson Design **CREATIVE DIRECTOR:** Scott Johnson **DESIGNER/COPYWRITER:** Josh Emrich **PRODUCTION:** Laurie Durham **ACCOUNT MANAGER/COPYWRITER:** Darrin Brooks **PHOTOGRAPHY:** Allsport

FACING PAGE: It's hard not to notice the arrival of USA Swimming in the mail. Metallic blue bubble envelopes encourage readers to jump in and get their feet wet. The pool tile and typographic lane marker motifs are reiterated in a clever bellyband mailing label.

THIS PAGE: Pool tiles serve as a recurrent design motif. Their shapes are reiterated in the brochure's rounded, die-cut corners, which, on a pragmatic level, prevent the cards from becoming dog-eared. Using text to form a graphic border, Emrich condensed and repeated the phrase *USA Swimming* in the sans serif font Trade Gothic in alternating light and dark hues to resemble lane markers.

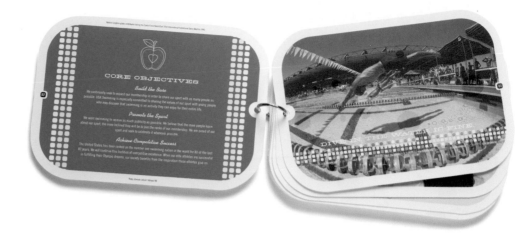

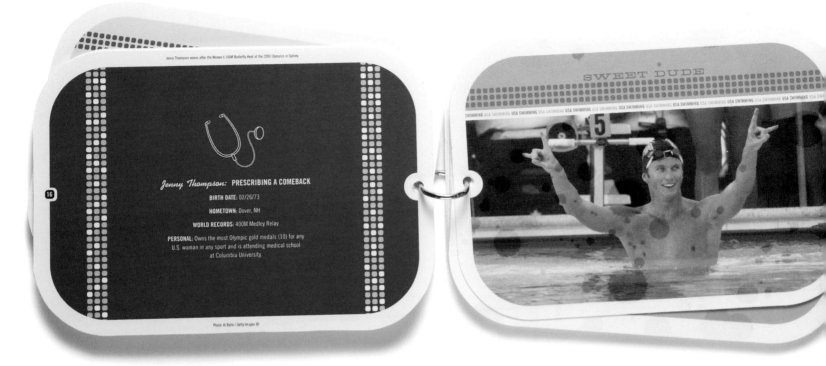

The Challenge

USA Swimming needed a nontraditional brochure that would excite current and potential marketing partners, bolster swimming's appeal as a spectator sport, and perpetuate its reign as the largest participatory sport in the United States. However, the organization didn't want its branding to fall in stride with the rest of the heat. A breakaway solution was in order. On a practical level, chief marketing officer Rod Davis wanted a flexible brochure format with interchangeable components that could double as presentation materials for meetings.

The Solution

In the race for sponsorship dollars, some sports have perfected the art of showmanship more than others (case in point: the Super Bowl and Budweiser). Creatives at Dean Johnson Design immersed themselves in pop culture to see how the big stars were playing the game. They realized that swimming's hip factor could be strengthened by giving the sport a face—that is, by zoning in on the qualities and quirks (and pecs and abs) of today's hot, young Olympians and world record holders. "Giving USA Swimming more personality helped marketing partners better identify and associate with the sport," says account manager Darrin Brooks. Thus, individual athletes and their accomplishments—both in and out of the water—became part of the pitch.

Rather than a standard trifold brochure or an 8½" x 11" (21.5 cm x 27.9 cm) press kit, the design team created a set of loose, die-cut cards, bound together with an O-ring. This format allows cards with dated material to be swapped out and replaced, thus prolonging the shelf life of the piece. The loose assembly also means that cards can be fanned out or removed from the ring binding and spread on a table for easy viewing.

The crowning production detail? Blobs of UV spot coating simulate splash marks on every card. To create this effect, designer Josh Emrich dropped black ink splotches onto white paper, then scanned the shapes and registered the artwork to lie appropriately over each card die, specifying the UV spot coating in lieu of a color. French Paper Smart White uncoated cardstock provided the perfect contrast to the shiny, thermographic watermarks. This substrate also left a stark-white edge around each card while allowing the rich, dense colors to pop. "The whole piece was printed on one big, double-sided sheet. We tried to position cards with similar colors together to avoid banding," says Emrich. Broad color planes give the appearance of spot color, although the entire piece was printed as a process build.

OPERA LYRA OTTAWA
Acting the Part

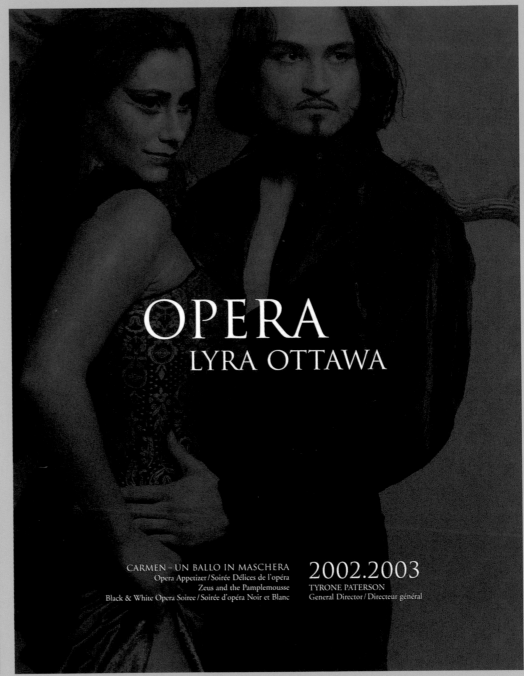

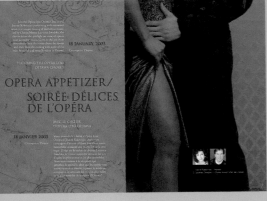

THIS PAGE: Marbled backgrounds and a moody palette give the 2002–2003 brochure a lusty edge.

Why Redesign?

Magic, intrigue, and high drama are prerequisites when it comes to promoting a professional opera company. To fuel anticipation for Opera Lyra Ottawa's 2002–2003 season, Kolegram Design composed a brochure of sensual duotone photographs with characters attired in classic Renaissance and Gothic garb. The piece was a hit, but a repeat performance the following year was out of the question. A new artistic interpretation was needed to woo both opera aficionados and newcomers to the grand stage.

CLIENT: Opera Lyra Ottawa **FIRM:** Kolegram Design
CREATIVE DIRECTOR: Mike Teixeira **ART DIRECTOR:**
Gontran Blais **DESIGNER:** Gontran Blais **PHOTOGRAPHY:**
Headlight Imagery **PRINTER:** St.-Joseph Corporation

RIGHT: The punchy 2003–2004 brochure is sized to fit in a
#10 envelope for direct-mail purposes.

BELOW LEFT AND BELOW RIGHT: Confectionary colors and mesmeriz-
ing patterns give the program book an amiable tone. The
front half of the brochure is printed with two spot colors plus
black. Appendices printed on Fraser Brights Electric Green
vellum make subscription information easy to locate.

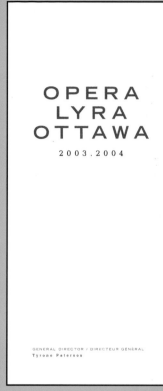

OPERA
LYRA
OTTAWA

2003.2004

GENERAL DIRECTOR / DIRECTEUR GÉNÉRAL
Tyrone Paterson

TAKE A SEAT

PRENEZ PLACE

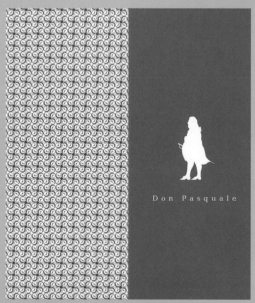

Don Pasquale

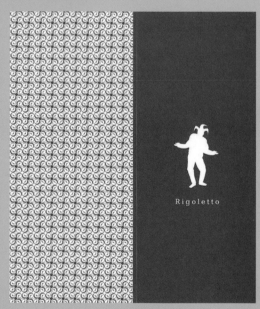

Rigoletto

Act II

For its 2003–2004 promo, the opera wanted to
recast its image to entice the uninitiated to give
its performances a try. This time, illustration re-
placed photography in the starring role. Silhouet-
ted figures create an air of mystery while

portending the arrival of performances such as
Don Pasquale and *Rigoletto*.

The redesigned brochure portrays opera as both
classic and hip. Uncoated stock (Cougar Opaque)
brings the genre down from its lofty perch to a

friendlier level. A duet of serif and sans serif fonts
(Candida and Trade Gothic Extended) makes page
layouts fresh, and funky colors convey a vibe that is
decidedly anti-stodgy. The high note? Whimsically
patterned section dividers, which the Kolegram de-
sign team created from scratch.

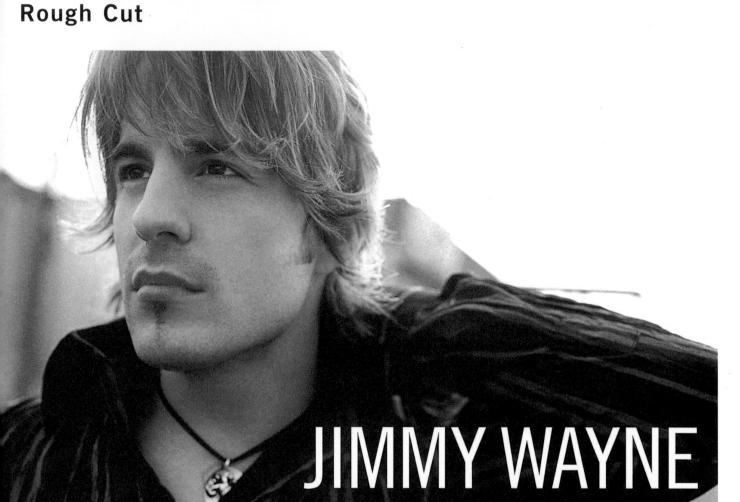

JIMMY WAYNE
Rough Cut

JIMMY WAYNE

A LIVE WIRE

CLIENT: Dreamworks Records **FIRM**: Anderson Thomas Design **ART DIRECTOR**: Darren Welch **DESIGNER**: Jay Smith **PRINTER**: Buford Lewis Co.

FACING PAGE: Image isn't everything, but it's important when you're trying to convince a recording exec to listen up. The artist's handsomely scruffy features are prominently featured throughout the brochure.

THIS PAGE: Lyrics in Wayne's own handwriting add authenticity to page borders. Trade Gothic—a clean, simple typeface—contributes to the frank aesthetic.

AN IMPORTANT VOICE. A VOICE THAT TRULY MOVES YOU. A VOICE THAT TOUCHES YOUR EMOTIONS. A VOICE THAT MAKES A STATEMENT. STRONG WORDS? YES.

TO YOUR SOUL.

WORDS WE RARELY USE. AND THAT'S BECAUSE THIS KIND OF VOICE IS RARE.
THIS IMPORTANT NEW VOICE IS JIMMY WAYNE.

THE SECOND SINGLE WILL BE "PAPER ANGELS."

AGAIN, IF YOU'VE HEARD IT, YOU KNOW WHAT I'M TALKIN' ABOUT! GROWING UP, JIMMY AND HIS SISTER WERE PAPER ANGEL TREE KIDS. FOR THOSE OF YOU WHO MAY NOT KNOW ABOUT PAPER ANGEL TREES, AT CHRISTMAS A LOT OF MALLS/DEPARTMENT STORES SET UP PAPER ANGEL TREES FOR NEEDY KIDS TO RECEIVE GIFTS. JIMMY HAS MANY MEMORIES OF BEING INVOLVED WITH PAPER ANGEL TREES AND PUT THOSE MEMORIES TO WORDS AND MUSIC. **LYRICAL TWIST? OH YEAH... GET READY, IT'S ONE OF THE BEST EVER.** WE WILL SHIP "PAPER ANGELS" IN LATE AUGUST TO TARGET STRONG ROTATION FOR THE HOLIDAYS. THIS SONG SHOULD PROVE TO BE ONE OF THE SEASON'S BIGGEST SONGS. IT'S ONE YOU'RE LIKELY TO BE PLAYING MANY YEARS FROM NOW.

The Challenge

Dreamworks Records in Nashville, Tennessee, needed an intra-industry piece to introduce country soul singer Jimmy Wayne as an up-and-coming artist on the music scene. The goal was to create an image compelling enough to pique the curiosity of radio and label executives who hadn't necessarily heard Wayne's music. "The time frame was like most music industry projects—ASAP," says art director Darren Welch. "We had about two weeks to pull it together."

The Solution

Getting to know the artist, his personality, and his music was key in painting a sound portrait. Dreamworks supplied the photos, but the question remained of how to treat them. Wayne's soulful introspection and down-to-earth demeanor were quickly translated into a simple, approachable layout. "We were looking to communicate a 'common man' feeling," says Welch.

To give the piece a gritty dose of reality, color fields were distressed to appear scratched or smudged at the edges. "We had a photocopier that was very sick for a while," notes designer Jay Smith. "It made horrible copies but cool art." Streaks and other toner mishaps were scanned into Photoshop and given a new purpose. Mohawk Superfine, with its sturdy, tactile finish, proved a good choice in paper (uncoated, not slick).

Jimmy Wayne's album hit stores in July 2003, soon after his first release began playing on country stations.

OBRTNA ZBORNICA SLOVENIJE
Art for Craft's Sake

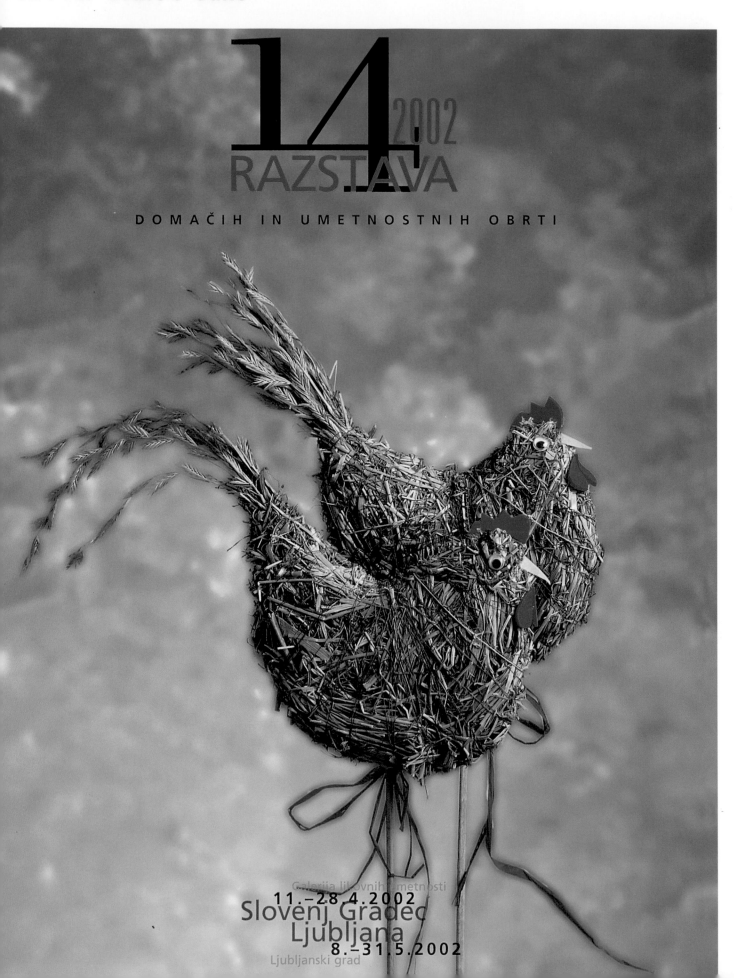

14 2002
RAZSTAVA

DOMAČIH IN UMETNOSTNIH OBRTI

Galerija likovnih umetnosti
11.–28.4.2002
Slovenj Gradec
Ljubljana
8.–31.5.2002
Ljubljanski grad

CLIENT: Obrtna zbornica Slovenije is an association of handcraft artisans in Ljubljana, Slovenia. **FIRM:** KROG **ART DIRECTOR:** Edi Berk **DESIGNER:** Edi Berk **PHOTOGRAPHY:** Janez Pukšič **EDITOR:** Dr. Janez Bogataj **WRITERS:** Dr. Janez Bogataj, Goran Lesničar Pučko, Dr. Vito Hazler, Janko Mlakar, and Vesna Moličnik

FACING PAGE AND RIGHT: The 2002 exhibition brochure demonstrates how traditional Slovenian art forms are being enhanced by new technologies and alternative creative interpretations.

BELOW LEFT: Sculpted typography adds deeper layers of meaning to artisan's wares. A stylized kettle becomes the vessel for the message *Rokodelstvo—zlitje preteklosti in sodobnosti,* which means "Handcraft—pouring together past and contemporary times."

BELOW RIGHT: Symbolic type arrangements add textual and visual dimension to the photographic subjects they mirror. An additional spot color in "deep black" was added to give the text extra weight.

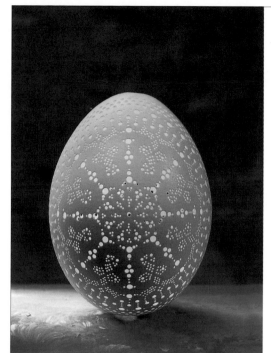
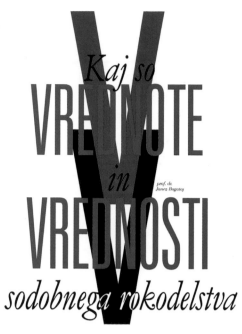

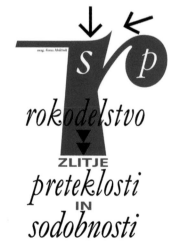

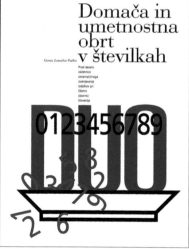

The Challenge

In planning its biennial exhibition of Slovenian folk art and crafts, the Handcraft Association of Slovenia (Obrtna zbornica Slovenije) needed a catalog that would preview the objects in the show while simultaneously contextualizing the history and future of Slovenian craftsmanship. Like the actual works on display, the brochure needed to marry cultural tradition with contemporary sensibilities. An important target audience was administrators in municipal, regional, and state organizations whose policy decisions influence the livelihood of local artisans.

The Solution

Arresting page layouts present craftsmanship as a significant force in Slovenia's cultural identity. Full-bleed photos of art objects take on deeper meaning when juxtaposed with poster-style graphics. On one spread, a dynamic type collage reads *Kaj so vrednote in vrednosti sodobnega rokodelstva,* or "What are the values and worth of contemporary handcraft?" The opposite page features an ornate eggshell designed in the pattern of medieval tradition but with a notable departure—the pattern is formed not by intricate brushwork but by delicate holes bored with modern tools. "This was a way to show that we have new possibilities in our time that capture Slovenian creativity without losing sight of tradition," says art director Edi Berk. Emphasizing the mechanics behind the egg design, the V letterforms in the type are stacked in the shape of a stylized drill.

Another spread positions an assemblage of carved wooden trays next to the title *Domača in umetnostna obrt v številkha,* or "Art and handcraft in numbers." The type arrangement, which depicts numerals cascading into a shallow dish, precedes an article explaining the association's system of artistic valuation used to grant its "good product" certification.

TARGET MARGIN THEATER
Chef D'Oeuvre

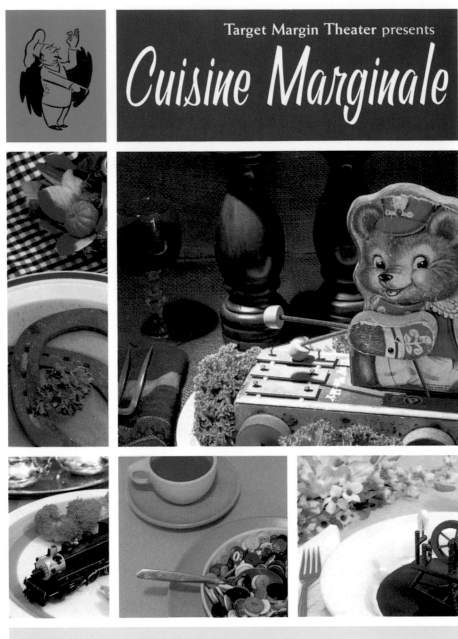

Target Margin Theater presents

Cuisine Marginale

an international assortment of new recipes and old favorites

CLIENT: Target Margin Theater is a Brooklyn-based production company that performs in Manhattan theater houses with fewer than 99 seats. FIRM: ALR Design
DESIGN AND PHOTOGRAPHY: Noah Scalin COPYWRITER: David Herskovits

FACING PAGE AND BELOW RIGHT: Used bookstores provided plenty of inspiration for "Cuisine Marginale." A few '60s cookbooks and recipe cards, and voilà—a style was born. The headline typeface is Tiki Holiday, by House Industries.

ABOVE RIGHT: Scalin rummaged through thrift stores, antique shops, and his own attic to find the right ingredients for each spread. For Eugene O'Neill's Civil War–era *Mourning Becomes Electra,* rusty horseshoes and gingham provided just the right flavor.

BELOW LEFT: Gertrude Stein's writings on theater-as-landscape counted among the menu items for Target Margin's 2003 season. A hearty lunch pays homage to the author's poem, "Tender Buttons."

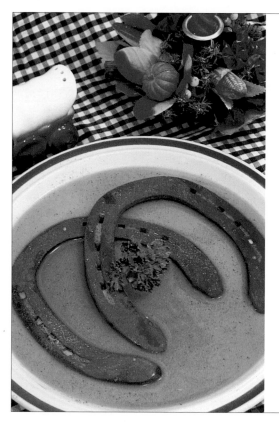

Virgil Geddes & Eugene O'Neill

Who says Americans are backward in the kitchen? Our homespun cookery offers some of the glories of the palate. O'Neill created our first great dishes (once you've tasted his unique cocktails you'll never look homeward), and Virgil Geddes is one of our unacknowledged masters. But—with a couple of exceptions—their recipes are relegated to the library. Some of the work is called too filling: *Mourning Becomes Electra* makes a meal that is almost too rich for today's tastes, but we aim to take it on. And they say Geddes' recipes use too much corn, but we are eager to revive his culinary magic. These are the lesser-known American feasts that we plan to give the time they deserve.

Some say a good Russian River Pinot Noir is best for American fare, but we also recommend a slug of Basil Hayden's bourbon after dinner.

The Challenge

Theater posters make a grand impression when they blanket every promenade on Broadway. But posters are pricey jobs, and it's hard for small stage companies in New York to get noticed. That's why some production houses have opted for direct mail targeting loyal followers.

Target Margin is one such operation. The scrappy stage company—known for its penchant for cross-breeding genres and reinterpreting the classics in quirky settings—needed an extra savory brochure to promote "Cuisine Marginale," a season devoted to experimental work.

The Solution

Theater director David Herskovits described the plays in Target Margin's 2003 lineup as works that needed to "simmer and stew." That said, an homage to cookbooks of yore seemed the appropriate format for a brochure inviting loyal patrons into the kitchen to see theater-in-the-making. "The idea was that the viewer would be participating in, or at least witnessing the creation of, these plays," says Noah Scalin, principal of ALR Design.

Scalin entertained the idea of "shooting real food shaped to look like nonfood things," but he later scrapped the idea over concerns that perishable concoctions wouldn't last through photo shoots. Plan B was to make nonfood items look edible (sort of). Finding the right culinary props was key to connecting each signature "dish" to a specific play or playwright.

Target Margin is known to be edgy and subversive, so going low budget on the production was hardly frowned upon. In fact, the brochure's low-tech aesthetic garnered points for being chic and ironic. Scalin shot each still life under bad lighting and even instructed the printer to shift one of the plates (cyan) off-register during production.

your needs

CHAPTER TWO:
Corporate

Slick and predictable 8½" x 11" (21.5 cm x 27.9 cm) corporate brochures went out the door a while back, along with buttoned-up dress codes and spray-mounted hairstyles. Today, freedom of expression is not only condoned in the corporate sector but expected. Alternative trim sizes and spicier palettes have become de rigueur. But one standard hasn't gone out of style: smart budgeting and shrewd allocation of resources.

GREYSTONE
Bigger Is Better

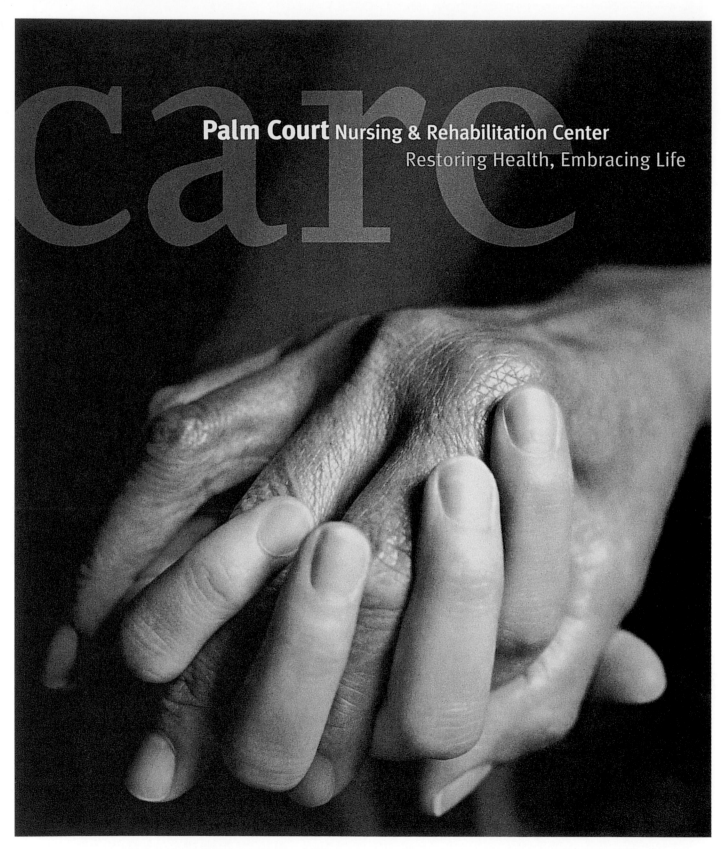

care

Palm Court Nursing & Rehabilitation Center
Restoring Health, Embracing Life

CLIENT: Founded as an independent investment banking firm, Greystone is part of a family of companies specializing in real estate financing and its ancillary functions. FIRM: Carbone Smolan Agency DESIGN DIRECTOR: Justin Peters PROJECT MANAGER: Catherine Goodman DESIGNER: Georgina Montana
PHOTOGRAPHY: Duane Rieder PRINTER: Toppan

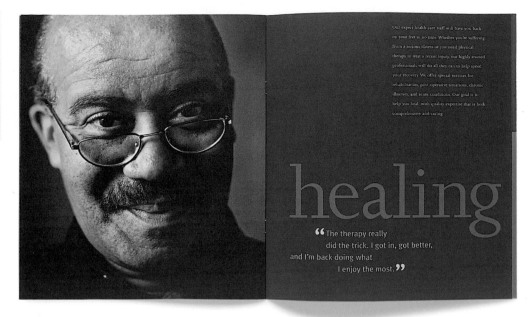

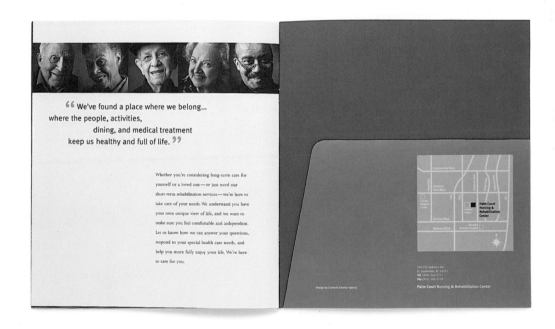

FACING PAGE AND ABOVE: Cover images of hands illustrate staff members' caring and compassion in an abstract yet powerful way.

RIGHT: Full-bleed color fields and tinted duotones are lively but not shocking. Dramatically scaled photos create a sense of intimacy and trust.

BELOW RIGHT: A back pocket can be customized with contact and map information.

The Challenge

Greystone wanted marketing materials for up to 27 long- and short-term health-care facilities, to be distributed through its sales channels as well as intermediaries, such as doctors and health plan providers. To appeal to an elderly audience and provide peace of mind to their children (who increasingly make financial decisions about their aging parents' health care), the brochure needed to communicate caring and nurturing in a personal, authentic way. The system needed to provide a template so each facility could customize the brochure to its location.

The Solution

A modular brochure system, with three different cover choices and customizable contact information, provides a consistent look with much-needed flexibility. Interviews with facility residents and managers, caregivers, and resident guardians led to a concept centering on care in which testimonials come across as advice from a friend or loved one, rather than as a sales pitch. This research, along with an industry audit and competitive analysis, helped inform key design decisions, such as large proportions, full-bleed imagery, and the use of uncoated stock for an unpretentious,

accessible feeling. The top priority was to present a face that was unassuming and elegant, rather than glossy and condescending.

Scale was key. The oversized pieces (10½" x 12" (26.5 cm x 30.5 cm)) provide maximum impact when displayed among other health-care literature in waiting rooms. The size also made it easier to accommodate large type—a must for older readers. Meta, a modern classic typeface, was selected for its friendly appearance and legibility.

SAFECO
Tale of Two Cities

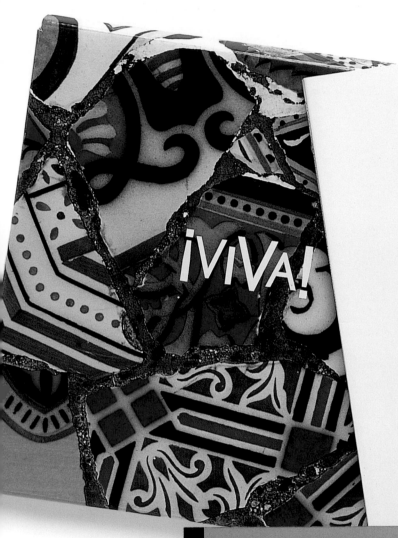

¡VIVA!

SAFECO Conference of Champions 2004

¡VIVA!
Celebrating Life

S SAFECO®

Brace your sense of wonder. Ready your sense of adventure. The SAFECO Conference of Champions 2004 is set to reward you with an explosion of art and indulgence, revelry and food, games to play, new cultures to discover and memories to grab. This year we're pointing our compass in two different, yet equally alluring directions: an excursion to Lake Las Vegas, Nevada and, for the top 100 agencies, a trip across the globe to Barcelona, Spain. In the high desert of southern Nevada,

CLIENT: Safeco is the tenth-largest insurance company in the United States. **FIRM:** Pentagram Design **CREATIVE DIRECTOR:** Kit Hinrichs **DESIGNERS:** Laura Scott and Myrna Newcomb **COPYWRITER:** Nancy Murr **PHOTOGRAPHY:** Robb Aaron Gordon, John LeCoq, Melba Levick, Karl Petzke, Richard Pla, Deon Reynolds, Mark Segar, Holly Stewart, Pere Vivas, Stuart Westmorland, and the Ritz-Carlton **STOCK PHOTOGRAPHY:** Corbis, Getty, Getty/Foodpix, Getty PhotoDisc, Alamy.com, and Photonica **ILLUSTRATION:** Ward Schumaker **PRINTING:** Anderson Lithograph

FACING PAGE TOP: A close-up shot of tiles from a Gaudí mosaic creates an arresting cardboard mailer. On the crisp, white brochure cover, the same vibrant motif peeks through custom-crafted letterforms.

FACING PAGE BOTTOM: Oversized Garamond type on five opening pages whets the reader's appetite for the sensual photomontage that follows. The introductory pages were printed on uncoated stock with six match colors, plus black. Subsequent photo spreads are CMYK builds, printed on Lustro Dull coated stock for maximum fidelity.

RIGHT: Wire-o binding accommodates a mixture of paper stocks while ensuring that the pages lie flat when open. For tactile variety, illustrated mini-brochures are printed on McCoy uncoated stock. One such insert overlaying a sumptuous food spread features a recipe for authentic Spanish paella.

BELOW: Another insert demystifies the art of reflexology by mapping out pressure points on the soles of the feet.

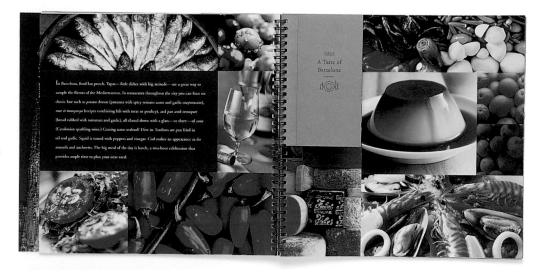

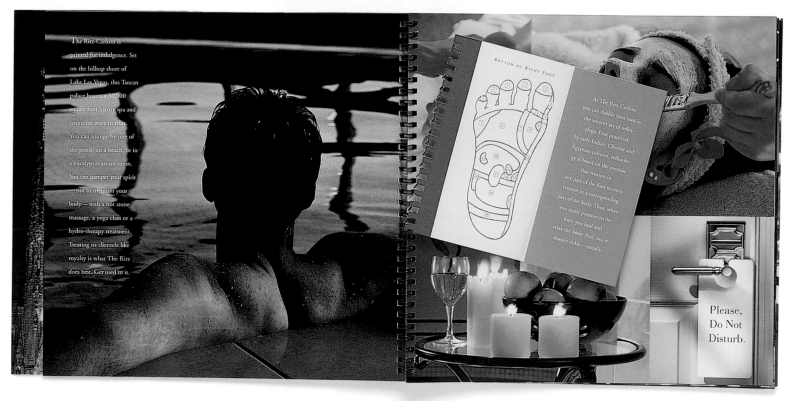

The Challenge

Safeco wanted to motivate its sales force to sell more insurance services than ever before. And the incentive was *muy caliente.* Top sales achievers would win a trip to the company's "Conference of Champions" in Barcelona, whereas second-tier winners would garner a similar junket at the Ritz-Carlton Resort and Spa in Lake Las Vegas. The trick for the design team at Pentagram was to create a luscious brochure that sold the sensory experience of both locales simultaneously. "These were two diametrically opposed places, one being remote desert and the other, a culturally rich urban center,"

notes Pentagram partner Kit Hinrichs. "We had to figure out a way to highlight both without denigrating one over the other. And we had about six weeks to do it."

The Solution

Language formed a common denominator between the two destinations, and the word *viva* quickly emerged as an all-encompassing theme. From there, the two hot spots were profiled, side by side, as places where one could "live life to the fullest." The design team relied heavily on photography to tell the story, scouring thousands of photographers'

portfolios and stock houses for irresistible imagery. Each saturated spread focuses on a different way to enjoy life, whether it's savoring Spanish cuisine, golfing in a desert oasis, indulging in luxurious spa treatments, or relishing Barcelona's famed nightlife. Mini-brochures on uncoated stock add harmony to select spreads. For example, a pocket-size street map highlighting Barcelona's major architectural attractions is sandwiched between shots of noted landmarks by Gaudí and Miró. The map can be torn out and used as a reference guide on location.

ANDERSON LITHOGRAPH
Waste Not

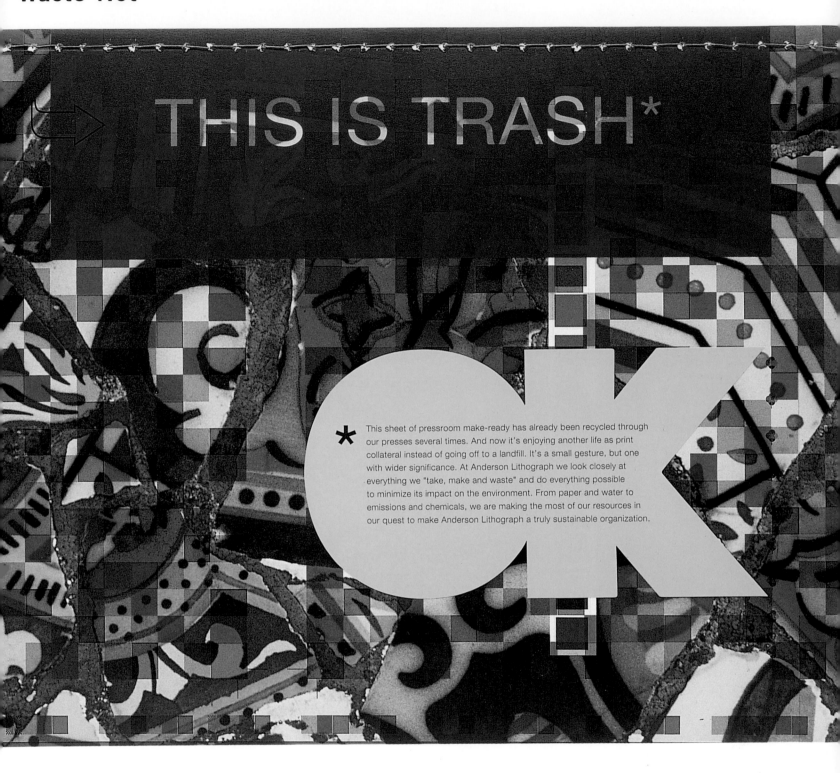

THIS IS TRASH*

* This sheet of pressroom make-ready has already been recycled through our presses several times. And now it's enjoying another life as print collateral instead of going off to a landfill. It's a small gesture, but one with wider significance. At Anderson Lithograph we look closely at everything we "take, make and waste" and do everything possible to minimize its impact on the environment. From paper and water to emissions and chemicals, we are making the most of our resources in our quest to make Anderson Lithograph a truly sustainable organization.

CLIENT: Anderson Lithograph is a high-end printer specializing in both sheet-fed and web printing. **FIRM:** Turner & Associates **ART DIRECTOR:** Phil Hamlett
DESIGNER: Kelly Conley **PHOTOGRAPHY:** Bob Lewis **WRITERS:** Phil Hamlett and Rebecca Dake

FACING PAGE: Does this cover look familiar? In a former life, this make-ready was used to calibrate a brochure job for Safeco. (See page 32.) The orange OK sticker plays off a common production convention while explaining the brochure's mission. The sticker made it easy to add cover copy in lieu of printing over the saturated stock.

RIGHT: All the insert pages are printed with spot color. To heighten the process-as-product metaphor, process colors are used like PMS colors to create solids and screens.

LEFT: To make the headline (*This Is Trash*) pop, the make-ready sheet went back on the press, where it was undercoated with white before receiving an additional hit of magenta.

The Challenge

Anderson Lithograph has long taken a leadership position in reengineering its manufacturing processes to minimize environmental impact. The company has implemented sustainable, replicable programs that make the most of paper and chemicals while lowering emissions and protecting water supplies. As a result, almost no volatile organic compounds (VOCs) are released from the company's facilities, and employees benefit from superior working conditions in a climate-controlled space. The company needed a brochure that would tell this story to clients and prospects, as well as to partners interested in developing similar programs.

The Solution

Providing pressroom make-readies with another lease on life, the brochure both shows and tells the story of Anderson's proprietary Environmental Management System. Headlines surprise the reader with visual irony. On the cover, the phrase *This Is Trash* confirms that the outer shell is, in fact, resurrected scrap from the pressroom floor. Inside, *This Is Home Insulation* explains how the company's supply-chain system transforms paper waste into a useful by-product. Another headline, *This Is Fuel,* highlights the fact that hazardous fumes at Anderson are safely recycled into energy.

The brochure's anatomy provides tangible evidence that Anderson's green-speak is more than lip service. The "found art" make-ready cover doubles as a self-mailer. Insert pages are printed on Monadnock Astrolite PC 100, an uncoated, 100 percent post-consumer-waste recycled paper that is Process Chlorine Free. The entire piece was produced on an eight-color Heidelberg UV press, which produces nearly zero VOC emissions. And thread stitching is used in lieu of metal fasteners.

Although the brochure proclaims itself to be trash, it's hardly treated as such. "There is a lot of pass-along occurring with this piece," says art director Phil Hamlett. "The message is powerful and specific enough that it ultimately finds its audience. People tend not to throw it away but rather send it along to others they think might be interested in it. Companies have whole departments devoted to sustainability and diminishing the size of their ecological footprints."

SCAN TURBO
Need for Speed

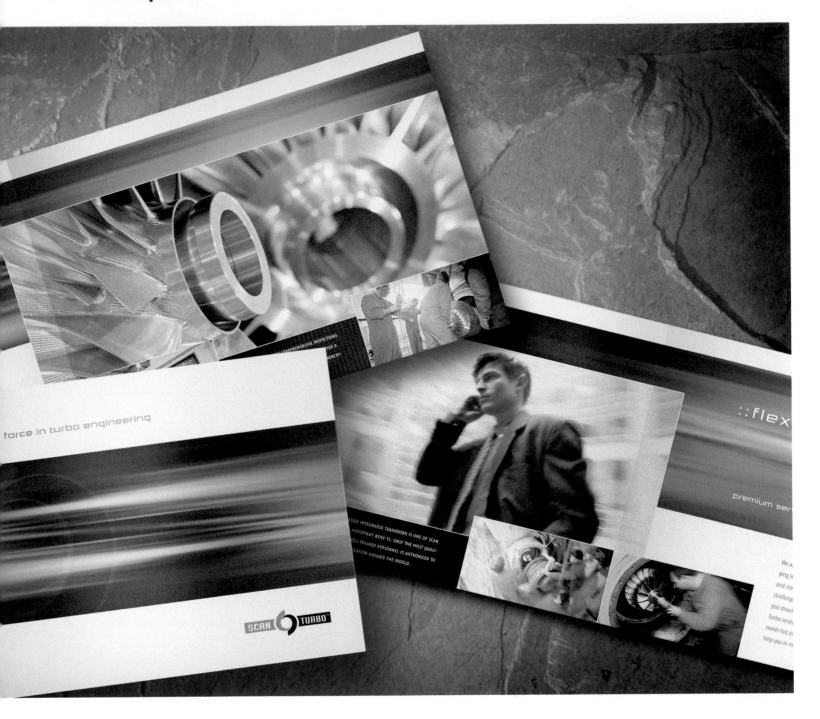

force in turbo engineering

SCAN TURBO

::flex

premium ser

CLIENT: Scan Turbo specializes in the overhaul and service of turbochargers for shipbuilders worldwide. **FIRM:** BRAUE: Branding & Corporate Design
CREATIVE PEOPLE: Kai Braue, Marçel Robbers, and Sandra Blum **WRITERS:** Kai Braue and Sandra Blum **PHOTOGRAPHY:** Martina Buchholz, plus stock
PRINTER: Druckhaus Wüst

Moving pictures give Scan Turbo's image an overhaul. All of the photos are originals except for the stock shot of the man on a cell phone, which was retained from an early set of comps.

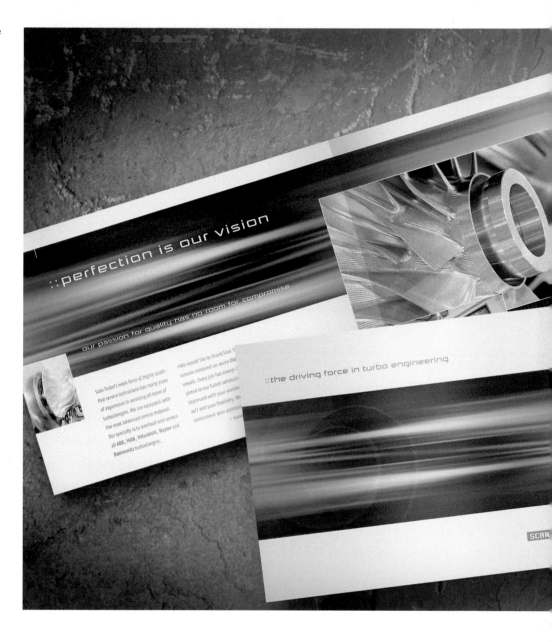

The Challenge

The fabled mantra "Time is money" is a favorite among shipbuilders and shipyard owners around the world. Scan Turbo's maritime prowess was well known in the industry, as evidenced by a vigorous spike in the company's turbocharger business. But this reputation was not accurately reflected in the static and dated imagery of an accordion-fold marketing brochure. The industrial-strength company needed a turbocharged identity of its own.

The Solution

The design language for a new branding approach became imminently clear when creatives at Braue pondered Scan Turbo's intrinsic strengths: speed and engineering. "Shipping is a 24/7 industry with tight deadlines. When Scan Turbo's clients are in need, the company has to respond fast so no precious time is wasted," notes strategist Kai Braue. Headlines are thus set in the dynamic face, Trade Marker, whereas body copy is Fago, a modern and flexible font. The substrate of choice is Arjo Wiggins's Curious Metallics paper—an iridescent stock that reflects light in the same manner as turbocharger rotor blades.

The company is in its element when it's in the water, so aquamarine dominates page spreads.

Color-correcting photos to reproduce well on the shimmering paper stock was a challenge. "Had we not done this, the photos would have appeared yellowish because the paper itself is not white," says Braue. "Because of the iridescent finish, the paper changes color, depending on the angle from which you are viewing it. Also, inks don't sink into the surface, so the black portions of the photos ended up looking dark gray. We had to intensify the black to compensate for that effect. The ink took almost 10 days to dry on this exceptional paper stock. It was a pain but worth the effort."

SOMA CAFÉ
Natural Ingredients

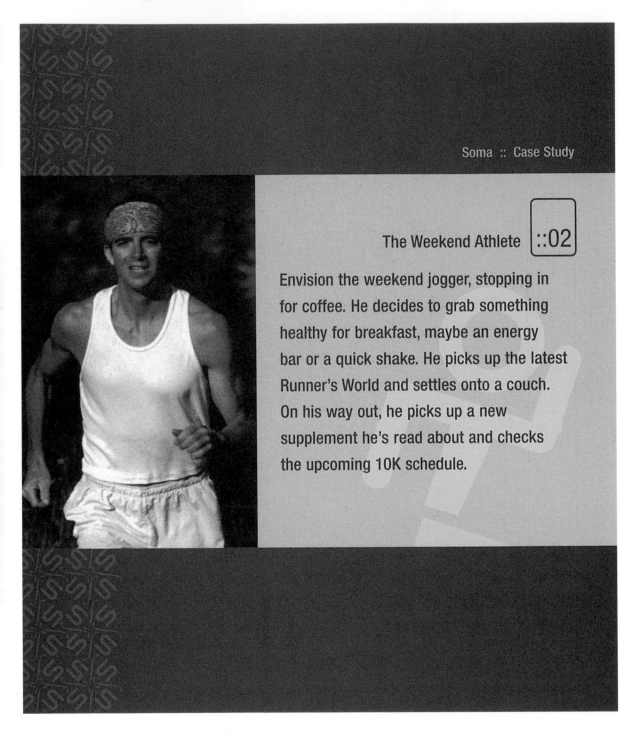

Soma :: Case Study

The Weekend Athlete | ::02

Envision the weekend jogger, stopping in for coffee. He decides to grab something healthy for breakfast, maybe an energy bar or a quick shake. He picks up the latest Runner's World and settles onto a couch. On his way out, he picks up a new supplement he's read about and checks the upcoming 10K schedule.

CLIENT: Soma Café is a Phoenix, Arizona, restaurant that combines the convenience of fast food with a focus on nutrition. **FIRM:** Campbell Fisher Design **CREATIVE DIRECTOR:** Greg Fisher **DESIGNER:** GG LeMere

FACING PAGE: The S from the Soma logo forms the basis for a textured pattern on page borders.

RIGHT AND BELOW CENTER: *Soma* means body. The restaurant's anthropomorphic logo not only is shaped accordingly, but also produces offspring. Icons rendered in a similar style populate the cover and inside spreads.

BELOW LEFT: Times New Roman and Viking typefaces provide maximum legibility. (The same fonts were used on the menu.) Screened type adds an abstract, graphic fiber to the inside covers.

Whether it's fitness, health, longevity or just a quick meal, Soma's got you covered.

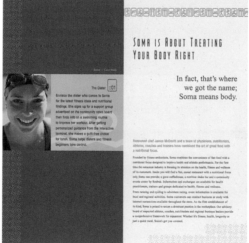

SOMA IS ABOUT TREATING YOUR BODY RIGHT

In fact, that's where we got the name; Soma means body.

The Art of Great Food with a Nutritional Focus

The Challenge

Soma Café is a healthy "fast-food" establishment for 18- to 55-year-old fitness enthusiasts. Created in partnership with a team of nutritionists, physicians, athletes, coaches, and trainers, the eatery features a coffee house, a nutrition-shake bar, and a community bulletin board announcing triathlons and similar events. The concept held promise from the start, but the client faced a catch-22: needing a brochure to attract additional investors yet not having a big budget to do it.

The Solution

Soma's logo, created by Campbell Fisher Design, eventually became the forefather of the brochure and other collateral materials. The brochure's tall and slender trim size (5½" x 11" (14 cm x 27.9 cm)) echoes the proportions of the logo, and an earthy palette of green and brown reflects the organic fare on the Soma menu. Neenah Evergreen Aspen, a recycled paper with a soft fleck, was a natural choice for an all-natural aesthetic.

In the absence of a budget for original photography, the design team converted stock images to half-tones and cooked up a few alternative means of creating texture and movement on each spread. Glyphic icons, rendered in a style similar to the Soma logo, prove highly versatile as background patterns and borders. Thematically, the icons reflect the restaurant's four brand promises—food, fitness, coffee, and community—as well as the various types of patron athlete.

MCKEE NELSON LLP
Turning a New Page

McKee Nelson LLP

An independent law firm allied with ERNST & YOUNG

CLIENT: McKee Nelson is an independent law firm headquartered in Washington, D.C., with offices in New York. **FIRM:** Grafik Marketing Communications, Ltd. **CREATIVE TEAM:** Jonathan Amen, Judy Kirpich, Kristin Goetz, Lynn Umemoto, and Kenn Speicher. **PHOTOGRAPHY:** Dean Alexander **ILLUSTRATOR:** Ben Shearn

FACING PAGE: Quality and substance are evident from the start. The cover is printed on textured Havana paper with sophisticated silver accents and an engraved tip-on.

THIS PAGE: Surreal renderings by illustrator Ben Shearn translate abstract concepts into digestible selling points.

The Challenge

McKee Nelson wanted to position itself as a firm that combines experience and talent with a new perspective on law. The partners hired Grafik Marketing Communications to create a corporate identity system and sales kit with a young, innovative tone. A medley of small brochures was slated to promote specific practice areas, but the firm also needed a big-picture piece to communicate its unique vision.

The Solution

Touting ingenuity without erring toward extremism was a fine line. A radical departure from the traditional suit-and-tie approach might have alienated prospective clients. So the vision brochure blends classic legal tones with a few surprising twists. Navy is the standard backdrop for a narrative punctuated with bright accents.

Apt metaphors combined with a clever production technique illustrate the firm's ability to see beyond the status quo. Specifically, orange spot-color renderings overlaid with crimson flysheets create an invisible ink effect. Through the red vellum, the reader views a seemingly impossible point of impasse; however, a clear solution materializes when the page is turned and the orange ink is revealed.

The design team tested a variety of vellum paper stocks and match colors before nailing a combination that produced the most seamless effect. "Cromatica is clearer than many vellums, and the color frequency of the red cancels out the orange well," says designer Jonathan Amen.

Small halftone images of McKee Nelson employees are positioned adjacent each illustration, connecting the metaphorical with the actual. The entire piece was printed CMYK plus PMS orange, blue, and metallic silver.

BRITESMILE
Promise with Polish

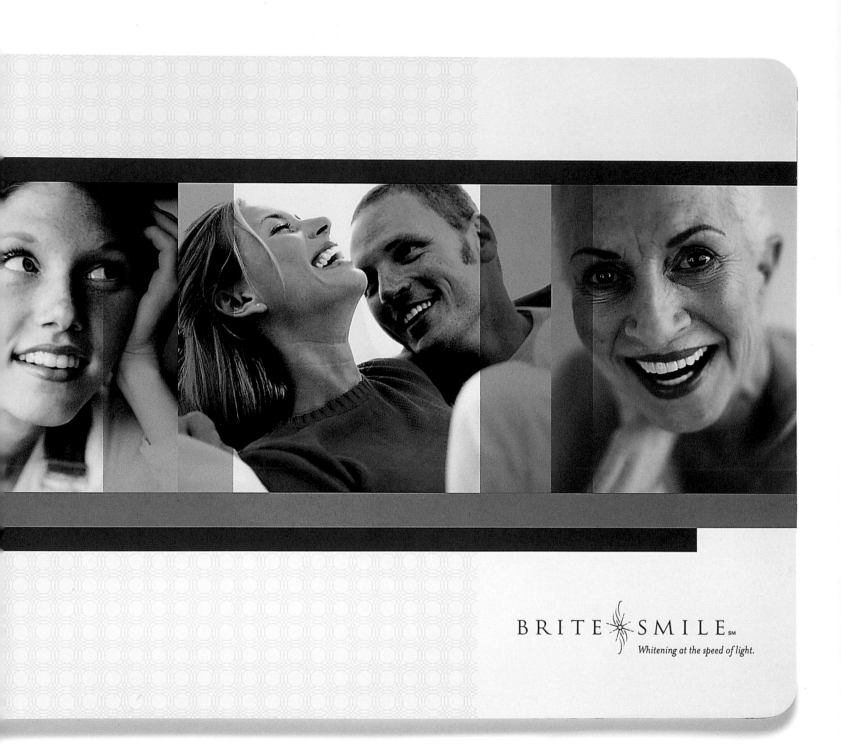

BRITE✳SMILE℠
Whitening at the speed of light.

CLIENT: BriteSmile's light-activated teeth-whitening program includes patented equipment, products, displays, and advertising materials to be used by partner dentists.
FIRM: Dotzero Design DESIGNERS: Karen and John Wippich COPYWRITER: Stacy Bolt PRINTING: Premiere Press

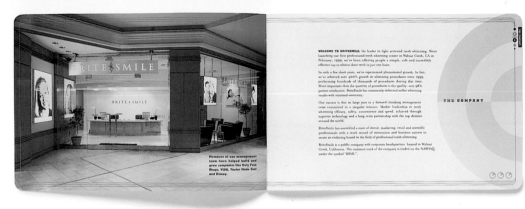

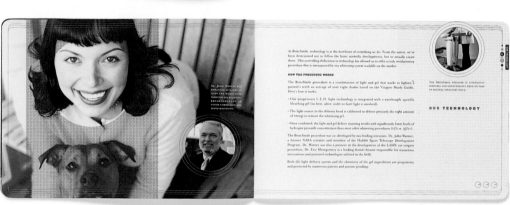

FACING PAGE: Most of the photos are stock. Dotzero had to doctor the teeth of some models to make them sparkle. Rounded corners make the brochure itself appear tooth-shaped.

THIS PAGE: Round graphics and intricate geometric patterns provide a high-tech undercurrent. Clock icons in the bottom-right corner of each spread work in harmony with other circular forms.

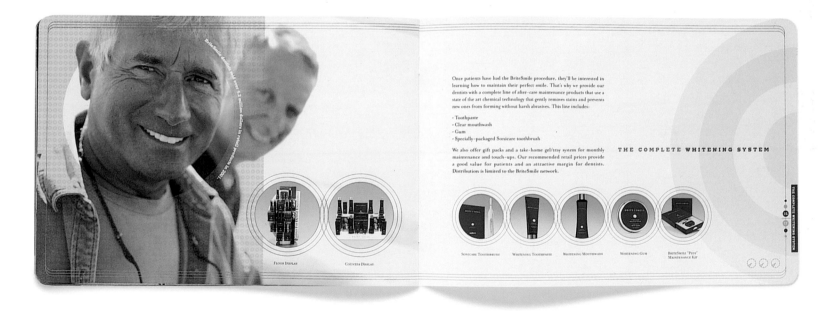

The Challenge
The cosmetic teeth-whitening business grew more than 900 percent from 1990 to 2000. BriteSmile needed a sales piece to promote its patented process and technology to dentists who might be interested in offering the company's state-of-the-art teeth-whitening service to patients. The brochure would also be used as a handout at trade shows.

The Solution
Hmm. What color should the brochure be? White-white, of course. Utopia 1X, a smooth, crisp sheet with 100 percent brightness was a no-brainer when it came to specifying the paper stock.

The client wanted a look that was clean and high-tech, and metallic silver ink delivered. BriteSmile's corporate colors—blue and gold—also needed to be featured, but Dotzero went easy on the gold, using it only as an accent color for pagination. "The gold we had to watch, because when we screened it back, it made the pages look dull," says designer Karen Wippich. The brochure was sized to fit into a 9" x 12" (22.9 cm x 30.5 cm) envelope, with horizontal orientation to make it fresh.

A major advantage of BriteSmile technology is speed; the whitening process takes less than one hour. To play up this selling point, a clock icon in the bottom-right corner of every page moves forward a notch as each new brochure section is introduced.

Circles are a prominent motif throughout the piece, often used to focus the eye on specific concepts or images—including faces showing off their pearly whites. A spot varnish was applied for emphasis to the portions of faces appearing inside the circle frames.

PROFILES
Expanding on a Good Thing

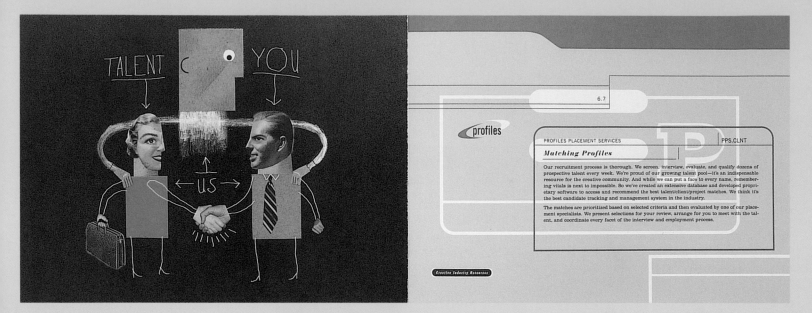

THIS PAGE: Profiles' original brochure, featuring uncoated paper stock and quirky illustrations by Dave Plunkert, signaled an unorthodox approach to personnel recruitment.

Why Redesign?

When Joe Parisi created the original identity and capabilities brochure for Profiles in 1996, the fledgling company specialized exclusively in creative-industry placement. But by 2002, the firm had expanded its scope to include marketing, sales, and accounting folks, and its flagship brochure no longer fit the, um, profile.

CLIENT: Profiles provides recruitment and placement services for marketing, creative, advertising, PR, and sales professionals in Baltimore and Washington, D.C.
FIRM: Flood Graphic Design **CREATIVE DIRECTOR:** Joe Parisi **COPYWRITER:** Tony Mafale and Bang **PHOTOGRAPHY:** Mike Northrup, plus stock from Eyewire and Getty Images **PRINTER:** Advance Printing

TOP LEFT: Color-wise, the redesigned brochures are chips off the old block—although each piece plays up a different hue on the inside. Whereas vibrant tones cater to sales and creative types, softer shades engage marketing and accounting pros.

TOP RIGHT: Good chemistry is especially important when it comes to creative hires—hence the theme "talentology" for the creative brochure. To keep the budget manageable, Parisi created simple graphics in lieu of hiring an outside illustrator.

BOTTOM: Info graphics in the sales recruitment brochure are bold and direct. Images for the marketing set take a softer, more people-oriented approach.

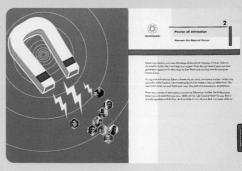

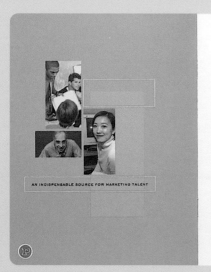

The Evolution

Profiles could have stuffed its expanded capabilities into a bulkier one-size-fits-all brochure, but such a move would have diluted the power of its message. "When you're trying to reach more and more people with the same piece, you tend to go more conservative," says Parisi. That tack wasn't going to fly. "Profiles has always positioned itself as more graphically engaging and forward-thinking than your typical recruitment company," he explains. The better solution? Little brochure offspring, each with a different personality.

The original brochure, with its edgy layouts and nontraditional palette, was instrumental in building

the firm's reputation as a hip resource for temporary and permanent talent. So when Parisi set out to repurpose Profiles's capabilities in a series of targeted booklets, he was careful to preserve elements of this proven visual equity. The new pieces are not so much overhauls as variations on the original theme.

The next generation of brochures are kindred but not identical. Some elements, such as trim size, are consistent, whereas others are unique. Typefaces, for example, are germane to each audience. The accounting brochure samples classic cuts of Baskerville, whereas the marketing piece features the modern glyphs of Balance. Clarendon Bold appeals to the in-your-face style of sales types.

And the revamped creative brochure—a retro remix using chemistry as a metaphor—features Future, a font reminiscent of the typefaces found in old chemistry textbooks.

While other companies were curbing their marketing efforts when the economy tanked in 2002, Profiles saw an opportunity to strike. "They felt the need for temps, especially, would continue to grow, and they were right," says Parisi. "They've experienced 25 percent growth in the past year by expanding their scope and making that move well known."

FERRAGAMO USA INC.
Dressed to Sell

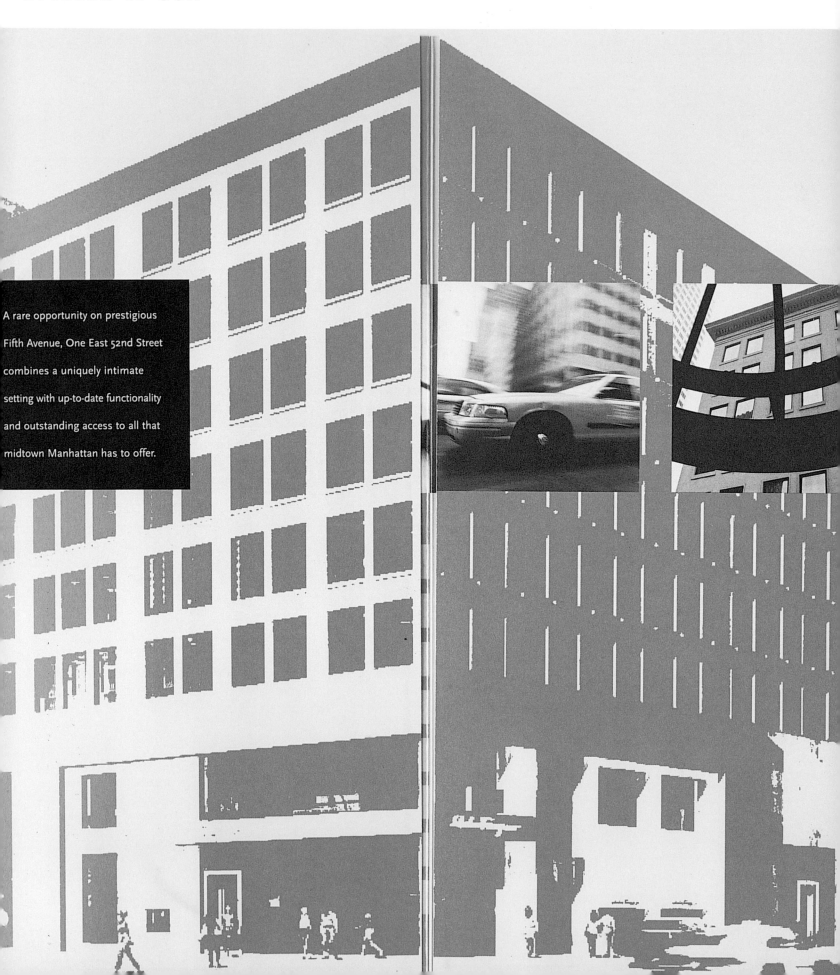

A rare opportunity on prestigious Fifth Avenue, One East 52nd Street combines a uniquely intimate setting with up-to-date functionality and outstanding access to all that midtown Manhattan has to offer.

CLIENT: Ferragamo is a fashion industry leader and bellwether. **FIRM:** i.e. Design (New York) **ART DIRECTOR:** Bethlyn B. Krakauer **DESIGNERS:** Bethlyn B. Krakauer, Louis A. Medeiros, and Carrie A. Brunk **PHOTOGRAPHY:** Bob Handelman **PRINTER:** Nugent Printing

FACING PAGE AND RIGHT: Photographer Bob Handelman was able to capture the energy and movement of Fifth Avenue in black-and-white with nothing more than a 35-mm camera.

BELOW RIGHT: The brochure cover is subtly rendered as a 30 percent metallic tint with a full halftone over it. The same imagery, palette, and dimensions were parlayed into a cocktail party invitation luring brokers to check out the space and receive a free Ferragamo tie. A bellyband, ganged up on the same press run, tied up things nicely.

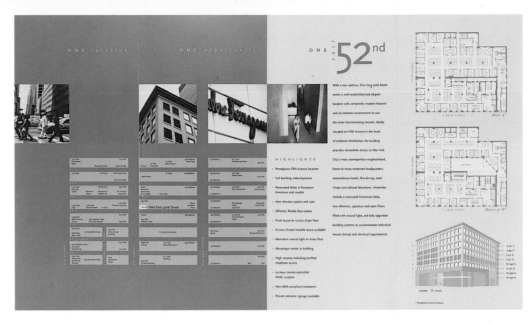

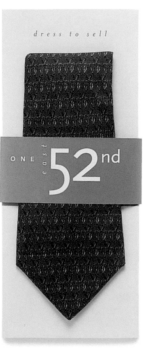

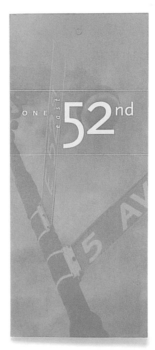

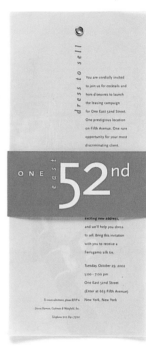

The Challenge

When Ferragamo USA bought the building housing its new flagship store on Fifth Avenue, the company faced the challenge of subletting excess office space in a weak market. The building wasn't particularly large or well known, so getting it on real estate brokers' radar screens would be tough. Several agencies proposed elaborate and expensive ad campaigns involving all the usual promotional tactics. But Ferragamo wanted something more astute than an off-the-rack approach. Could the same goals be achieved at a discount without sacrificing the brand's reputation for quality and innovation?

The Solution

i.e. design crafted a stylish and effective solution at a mere quarter of the cost proposed by other agencies. Logic was the fabric: Ferragamo makes products to die for. Real estate brokers want to look good. Ergo, lure them with fashion. What the client lacked in budget, it more than made up for in inventory. A sleek brochure bearing the promise of a free Ferragamo tie was the perfect bait to get brokers to come and see the space.

The Ferragamo building at One East 52nd Street is a slim and elegant edifice, imbued on the inside by monochromatic furnishings and frosted glass. It made sense for the brochure to be similarly attired. "We made the trim size tall and skinny and went with a stone-colored metallic ink to give the piece richness,"

says art director Beth Krakauer. "The added benefit is this knocked the piece down from four colors to two. It cost less, but it looked like we spent more."

For the opening spread, the only representation the client had of its space was a color rendering of what the building facade would look like upon completion. Full color would have clashed with the neutral cover, so the design team blew out the image as high-contrast art and ran the shot in 100 percent metallic ink. The corner of the building is aligned with the fold that runs down the middle the brochure, alleviating what might have been a tricky production problem.

More than 250 brokers came to view the space.

COMVENTURES
What's the Big Idea?

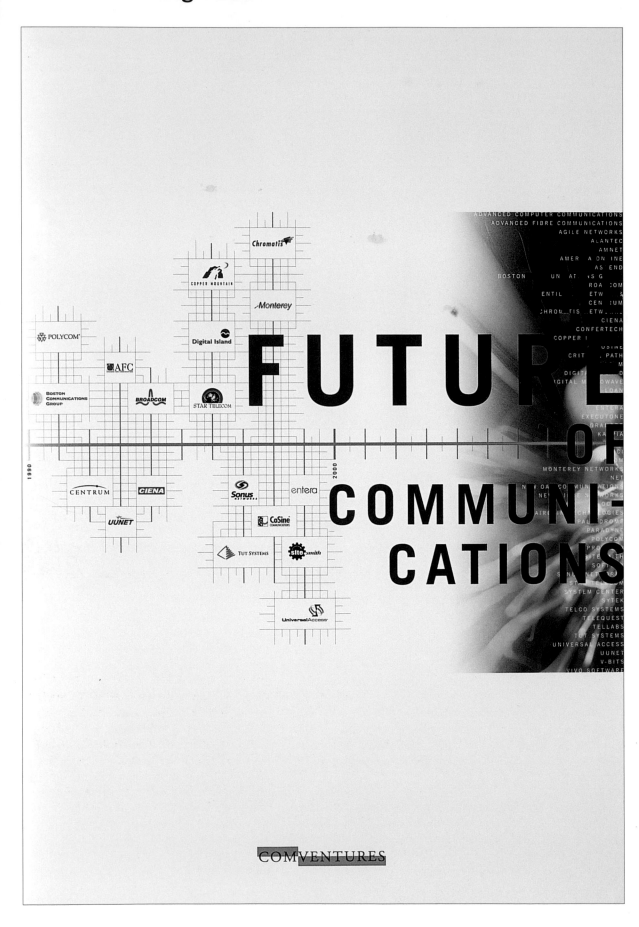

CLIENT: ComVentures is a venture capital firm investing in early-stage communications, networking, and Internet companies. **FIRM:** Gee + Chung **CREATIVE DIRECTORS:** Earl Gee and Fani Chung **DESIGNERS:** Earl Gee and Fani Chung **PHOTOGRAPHY:** Henrik Kam **PRINTER:** ColorGraphics

FACING PAGE: A pictorial timeline on the cover chronicles ComVentures' long line of successful portfolio companies. Investments that have not yet gone public or have not been acquired are listed at the far right of the timeline.

ABOVE RIGHT AND BELOW LEFT: In the ComVentures' world, router cables and other hardware staples are part of the terrain. Type and graphics blend and interact to emphasize core themes.

BELOW CENTER AND BELOW RIGHT: "Connections and interrelationships form the essence of venture capital," notes Gee. A spread highlighting the ComVentures team assigns a specific color to each partner. The same color coding forms the logic for a "Past Successes" diagram linking specific partners to specific investment coups.

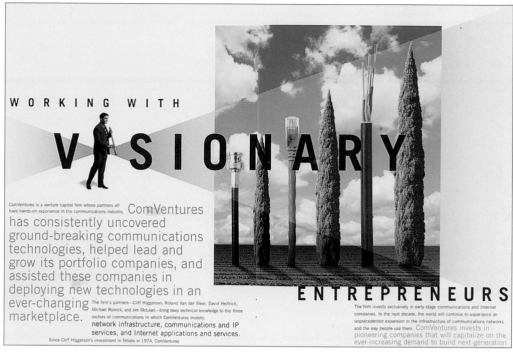

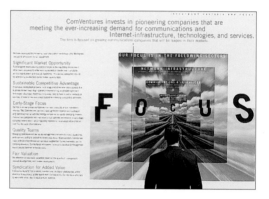

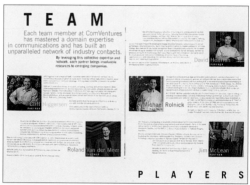

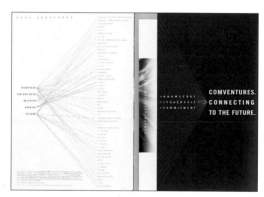

The Challenge

The venture capital industry generally leans toward the conservative side, but ComVentures' target audience didn't necessarily fit the profile. The tech-hungry VC firm wanted a brochure that would anchor its leadership position while catering specifically to young, innovative entrepreneurs. Furthermore, the firm's core principles needed to be distilled into a compelling graphic vocabulary—one that would resonate with the wunderkind set.

The Solution

Visual metaphors blend with bold typography to convey ComVentures' main themes: vision, commitment, and focus. Each spread features a surrealistic landscape populated by larger-than-life objects, where diminutive human figures create a sense of scale. "Our goal was to portray ComVentures' dynamic outlook for the future and a sense that the ideas behind the entrepreneurs can often be bigger than the entrepreneurs themselves," says partner Earl Gee. "Our photographer, Henrik Kam, went deep into the California desert to find the uninhabited landscapes necessary for the right look for the concept."

The narrative has proved an effective leave-behind piece for ComVentures. "As an added testament to the brochure's success, we have been asked by other venture capital companies to create a brochure 'like the ComVentures brochure,'" says Gee. "Obviously we cannot provide the same solution, but we have enjoyed developing unique strategies tailored to the specific qualities of other firms and continuing to learn more about their industry."

K/P CORPORATION
People Power

K/P Corporation

your needs / our purpose

A BLUEPRINT FOR RESULTS

The right message delivered today,

technologies working to help you respond to tomorrow,

and a partner who works relentlessly for your success.

Kathryn Wallace
SOLUTIONS PROJECT MANAGER
K/P CORPORATION

CLIENT: K/P Corporation specializes in fulfillment, printing, and direct mail. **FIRM**: Belyea **CREATIVE DIRECTOR**: Patricia Belyea **DESIGNER**: Ron Lars Hansen **PHOTOGRAPHY**: Rosanne Olson

FACING PAGE, LEFT: Original plans to do a 20-page brochure were scrapped when it became clear the client needed to get its message out fast. A no-fuss gatefold piece gets to the point quickly.

FACING PAGE, RIGHT: Eye contact conveys a feeling of trustworthiness. Every individual is looking straight at the camera with one exception: A client featured on the back cover appears to be looking toward the K/P team and applauding.

THIS PAGE: A tab folder die cut adds interest to the gutter of the brochure. The same motif is used in the company's business cards, stationery, and other collateral pieces.

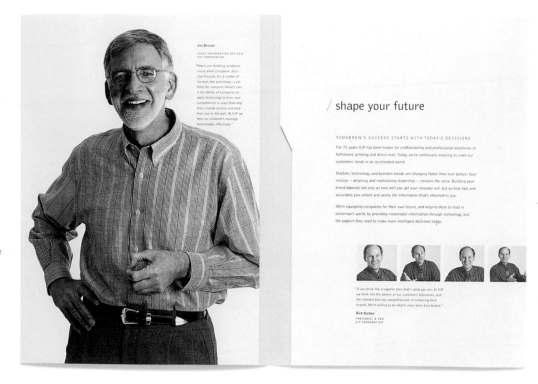

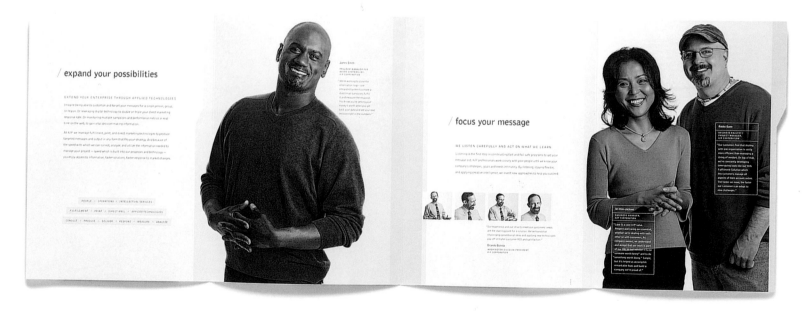

The Challenge

Technology is a major selling point for K/P Corporation, but the 400-some employees who staff its offices in Utah, California, and Washington state are key to every project's success. K/P wanted real employees featured in its capabilities brochure.

The Solution

"Usually when printing companies feature their staff in their brochures, that means lining everyone up for shots that look like class photos or showing people standing next to presses. We wanted something cleaner and fresher," says creative director Patricia Belyea.

Working with shooter Rosanne Olson and a wardrobe stylist, the Belyea team photographed 16 K/P employees over two days. During the shoot, subjects were asked questions about their hobbies and families—not work—to get their facial muscles and body language relaxed. In the end, scale was an important device in illustrating K/P culture. Photos of front-line employees were cast large in full color, whereas images of the highest-ranking executives ran in small, black-and-white strips.

VODOVOD-KANALIZACIJA
Maximum Utility

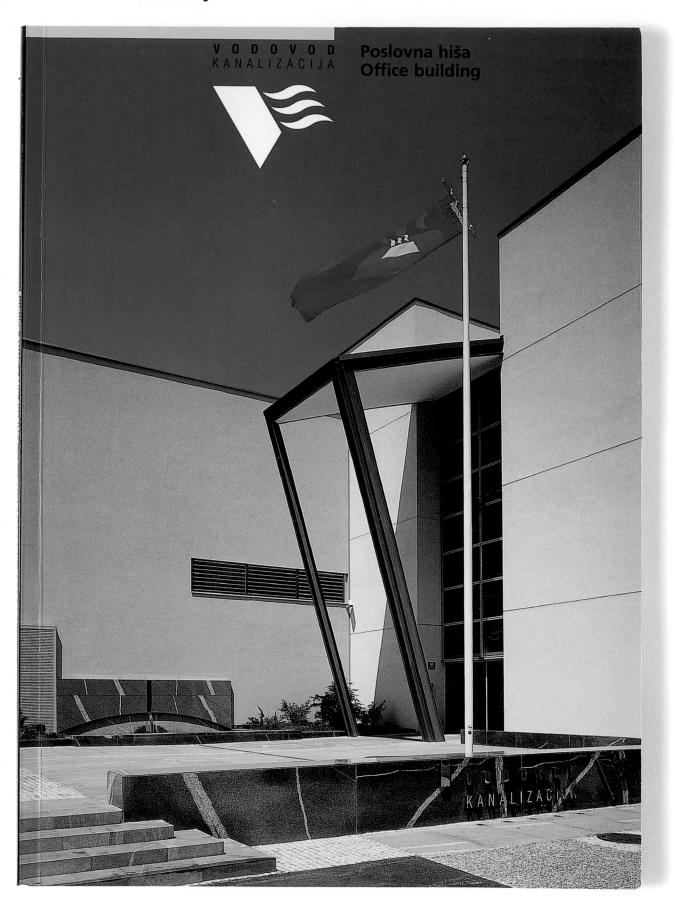

VODOVOD
KANALIZACIJA

Poslovna hiša
Office building

CLIENT: Vodovod-Kanalizacija is a town water supplier in Ljubljana, Slovenia. **FIRM:** KROG **ART DIRECTOR:** Edi Berk **DESIGNER:** Edi Berk **PHOTOGRAPHY:** Miran Kambič **EDITOR:** Andrej Mlakar **WRITER:** Miha Dešman

FACING PAGE: Inventively cropped photos chronicle the building's conception and development over a 10-year period. Magnomat gloss paper (cover and text) ensures crisp, clear reproductions.

THIS PAGE: The layout fuses several languages, including English, Slovenian, and the nonverbal lexicon of architectural blueprints.

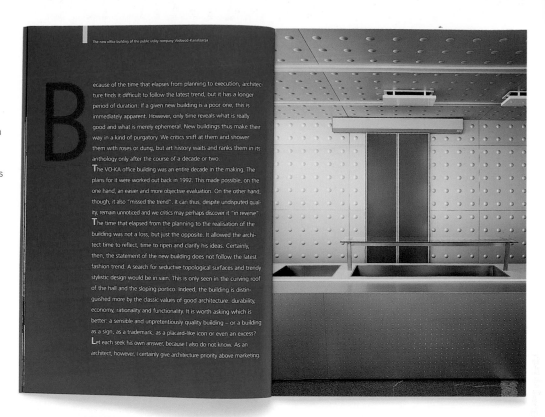

The Challenge

When the municipal water supplier Vodovod-Kanalizacija moved to a newly constructed building in 2002, the company needed to convince local administrators and senators that its fresh space was a sound investment of public dollars—one that added beauty and functionality to the landscape without excessive indulgence.

The Solution

A moving announcement brochure (which doubles as a promo for the architect) highlights the fact that exceptional architecture can be achieved on a limited budget. "This was particularly important to demonstrate in Slovenia, which is not as rich as some western countries," says art director Edi Berk. Bilingual text blocks, penned by architect Andrej Mlakar, complement photos, sketches, and CAD renderings to explain the rationale behind every building detail—from the structure's external facades of stone, concrete, metal, and glass to its open interiors.

For Berk, a registered architect herself, issues of balance weighed heavily in the page layouts. Photos, text, type accents, and project descriptions are arranged to create fluid movement and stability. The page grid itself is designed with the architectural principals of durability, economy, functionality, and beauty in mind.

CONWAY MACKENZIE & DUNLEAVY
Good Sportsmanship

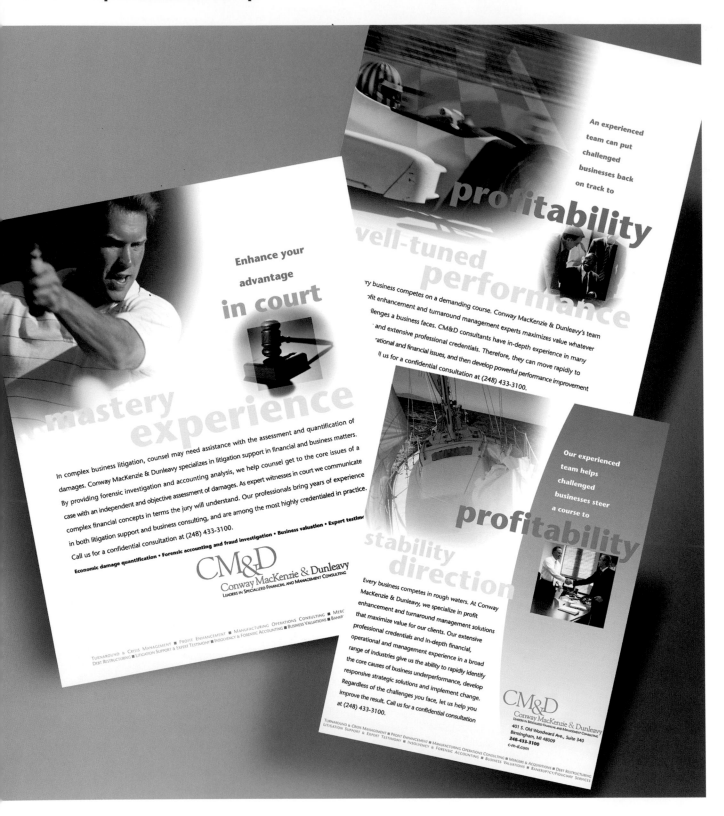

Enhance your advantage **in court**

...mastery

experience

In complex business litigation, counsel may need assistance with the assessment and quantification of damages. Conway MacKenzie & Dunleavy specializes in litigation support in financial and business matters. By providing forensic investigation and accounting analysis, we help counsel get to the core issues of a case with an independent and objective assessment of damages. As expert witnesses in court we communicate complex financial concepts in terms the jury will understand. Our professionals bring years of experience in both litigation support and business consulting, and are among the most highly credentialed in practice.

Call us for a confidential consultation at (248) 433-3100.

Economic damage quantification • Forensic accounting and fraud investigation • Business valuation • Expert testimony

CM&D
Conway MacKenzie & Dunleavy
LEADERS IN SPECIALIZED FINANCIAL AND MANAGEMENT CONSULTING

TURNAROUND & CRISIS MANAGEMENT ■ PROFIT ENHANCEMENT ■ MANUFACTURING OPERATIONS CONSULTING ■ MERG
DEBT RESTRUCTURING ■ LITIGATION SUPPORT & EXPERT TESTIMONY ■ INSOLVENCY & FORENSIC ACCOUNTING ■ BUSINESS VALUATIONS ■ BANKR

An experienced team can put challenged businesses back on track to

profitability

well-tuned

performance

...ry business competes on a demanding course. Conway MacKenzie & Dunleavy's team ...ofit enhancement and turnaround management experts maximizes value whatever ...llenges a business faces. CM&D consultants have in-depth experience in many ... and extensive professional credentials. Therefore, they can move rapidly to ...ational and financial issues, and then develop powerful performance improvement ...ll us for a confidential consultation at (248) 433-3100.

stability
direction

Every business competes in rough waters. At Conway MacKenzie & Dunleavy, we specialize in profit enhancement and turnaround management solutions that maximize value for our clients. Our extensive professional credentials and in-depth financial, operational and management experience in a broad range of industries give us the ability to rapidly identify the core causes of business underperformance, develop responsive strategic solutions and implement change. Regardless of the challenges you face, let us help you improve the result. Call us for a confidential consultation at (248) 433-3100.

TURNAROUND & CRISIS MANAGEMENT ■ PROFIT ENHANCEMENT ■ MANUFACTURING OPERATIONS CONSULTING
LITIGATION SUPPORT & EXPERT TESTIMONY ■ INSOLVENCY & FORENSIC ACCOUNTING

Our experienced team helps challenged businesses steer a course to

profitability

CM&D
Conway MacKenzie & Dunleavy
LEADERS IN SPECIALIZED FINANCIAL AND MANAGEMENT CONSULTING
401 S. Old Woodward Ave., Suite 340
Birmingham, MI 48009
248-433-3100
c-m-d.com

■ MERGERS & ACQUISITIONS ■ DEBT RESTRUCTURING
■ BUSINESS VALUATIONS
■ BANKRUPTCY/FIDUCIARY SERVICES

CLIENT: Conway, MacKenzie & Dunleavy (CM&D) is a business consulting, corporate turnaround, and litigation firm. **FIRM:** Group Fifty-Five Marketing
PRESIDENT/ACCOUNT EXECUTIVE: Catherine C. Lapico **ART DIRECTOR:** Jeanette Gutierrez **COPYWRITER:** David Stewart **PHOTOGRAPHY:** Richard Hirneisen

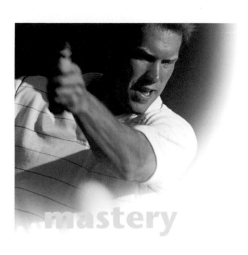

mastery

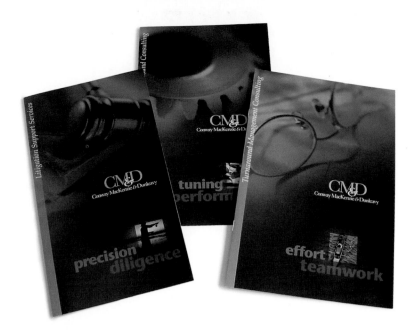

FACING PAGE: Sporty collateral emphasizes three areas in which CM&D excels: management turnaround, automotive turnaround, and litigation. Flexible inserts allow the brochure to be customized to match individual client priorities. A flood aqueous coating repels fingerprints.

THIS PAGE: Creating a winning design meant knowing where to conserve energy and where to go all out. A fifth metallic spot color and gold foil stamping were eliminated from the specs to control costs. But original photography was a must for capturing CM&D partners in the game.

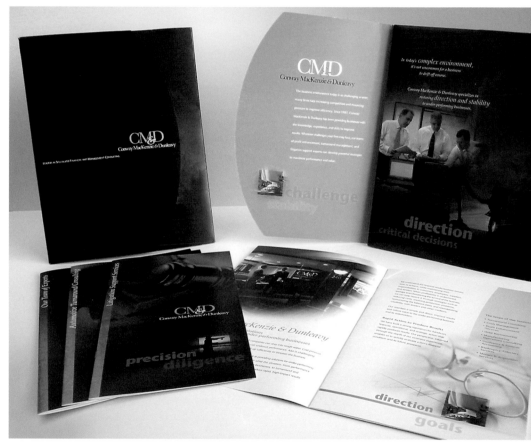

The Challenge

Business consultancies often use the same, tired metaphors to illustrate what they do—particularly directional themes laden with compasses, maps, and other navigational devices. Even less adventurous firms stick with dry headshots of their partners. Conway, MacKenzie & Dunleavy (CM&D) wanted to deliver its brand message in a way that was original, memorable, and powerful.

The Solution

Compasses were out, "but we still liked the idea of using a metaphor for emotional impact," says Catherine Lapico, president of Group Fifty-Five Marketing. "A good metaphor can define what a company does in a way that a laundry list of services can't."

Interviews with CM&D revealed professionals who work hard and play hard. One consultant, it turns out, was a competitive sailboat racer; another was an avid fly fisherman. This commitment to athletic excellence dovetailed with CM&D's dedication to increasing the speed and muscle of its clients' businesses. From there, a clear strategy emerged. Sports imagery tied with dynamic shots of CM&D consultants in action positioned the firm as a coach that could help businesses achieve peak performance.

CLIFFORD CHANCE
See a Chance? Take It.

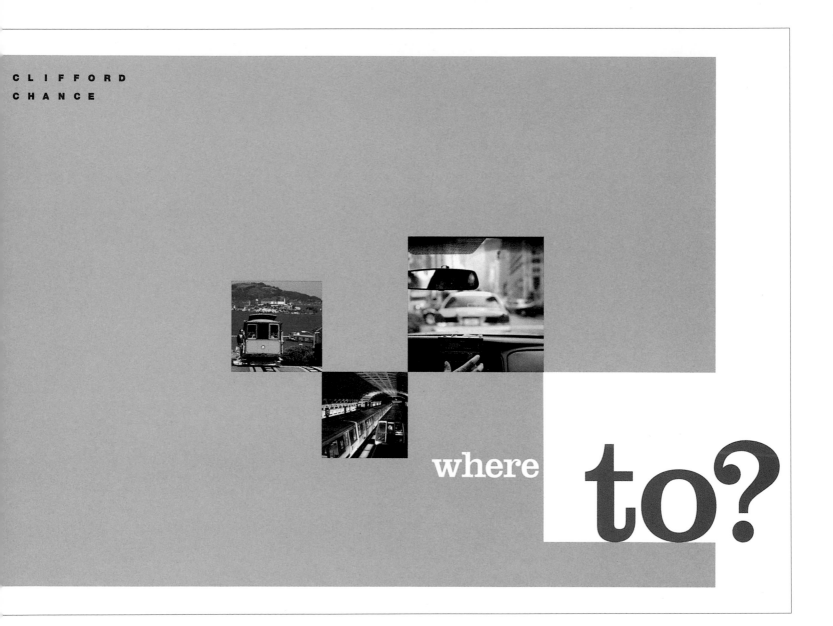

CLIFFORD
CHANCE

where to?

CLIENT: Clifford Chance is a fully integrated global law firm with 32 offices in 19 countries. FIRM: Carbone Smolan Agency DESIGN DIRECTOR: Justin Peters
PROJECT MANAGER: Sally Fonner DESIGNER: Cybele Grandjean PHOTOGRAPHY: Erica Freudenstein PRINTER: Print International

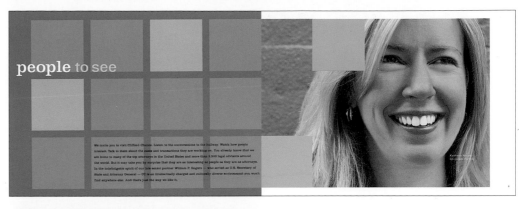

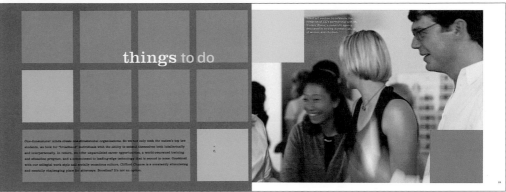

FACING PAGE: A tart yellow cover immediately signals that this is no ordinary law firm. Inset photos of taxicabs, trolley cars, and subways provide brisk color accents and anchor the headline/theme, *where to?*

RIGHT TOP AND CENTER: Color coding creates a visual logic for the brochure's three main content sections: people, places, and things. The palette is dense; the copy isn't.

BOTTOM RIGHT AND BELOW: Portrait photography was painstakingly art directed to coordinate with the layout. The designer and photographer worked together to identify colorful locations and set up shots to fit the personality of each spread. A few of the cityscapes (Hong Kong, London, San Francisco, and Washington, D.C.) are stock.

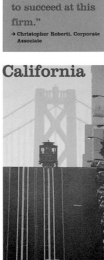

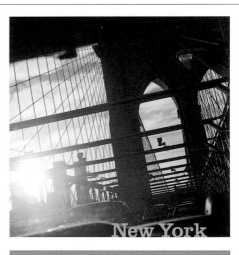

"If you work hard, there are many opportunities to succeed at this firm."
→ Christopher Roberti, Corporate Associate

California

Washington, D.C.

New York

places

"I observed numerous law firms when I worked at the FTC. When I decided it was time to leave the government,
I knew this was the place to be."
→ Craig Waldman, Litigation Partner

10

The Challenge

The U.S. offices of Clifford Chance, a global law practice employing more than 3,500 legal advisors worldwide, needed a recruitment piece to tickle the fancies of young, smart, talented law students, as well as attorneys at other firms looking to make lateral moves. The style and color scheme had to be authoritative but also bright and accessible to match the target audience. The firm took a chance and made a dramatic departure from the staid pomp-and-pinstripes look of a typical law-firm brochure.

The Solution

Law professionals and students have enough to read, so the brochure makes its case in a compact format. Concise testimonials from real partners and associates paint a vivid portrait of the firm's culture with a shrewd economy of space. Squares a pervasive design element—are used to compartmentalize quotes, case studies, and practice area descriptions. In select instances, however, the copy is allowed to break the boundaries of the grid. (Feel free to interpret.) The cumulative effect is a potent metaphor for the intellectual and structural building blocks of a groundbreaking firm.

Whereas much of the competition looks the same on paper, Clifford Chance dares to be unique. Astrolite Smooth uncoated stock conveys an image that is substantive but not slick, and type set in Clarendon is easy to digest. Now in its third reprint, the brochure sports a unique trim size (10¾" x 7⅝" (27.3 cm x 19.34 cm)) and horizontal orientation, both of which serve as points of differentiation in a competitive field.

GLOBE CORPORATION
Chronicling the American Dream

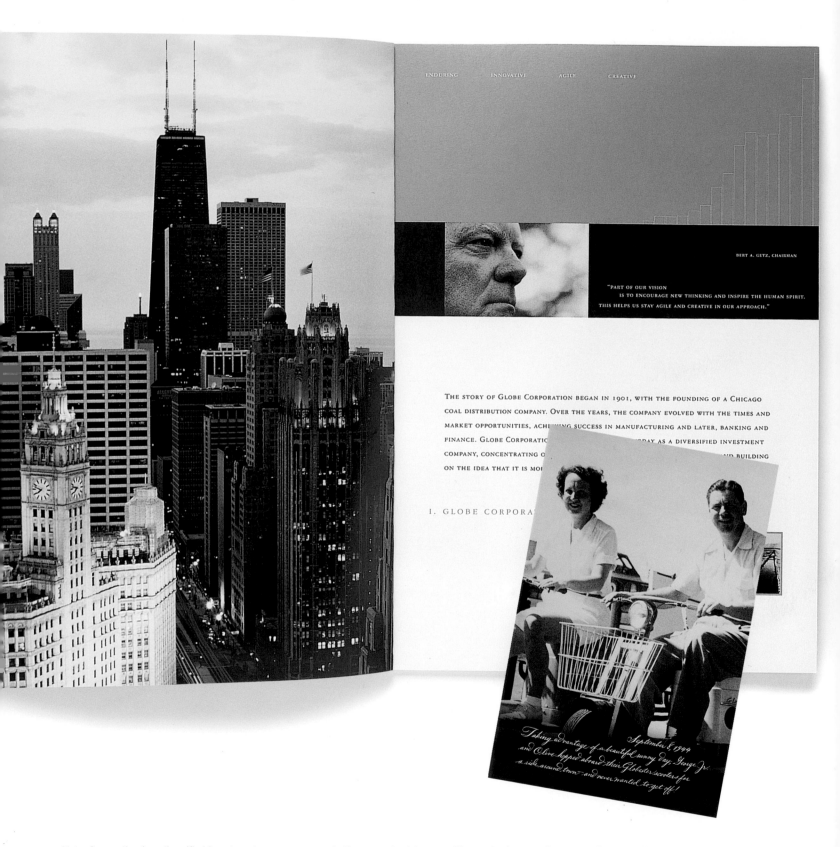

ENDURING INNOVATIVE AGILE CREATIVE

BERT A. GETZ, CHAIRMAN

"PART OF OUR VISION
IS TO ENCOURAGE NEW THINKING AND INSPIRE THE HUMAN SPIRIT.
THIS HELPS US STAY AGILE AND CREATIVE IN OUR APPROACH."

THE STORY OF GLOBE CORPORATION BEGAN IN 1901, WITH THE FOUNDING OF A CHICAGO
COAL DISTRIBUTION COMPANY. OVER THE YEARS, THE COMPANY EVOLVED WITH THE TIMES AND
MARKET OPPORTUNITIES, ACHIEVING SUCCESS IN MANUFACTURING AND LATER, BANKING AND
FINANCE. GLOBE CORPORATION ... TODAY AS A DIVERSIFIED INVESTMENT
COMPANY, CONCENTRATING O... ...ND BUILDING
ON THE IDEA THAT IT IS MO...

I. GLOBE CORPORA...

September 8, 1944
Taking advantage of a beautiful sunny day, George Jr.
and Olive hopped aboard their Globster scooters for
a ride around town — and never wanted to get off!

CLIENT: Globe Corporation is a diversified investment company concentrating on real estate, securities, and private equity. FIRM: Campbell Fisher Design
CREATIVE DIRECTOR: Mike Campbell DESIGNERS: GG LeMere and Stacy Johansen COPYWRITER: Steve Hutchison PHOTOGRAPHY: Rick Gayle
HAND LETTERING: Jill Bell

FACING PAGE BOTTOM AND BELOW RIGHT: Historical photos mined from the Globe archives were scanned and printed as tri-tones, then deepened with spot varnish on Strobe gloss stock. The cream-colored backgrounds are a CMYK build.

FACING PAGE AND BELOW LEFT: The inside of the vision brochure, printed 7/7 on Sappi McCoy, depicts a company poised for its next chapter of greatness. Monochromatic photos reproduced as black-and-silver duotones convey a high-tech edge.

RIGHT: For continuity, the covers of both brochures are printed on French paper and elegantly stitch-bound. The photo corners on the history brochure are not actual adhesive stickers; they were printed, die-cut, and embossed to mimic the real deal. The photo was printed as a separate card and inserted by hand.

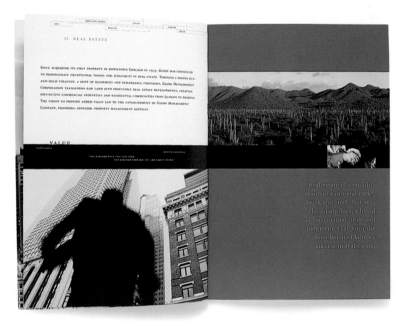

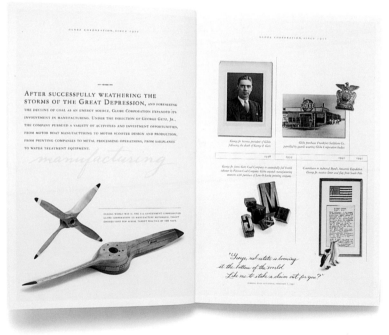

The Challenge

The coal distribution company that would become Globe Corporation was founded in 1901, a time when coal powered most of America's manufacturing plants and transportation systems. Over the years, as coal was replaced by other energy sources, the company evolved, achieving success in manufacturing, banking, and finance. To celebrate its 100th anniversary, Globe wanted to reflect on its rich and diverse past but also to communicate a strong outlook for the future. "This was an old company with contemporary vision," says designer GG LeMere. "We needed to use old elements in a way that didn't make them look staid or trapped in time."

The Solution

The Globe story is as broad as it is long. Twin brochures focusing alternately on the company's history and vision proved best for telling the corporate tale to community leaders, elected officials, financial institutions, business partners, and even the president of the United States.

But achieving a visual language that married past, present, and future wasn't easy. The anniversary brochure speaks in the vernacular of antique photo albums, combining sepia-toned prints with hand lettering for a vintage look. On the cover, a photograph of founder George Fulmer Getz rests inside

antique photo corners of the ilk used before the advent of plastic photo sleeves.

A binding simulating old, tape-bound notebooks creates visual continuity from one brochure to the next—but the vision brochure's nod to posterity stops there. Its cover is otherwise distinctly modern, bearing nothing more than an engraved corporate logo within a crisp, debossed box. Inside, the vision piece speaks the language of 21st-century commerce with kinetic photographs and silver metallic accents.

REALITY

CHAPTER THREE:
Educational, Institutional, and Nonprofit

The stereotypes are well rooted: Educational means staid, institutional means sterile, and nonprofit means a shoestring job slapped together on a photocopier. Think again. The fund-raising game has become infinitely more vibrant in recent years. The best brochures are precious keepsakes that don't get thrown out but rather keep on giving.

THE PRITZKER INSTITUTE OF BIOMEDICAL SCIENCE + ENGINEERING
From Lab to Boardroom

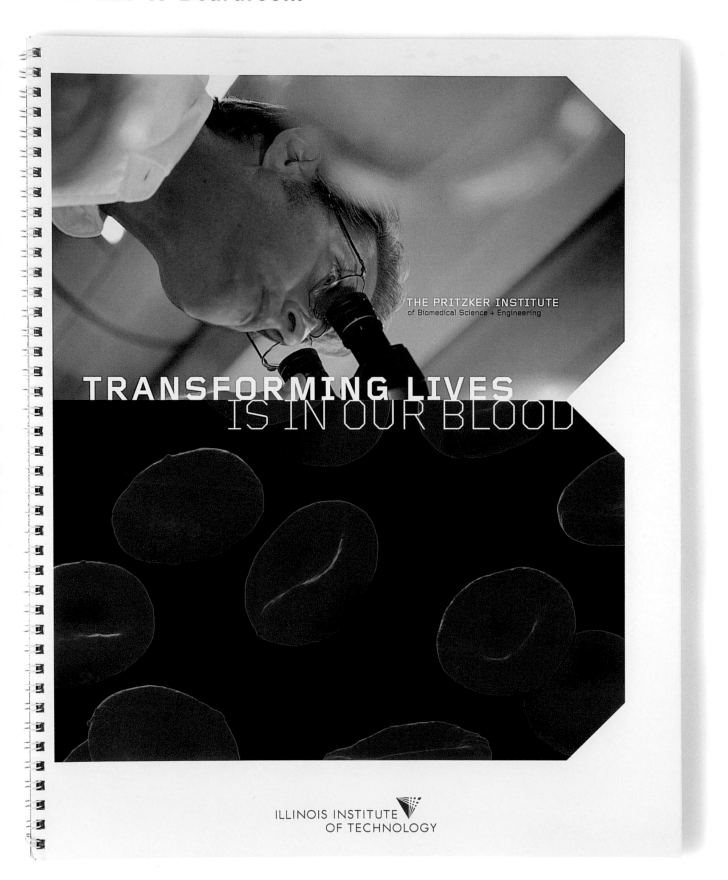

THE PRITZKER INSTITUTE
of Biomedical Science + Engineering

TRANSFORMING LIVES
IS IN OUR BLOOD

ILLINOIS INSTITUTE
OF TECHNOLOGY

CLIENT: The Pritzker Institute is a new biomedical research facility housed on the campus of Illinois Institute of Technology. FIRM: sparc inc. ART DIRECTOR: Richard Cassis DESIGNER: Richard Cassis CONTENT: Kate Chappell, Allan Myerson, and Pam Reardon EDITORS AND COPYWRITERS: Kate Chappell, Carl Marziali, Ralph Strohl, Michael Szeremet, Philip Troyk, and Rob Wittig ILLUSTRATION: Victor Koen PORTRAITS: David Joel and Chris Kirzeder

FACING PAGE: The cover imagery is cropped to form an abstract, beveled B for biotechnology. The same design motif was later used for environmental graphics and signage on campus.

TOP AND BOTTOM RIGHT: Cropped insert pages of varying dimensions create a layered effect inside. "The contrast between the short sheets, full-bleed images, and white-space text pages makes for an interesting and motivational pacing throughout," says Cassis.

BELOW: Surprisingly, almost all of the scientific images are stock—made extra crisp with dotless stochastic printing on Utopia One X, a 100 brightness coated paper. Most forms were printed CMYK with two varnishes added offline. Magenta-heavy pages received an extra pass with a bump red for added richness and depth.

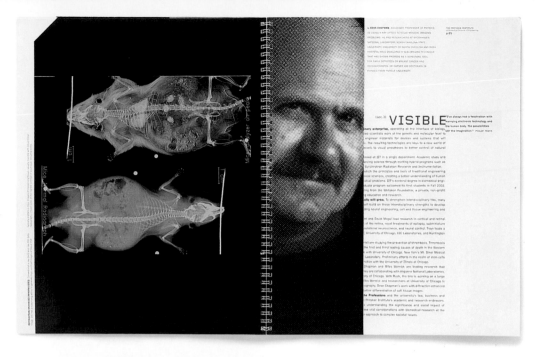

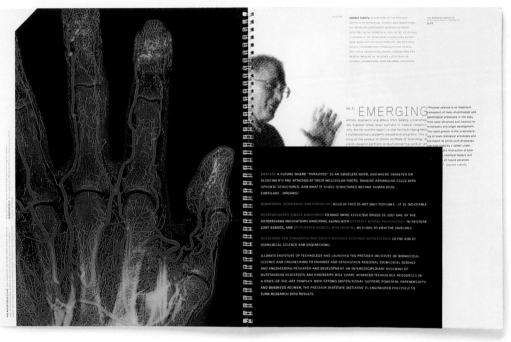

The Challenge

Upon its inception, the Pritzker Institute needed to appeal to national business and political bigwigs to raise capital for biomedical research. Realizing, however, that this audience receives truckloads of such solicitations daily, the Institute needed an arresting piece that would get noticed. Also critical: translating scientific jargon into a compelling visual language that would be easily digestible for a lay audience.

The Solution

To avoid slow death-by-file-cabinet syndrome, designer Richard Cassis specified an oversized piece that just wouldn't stand to be put away in a drawer. But he also realized that CEOs and foundation decision makers might want to tote the Institute's reading material around in their not-so-oversized briefcases. So he added a 9" x 12" (22.9 cm x 30.5 cm) detachable insert sleeve in the back of the brochure to hold customized literature.

Each spread focuses on a specific field of biomedical advancement and the leading researchers behind it. Portraits of scientists were, therefore, a necessity, although the quality of available images was mediocre. Some portraits existed only as web-resolution RGB files, and no budget for new photography was

available. Cassis overcame this minor setback by rendering each portrait as a coarse line screen. "There's a filter in Photoshop that allows you to assign pixel dimensions to the dots," he explains. "The little dots ended up looking like atomic structures, which fit well with the concept. Plus, the dots provided some textural variety against the pristine fidelity of the scientific images."

The type connotes an air of analytical authority. "Verbiage is presented in Foundry Gridnik, a font that lends itself to technology with a nose for mathematics and grid orientation," says Cassis. "It has a forward-looking character."

THE PEAR BUREAU NORTHWEST
Quite a Pear

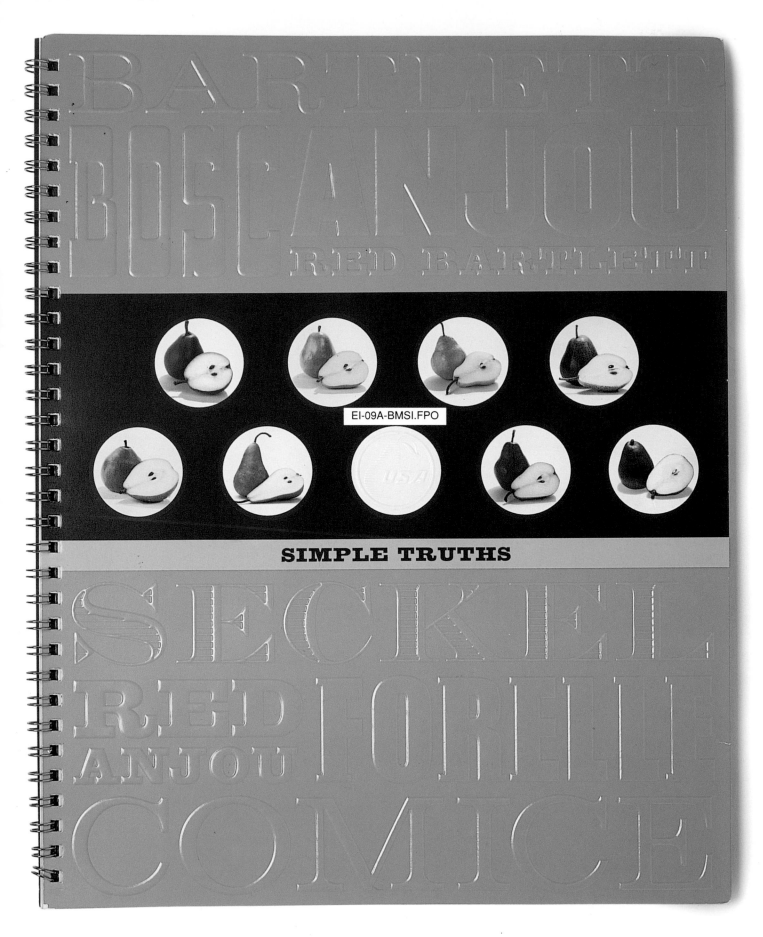

CLIENT: The Pear Bureau Northwest is a nonprofit marketing organization that promotes, advertises, and develops markets for fresh pears grown in Oregon and Washington state. **FIRM**: Dotzero Design **DESIGNERS**: Karen and John Wippich **PRINTER**: Dynagraphics

FACING PAGE: The cover had to feature the eight pear varieties represented by the Pear Board. About this the client was adamant. An embossed type collage bisected by little pear cameos proved a delicious solution.

RIGHT: Sensual fruit photos are meant to entice. Pears count among the highest impulse-purchased fruits in the produce department.

BELOW: Armies of silhouetted pear shapes add flavor and texture to backgrounds.

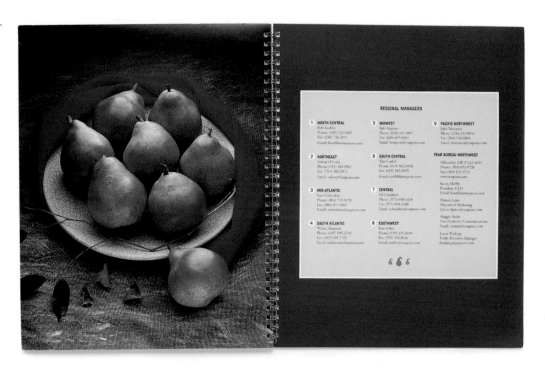

The Challenge

Stocking produce shelves isn't just a matter of apples and oranges. The Pear Bureau wanted supermarkets and other retailers to think of pears more often as a signature display item. Territory managers representing pear growers in the Northwest needed a merchandising brochure to make their case to grocery chains and other key produce resellers. But getting noticed wouldn't be easy. "A produce section in the grocery store may have 300 different items, and representatives of each item send materials to the retailer to influence how they stock their shelves. We needed to create something eye-catching that could be used during presentations but that would also fit in a file drawer for future reference," says John Wippich at Dotzero Design.

The Solution

The Pear Bureau's former promo had been an unassuming white flyer folder that was easily lost in the shuffle. This time the client wanted something more dramatic. Dotzero went big and bold with a juicy palette inspired by pear varieties, from green anjous to red Bartletts to yellow boscs.

When it came to photography, the client's abundant archives proved more than fruitful, bearing 30 years' worth of delectable prints, slides, and transparencies. "Their product never changes, so they can get a lot of mileage out of photos, and they invest a lot in them," notes Wippich.

Embossing and French-fold pages lent substance and dimension to the finished piece, making it a definite standout. Originally, the design called for die-cut windows in the French-fold pages to reveal an underpinning of clever graphics. The double-heft pages stuck, but the die cuts were eliminated for budget reasons.

ROBIN HOOD FOUNDATION
Hitting the Bullseye

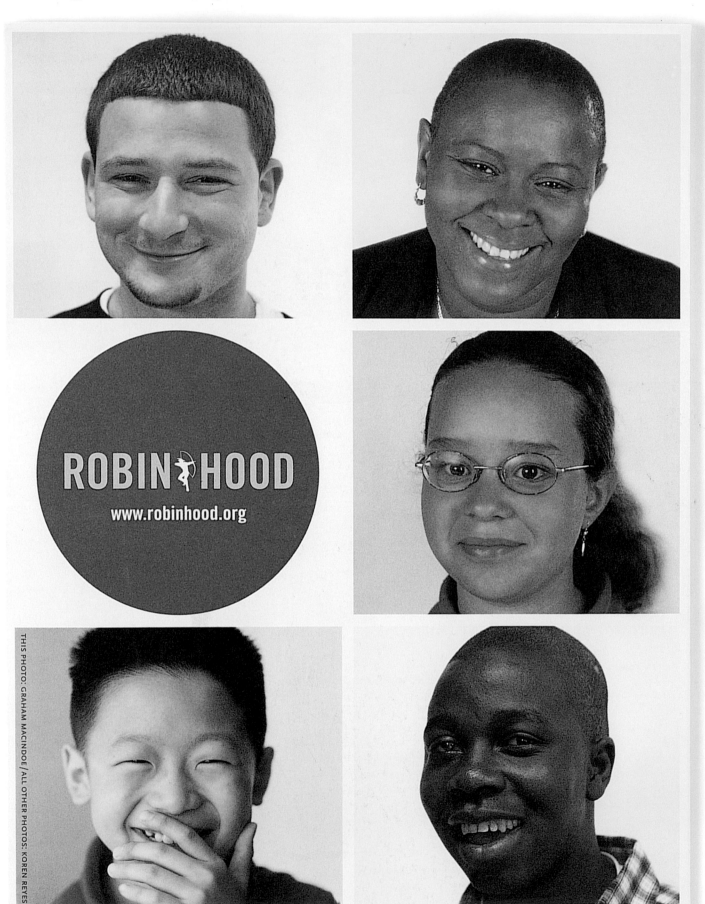

THIS PHOTO: GRAHAM MACINDOE / ALL OTHER PHOTOS: KOREN REYES

CLIENT: Robin Hood Foundation provides funding and support services to poverty-fighting organizations in New York City. **FIRM:** goodesign **DESIGNERS:** Diane Shaw and Kathryn Hammill **COPYWRITER:** Laurie Fabiano **PHOTOGRAPHY:** Graham Macindoe and Koren Reyes **PROJECT COORDINATOR:** Azania Andrews **PRINTER:** Paul Caprio, SFI Printing

FACING PAGE: The back cover features candid snaps of real people who have benefited from Robin Hood programs. Images were edited to show a range of ages and ethnicities, emphasizing the charity's broad scope.

ABOVE RIGHT: The piece was printed CMYK with a fifth spot color (lime green) on Mohawk Superfine Ultrawhite 130-lb cover. A sturdy stock was key to ensure the pocket would hold inserts securely.

BELOW RIGHT: Type and color tell a powerful story. Scala and Trade Gothic Bold Condensed are the flagship fonts in Robin Hood's identity.

The Challenge

Robin Hood Foundation knew it wouldn't be the first charity to approach corporate CEOs, celebrities, and philanthropists with its hand out. Or the fiftieth. Or the thousandth. In lieu of an annual report, the organization sought a crisp, friendly brochure that doubled as a press kit and fund-raising tool. Most important, the brochure needed to be digestible at a glance.

The Solution

Want big bucks from a CEO? Get straight to the point and provide hard numbers. A simple accordion fold with big, bold type explains how Robin Hood Foundation takes from the rich and gives to the poor, all the while yielding maximum return on investment. In Robin Hood's model, sound investment principles are applied to charitable giving to stretch dollars farther. Accountability and real-world results are highlighted with pithy graphs and charts.

Certain design decisions—namely, the color scheme and type—were shaped by the foundation's existing graphic standards. "Part of what has made Robin Hood successful is that they are very design savvy," says goodesign partner Diane Shaw. "They realize that coming across as organized, smart, and hip will give them added credibility with their target audience."

Whereas the organization's original press kit was an amalgam of loose sheets bearing statistics, grantee lists, board lists, and newspaper clips, the brochure tucks all of this information into a neat pocket. This solution makes it easy to update content that changes frequently, while maintaining a longer shelf life for the shell.

The brochure made its debut at a May 2003 gala fund-raiser that drew 3,500 attendees and netted the organization $16.5 million. Needless to say, it hit its mark.

HOLY NAMES ACADEMY
No Place for Old School

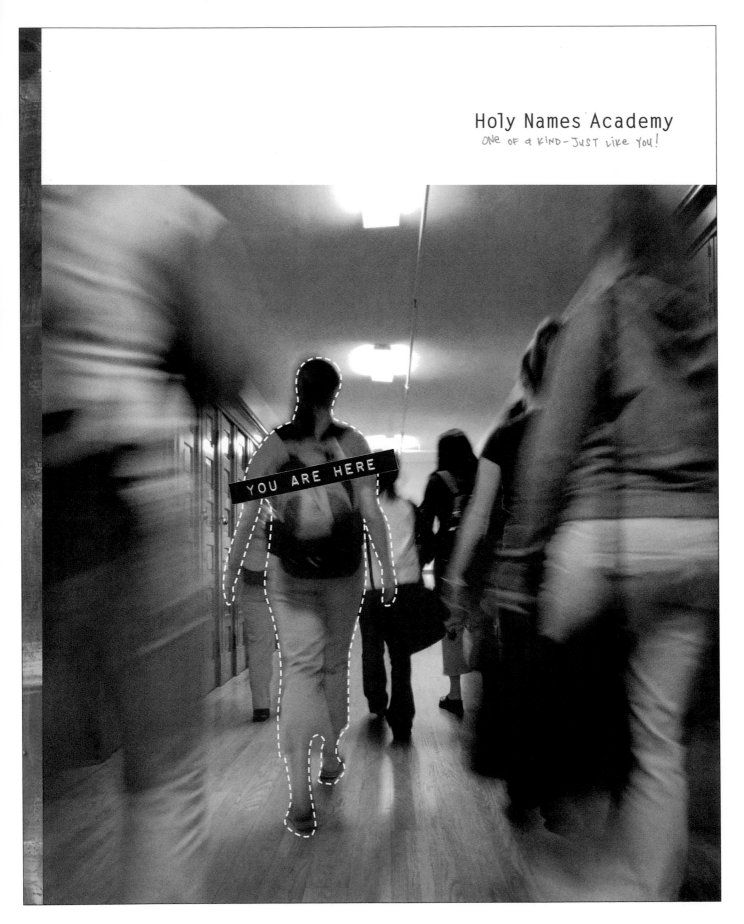

Holy Names Academy
ONE OF a KIND - JUST Like You!

YOU ARE HERE

HOLY NAMES ACADEMY
No Place for Old School

CLIENT: Holy Names Academy is a private girls' high school in Seattle. **FIRM:** Belyea **CREATIVE DIRECTOR:** Patricia Belyea **DESIGNER:** Anne Dougherty **DESIGN INTERN:** Dara Turransky **COPYWRITER:** Jessica Heasley **PHOTOGRAPHY:** Remy Haynes

FACING PAGE AND BELOW: Professionally shot black-and-white photos live large, with amateur snapshots punctuating each page. Headlines set in Letter Gothic and body text in Trade Gothic are fresh and easily legible.

ABOVE RIGHT: To give student testimonials an edgy aesthetic, designer Anne Dougherty doctored and blew out photos in high contrast and perched them on index cards.

BELOW RIGHT: Artifacts collected from real students tell the story of life on campus. No copy necessary.

BELOW: Wacky page borders and painterly backgrounds reiterate the promise of a place where girls can discover their own voices and styles. Label-maker-style headers convey a sense of fun.

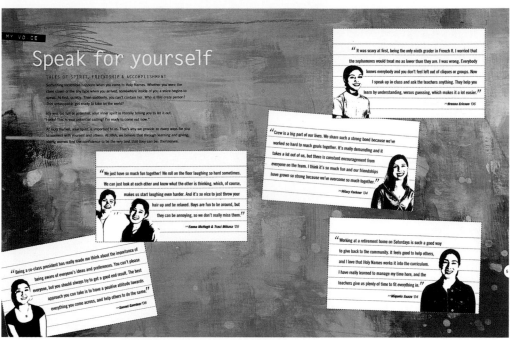

The Challenge

Utter the phrase "Catholic girls' school" and images of scowling nuns wielding rulers often come to mind. Holy Names Academy needed a recruitment brochure with spirit and spunk to tell prospective students (and their parents) that the school's hallowed halls offer stellar academics and much more. Most of all, the academy sought to present itself as a "one of a kind" place where each girl is free to discover her own voice.

The Solution

Speaking the right language was key. Inspiration for the design came partly from the book *Spilling Open* by Sabrina Ward Harrison, which documents a young woman's creative expression through art and journals. Using the book's untamed palette as a model, design intern Dara Turransky painted a series of abstract acrylic panels, which were then scanned and used as page borders and backgrounds for the brochure.

Capturing the vibrant energy of the student body was a simple matter of going straight to the source. Interviews with a dozen or so students yielded potent insights and direct quotes about everything from academic life to sports to leadership to volunteerism. Students and staff also submitted photos and memorabilia, giving the design team a stockpile of material with which to work. The hard part was picking and choosing among the goodies—and then color-correcting images at the prepress stage to ensure tonal balance and consistency.

INTERNATIONAL ENGRAVED
GRAPHICS ASSOCIATION
Putting Things in Perspective

FIRST IMPRESSIONS

CLIENT: International Engraved Graphics Association is a professional organization dedicated to promoting the centuries-old art of engraving. **FIRM:** Williams and House/Fred Schaub Design **CREATIVE/ART DIRECTOR:** Pam Williams **DESIGNER:** Fred Schaub **COPYWRITER:** Pam Williams **PHOTOGRAPHY:** Jim Coon and stock **PRINTER:** Teldon Print Media

FACING PAGE: Engraving, embossing, and debossing make a lasting impression on the brochure's cover. Gilbert Oxford Black in 100-lb cover weight was a substrate pliable enough to capture the detail in the embossed pattern yet sturdy enough to withstand the embossing process and the self-spine wraparound without cracking. A double hit of black ink and a satin spot varnish provided a crisp finish.

RIGHT (ABOVE AND BELOW): French-folded pages create an added dimension of quality by giving each spread more heft, while building up enough thickness to warrant a perfect bind.

BELOW: The business card and stick of gum were inserted by hand. A custom-match cream color was mixed to create patterned background pages echoing the intricate cover motif.

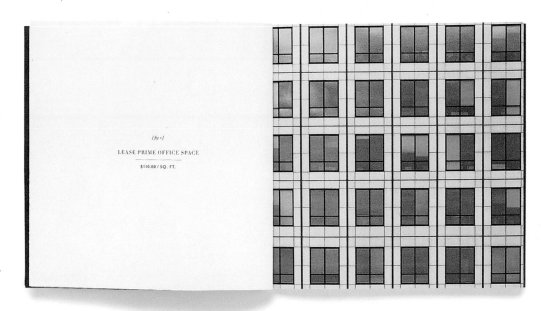

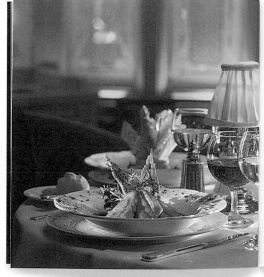

The Challenge

In a tight economy, engraving is often viewed as a luxury that can be easily slashed from a printing budget. International Engraved Graphics Association (IEGA) members (engraving firms) needed a tool to promote their craft and initiate discussions with corporate decision makers on the relative cost of engraving.

The Solution

John Dumouchel, president of the Artcraft Company (an IEGA member) conceived the core concept for the piece. The cost of engraving is marginal compared with the other extravagances execs spring for in the name of image and good taste. "Our goal was to get prospects to think about how much they invest each day, week, and year in making a great impression on their clients," says creative director Pam Williams. "When you think about how much a company spends on client lunches or flowers for the front lobby, the cost of an engraved business card is nearly irrelevant."

To kick off the process, the creative team brainstormed a list of all the things corporations, law firms, and professional services companies do to look good and exude status. Sumptuous photos were either commissioned or collected from stock sources to represent a range of big-ticket items, from prime office space to leather boardroom chairs to custom suits. Price tags for each item were then researched and artfully displayed on adjacent pages. The last two spreads of the brochure reveal that the cost of an engraved business card is equal to the cost of a stick of gum—about 20 cents.

"We wanted to create a piece that you wouldn't want to throw away—something that felt like a coffee table book, only smaller," says Williams. "Everything about the book speaks to the quality of the product." Engraving is a classy touch, and you don't have to put your bottom line in the red to have it.

LOWER MANHATTAN DEVELOPMENT CORPORATION
Structure for Structures

Plans in Progress
Innovative Designs for the World Trade Center Site
December 18, 2002

Foster and Partners
Meier Eisenman Gwathmey Holl
Peterson/Littenberg
SOM Team
Studio Daniel Libeskind
THINK: Ban Schwartz Smith Viñoly
United Architects

Lower Manhattan Development Corporation

Foster and Partners

CLIENT: The Lower Manhattan Development Corporation was set up to help plan and coordinate the rebuilding and revitalization of Lower Manhattan after September 11. **FIRM:** Two Twelve **PRINCIPAL/CREATIVE DIRECTOR:** Ann Harakawa **ASSOCIATE/SENIOR DESIGNER:** Colleen Hall **DESIGNER:** Amanda Washburn **PRINTING:** National Reprographics, Inc.

FACING PAGE: The buff cover, jacket, and vellum inserts were inspired by the yellow tracing tissue often used by architects. The color also pays subtle homage to New York City taxicabs.

RIGHT: Because the folio chronicles ideas in progress—including the plan by Daniel Libeskind that was ultimately selected for development—the designers didn't want it to appear too "finished." Black wire-o binding makes the book feel more like a proposal.

BELOW RIGHT: The body of the brochure is printed on 80-lb Sappi McCoy matte text, a paper that proved light enough to form a gatefold on every spread but substantial enough to endure wear and tear. "We wanted the renderings to glow, so we used a very white sheet, onto which we printed almost every inch," says designer Amanda Washburn.

The Challenge

One year after the September 11 attacks, the Lower Manhattan Development Corporation (LMDC) initiated a worldwide search for visionary land-use proposals for the World Trade Center site. Out of 400 submissions from leading architectural firms, LMDC selected nine finalists. Two Twelve, a graphic design firm that lost its studio on September 11, was hired in early 2003 to create a limited-edition compendium of the finalists' plans for an exhibit at the World Financial Center Winter Garden. The piece was to be given as a gift to those who supported and participated in the design competition to rebuild the Trade Towers site. The major design challenge was arriving at an appropriate format for showcasing a diverse mix of architectural plans—all of grand proportions and ambition—within modest budget, scheduling, and size parameters. The layout had to give each plan equal representation and accommodate a range of artwork and rendering styles.

The Solution

The format that Two Twelve devised is largely transparent, so as not to detract from the power of the architectural plans themselves. Each plan submission is offset by a page of introductory text printed on vellum—a quiet but effective dividing mechanism.

The spiral-bound folio contains dense, full-color pages, most of which fold out to give the plans and renderings maximum real estate. "Experience has taught us that horizontal books are cumbersome and floppy, so gatefolds were a stronger solution," says senior designer Colleen Hall. However, because nearly every page was a gatefold, "it was hard to envision what the experience of flipping through this book would actually be," adds designer Amanda Washburn. "Every comp presented to the client had to be mocked up with the actual gatefold in place."

Only 1,200 copies of the original piece were produced, but the momentum has spread. Based on positive reactions to the limited-edition brochure, a leading publisher is now considering a more developed version for commercial sale.

PAWS CHICAGO
Gone to the Dogs (and Cats)

Dogs deserve life.

CLIENT: PAWS is the largest no-kill humane organization in Chicago. FIRM: Esdale Associates CREATIVE DIRECTOR: Donna Somerville
COPYWRITER: Susan Esdale PHOTOGRAPHY: Jessica Tampas and Jim Warych PRINTING: Gannon Graphics

FACING PAGE AND RIGHT: Close-cropped photos and warm copper inks create a classic, timeless look. A blow-in card thanking Fur Ball sponsors was inserted into the piece for the gala.

BELOW: Quotes from famous animal lovers, ranging from Gilda Radner to E.B. White, set the stage for the brochure's main call to action in which readers learn the mission of PAWS and how they can make a difference.

Cats deserve life.

Chicago wishes to
deepest appreciation
e who made
all possible.

I think dogs are
the most amazing
creatures; they
give unconditional
love. They are
the role model
for being alive.

Gilda Radner

7
simple ways to
ensure cats in
Chicago live the
lives they deserve.

The Challenge

Esdale Associates had six weeks to write, design, and produce a compelling keepsake brochure to be distributed at Chicago's first annual Fur Ball, a fund-raising gala for PAWS (Pets Are Worth Saving). Guests at the highbrow affair were wealthy animal lovers paying $300 a head to attend. But there were two camps—cat lovers and dog lovers—and the brochure had to appeal to both groups. It also needed to serve yet another purpose: After the event was over, PAWS planned to print an additional 15,000 copies of the brochure to use as a direct-mail fund-raising piece.

The Solution

The brochure's debut at a black-tie affair necessitated an aesthetic that pulled at heartstrings without being too cutesy. Copper metallic ink, rich monochrome photography, and an intimate trim size (4½" x 6" (11.4 cm x 15.2 cm)) produced an effect that was both sophisticated and poignant. As a substrate, Sappi Strobe Silk paper with a satin varnish yielded a smooth sheen that was elegant but not flashy. To satisfy both feline and canine aficionados, the book was outfitted with two front covers, allowing it to be flipped and read from either side. "The end page number indicated that a perfect bindery would be most appropriate, but we also felt the booklike feeling that a perfect binding would afford would create more impact—an important consideration when seeking dona-

tions," says principal Susan Esdale. The Fur Ball raised more than $100,000, and PAWS subsequently printed a second, larger run of the brochure to use as a direct-mail fund-raiser.

Some production challenges arose along the way. "We were working with an unknown printer that donated its services and chose not to communicate with us during production," says Esdale. "This is not how we are accustomed to working. As a result, the middle binding was too tight, causing copy to fall into the gutter—a problem that could have easily been remedied through open communication. Fortunately, we were able to adjust the center spread type to accommodate the perfect binding for the second print run."

SECURITIES FINANCE INTERNATIONAL
Climb Every Mountain

OVERCOMING OBSTACLES

THE 2003 SECURITIES FINANCE SYMPOSIUM
OVERCOMING OBSTACLES

CLIENT: Securities Finance International is an independent consultancy in the United Kingdom serving securities owners, asset managers, custodian banks, intermediaries, investment banks, proprietary traders, prime brokers, and hedge funds. **FIRM:** Radford Wallis **CREATIVE DIRECTORS:** Stuart Radford and Andrew Wallis **DESIGNERS:** Stuart Radford and Lee Wilson **ILLUSTRATORS:** Stuart Radford and Lee Wilson **PRINTER:** Boss

FACING PAGE: A textured, uncoated board contrasts nicely with the shiny acetate.

THIS PAGE: Simple illustrations underscore a symposium agenda designed to help participants reap the fruits of their labor.

The Challenge

Securities Finance International (SFI) hosts an annual symposium for key players in the international securities-financing arena. The 2003 conference, themed "Overcoming Obstacles," candidly acknowledged a downturn in worldwide financial markets. Unfortunately, so did the budget for the conference brochure. An engaging yet cost-effective solution was in order.

The Solution

The SFI symposium is a highly interactive event, so designers at Radford Wallis considered how they might build interactivity into the brochure itself. The answer came in the form of a free-floating acetate sheet, which the reader could use to scale walls, climb mountains, and reach for the stars. The clear plastic overlay features an opaque ladder which, when placed on top of allegorical illustrations, provides a conduit to rewards that otherwise seem unattainable.

The acetate sheet wasn't cheap, nor were illustrations silk-screened for a rich finish. But four-color digital printing kept costs under control, and the illustrations were generated by Radford Wallis instead of being outsourced. The client lauded the creative solution as not only clever and cost-effective but also instrumental in recasting the conference agenda in a positive light. "The result was our best SFI program yet," says Cecile Pasa at SFI.

U.S. CONFERENCE OF MAYORS
CITY LIVABILITY AWARDS
The Annual Makeover

TOP AND RIGHT: Whimsical cityscapes by illustrator Michael Bartalos breathed new life into the 2002 application and guidelines. Bartalos's crisp style is reminiscent of cut paper, and the design reinforces the aesthetic. The flaplike cover is foreshortened with a wavy die cut that blends seamlessly with the illustration underneath it.

ABOVE: A clean, straightforward entry form remains largely unchanged from one year to the next.

Why Redesign?

For years, the entry package for the annual City Livability Awards—a competition cosponsored by the U.S. Conference of Mayors (USCM) and Waste Management—was a 40-page Word document sandwiched inside a two-color cover bearing the sponsors' logos. The program itself was a success, but submissions were perennially disorganized, mainly because the entry guidelines were redundant and confusing. USCM and Waste Management wanted to improve the quality and quantity of submissions—and did, with a deft redesign of the entry materials. But as the program matured, another issue arose: how to build new momentum and excitement for the same old awards year after year.

CLIENTS: The U.S. Conference of Mayors is a nonpartisan association of mayors representing 1,183 U.S. cities with populations of 30,000 or more. Waste Management is a leading provider of trash collection, landfill, waste transfer, recycling, and other services to municipal, commercial, industrial, and residential customers. **FIRM:** Fuszion Collaborative **ART DIRECTOR:** John Foster **ILLUSTRATORS:** Michael Bartalos (2002) and Leigh Wells (2003) **PRINTER:** Westland Printers

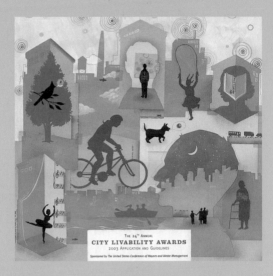

The Metamorphosis

"The original redesign was sold on the basis of information design, not aesthetics," says John Foster, who spearheaded the first overhaul during his tenure as an in-house art director for USCM. With the creation of a succinct FAQ list, the content was pared down from 40 to 16 pages. "That solved 99 percent of the logistical problems they were having with submissions," says Foster, now VP Creative at Fuszion Collaborative.

The next order of business was to build incentive by generating winner envy. "The mayors' club is obviously very competitive, so we started using the entry brochure as a place to profile the previous year's elite winners," says Foster. "Every city that receives the booklet now imagines itself featured in next year's version."

For consistency and ease of use, the size of the entry brochure and the chronology of its content have remained constant since the initial redesign. What makes each iteration fresh and distinct is top-notch illustration. "The City Livability Awards honor a diverse array of programs—from after-school lunch programs to breast cancer 10K races to downtown revitalization projects—in cities of all sizes with multicultural populations," explains

Foster. "It's easier to encapsulate all of that with illustration than photography."

Every year, Foster scouts out a new artist to reinterpret the competition materials. "The key is finding work that is contemporary yet appealing to a broad cross section of people," he says. "I'm a firm believer in hiring talented people and then getting out of the way. The only prerequisite is that images must be created in such a way that I can use an entire illustration as a central image for a poster or

cover but then cut it up and use little segments as spot graphics throughout the booklet."

Foster gets extra mileage out of every illustration, but then again, the benefit for illustrators is reciprocal. "We pay market value for nonprofit work, but we've been able to attract illustrators who might demand a higher budget normally," he says. "They know we'll enter this piece in every competition we can find." Not only does the piece promote awards, it consistently wins them.

FASHION INSTITUTE OF DESIGN & MERCHANDISING
What's Hot in Fashion Circles

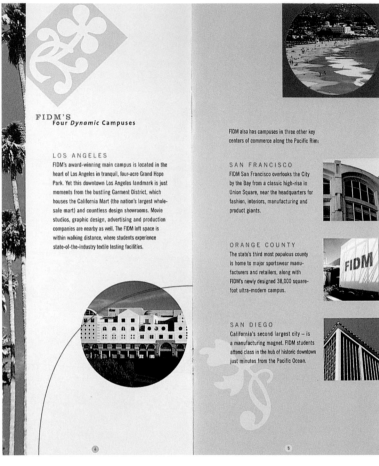

CLIENT: Fashion Institute of Design & Merchandising (FIDM) is a private, specialized college with campuses in Los Angeles, San Francisco, San Diego, and Orange County, California. **FIRM:** Vrontikis Design Office (35k.com) **CREATIVE DIRECTORS:** Tamar Rosenthal (FIDM) and Petrula Vrontikis **DESIGNERS:** Petrula Vrontikis, Ania Borysiewicz, and Rebecca Au **PROJECT MANAGER:** Richard Roman (FIDM) **COPYWRITERS:** Candace Pierson and Victoria Namkung **PHOTOGRAPHY:** Brian Sanderson (FIDM) **PRINTER:** Foundation Press

The Challenge

Fashion Institute of Design & Merchandising (FIDM) needed a versatile capabilities piece that would appeal to a range of audiences, from prospective students to alumni to donors. But dressing for any occasion meant more than donning the graphic equivalent of a little black dress. The brochure needed a long shelf life; therefore, it couldn't get too trendy. At the same time, a classic look wouldn't adequately represent a school known for cultivating new generations of design trailblazers. "We had to turn up the dial but stay away from clichés or fads," says creative director Petrula Vrontikis.

The Solution

Innovative architecture on FIDM's Los Angeles campus provided the genesis for a rich, energetic visual language. "We started by poring through a dense library of images in the school's collection," says Vrontikis. "The photographer had shot some detail work of the Los Angeles campus, which I saw as an opportunity for inspiration. The facade has this window motif of circles within squares. The circles function as portals that you can look through and see FIDM." That metaphor formed a basic aesthetic construct.

Then came the matter of accoutrements. Skinny photographic borders are hemmed into the margins, adding texture and narrative depth to page layouts. "Everything that goes on at FIDM is visually stimulating, and there is much to draw from," says Vrontikis. "The photos tell different stories and expand the view of the school. Words were important, but I was also trying to let the pictures speak a lot about FIDM. You can feel the creativity just by being in these spaces." Using photos as borders (not full backgrounds) meant they could be reproduced in 100 percent saturated color, as opposed to the watered-down, tinted screens that would have been necessary to accommodate text overlays. Finch Fine paper in cover and text weights gives the ink maximum holdout, ensuring full-bodied colors.

Happily, there was enough in the budget for quality printing. "In the case of a client like FIDM, it's not appropriate to cut corners because everybody notices it," observes Vrontikis. "It's like the difference between a good piece of fabric and a lousy piece of fabric. Everything they produce has to show a consistent level of quality."

CLIENT: Advertising and Design Association of Ottawa is a nonprofit professional association dedicated to linking, inspiring, and promoting the advertising and design communities of Gatineau-Ottawa. **FIRM:** Kolegram Design **CREATIVE DIRECTOR:** Mike Teixeira **DESIGNER:** Mike Teixeira **PRINTER:** St.-Joseph Corporation

FACING PAGE: As in much of Carson's staccato work, the cover type is not readily decipherable—until the back and front are viewed simultaneously.

THIS PAGE: The colors say California. The letterforms say Carson.

The Challenge

David Carson was coming to town for a presentation at the Advertising and Design Association of Ottawa. Kolegram Design had two weeks to design an eye-catching brochure announcing the type pioneer's impending arrival. The group needed something that had Carson written all over it.

The Solution

An homage to the legendary typographer seemed only appropriate, so revisiting Carson's earlier work was the first order of business for Mike Teixeira,

creative director at Kolegram Design. After immersing himself in back issues of *Raygun* and *Speak* magazines, Teixeira set his sights on a "surf culture/California" feel for the brochure and chose a warm-weather palette accordingly. "Odd colors are common in most of David's work, so I tried to do the same," he says.

Colors reminiscent of sand, beach, water, and deep red sunsets create allure, but the dead giveaway that this was a Carson event was, of course, the minefield of deconstructed type, running backward,

forward, vertically, and in reverse. "The typeface used in the brochure is Johndvl, a font used by Carson on many occasions," says Teixeira, who kept the trim size small to keep postage costs in check. For added dimension, the CMYK graphic on the cover is overprinted with a tinted varnish. Uncoated stock provided a nice contrast to the shimmering effect created by the varnish.

In the end, Carson took the imitation as a sincere form of flattery. He plans to do another workshop for the organization in 2004.

UCSF COMPREHENSIVE CANCER CENTER
Seeing Beyond the Status Quo

CLIENT: The University of California at San Francisco Comprehensive Cancer Center is a research facility devoted to studying cancer causes, treatments, and prevention, as well as improvements in patient care. FIRM: IE Design (El Segundo, CA) in partnership with UCSF, University Publications CREATIVE DIRECTOR: Carol Kummer, UCSF
ART DIRECTOR: Marcie Carson COPYWRITER: Jeffrey Norris PHOTOGRAPHY: Majed and Kaz Tsuruta PRINTER: Lithographix

FACING PAGE: Amorphous forms were printed on Yupo translucent plastic paper with a single ink mix of 30 percent PMS Warm Gray, 20 percent PMS Metallic, and 50 percent varnish.

BELOW: The words *seeing beyond* are repeated in a tiny line of fluorescent orange type that threads its way through the report, pulling the reader from one page to the next.

BELOW RIGHT: Scientific images aren't just textbook. A virtual colonoscopy proves to be both beautiful and instructional.

The Challenge

IE Design had four weeks to design a 58-page report that would appeal to a diverse range of donors, including corporations, government, educational organizations, foundations, and individuals—in other words, everyone. The Cancer Center had already established the theme *Seeing Beyond*, to convey its ongoing efforts to push the borders of conventional medicine, technology, and practice. For the design team, the key was seeing beyond the typical clinical fund-raising vernacular to develop a unique creative approach.

The Solution

The brochure's cover and three chapter-divider pages are printed on durable, tear-resistant Yupo plastic, offering a subtle glimpse of what lies beneath the surface. Each transparent overlay is patterned by an ethereal blend of organic shapes. The abstractions, shot by photographer Kaz Tsuruta, are actually not scientific images but close-ups of everyday objects, such as metal shavings, nails, film, and undulating lava-lamp blobs. "Originally these shots were vibrant and colorful, but when we received scientific images from the client (which we also had to include), the two styles clashed," says Marcie Carson, principal, IE Design. "So we ended up converting Kaz's images to grayscale."

Interior pages were printed on McCoy gloss stock with CMYK builds plus two PMS colors—warm gray and fluorescent orange. But there were six pale blue pages sprinkled throughout the report that posed a problem. The budget couldn't accommodate a third match color, and process builds would have looked messy. "When you have several sheets of the same solid color, creating consistency with CMYK can be difficult. It's hard to get the same value on every page, plus you get banding and ghosting" says Carson. "We didn't have an extra print tower to add another PMS color, so we printed those pages as a warm gray/cyan build instead. That worked out pretty well and gave us more control."

The report has proved to be good medicine for the Cancer Center. The piece has generated millions of dollars in additional funding and serves as an important archival document of record.

INTERNATIONAL SCHOOL OF BASEL
Live and Learn

CLIENT: International School of Basel (ISB), based in Switzerland, provides an invigorating setting for students from kindergarten to grade 12, representing more than 40 nationalities. FIRM: Form ART DIRECTORS: Paula Benson and Paul West DESIGNERS: Paula Benson and Paul West COPYWRITER: Richard West PHOTOGRAPHY: Kate Martin

FACING PAGE: Candid photography and fluorescent type emphasize the kinetic energy of the school. The brochure theme is "Forty Nationalities, One Spirit."

RIGHT: Key passages of text—typeset in VAG and printed in a custom gray—are nested in fluorescent yellow blocks as though emphasized with a highlighter pen. An arresting hardcover case, which can be self-sealed and mailed, carries the fluorescent yellow color as well.

BELOW: Friendly, exuberant photos showcase a diverse student body and refreshing architectural style.

The Challenge

There was a reason International School of Basel (ISB) picked Form—a hip, London-based design shop known for its work in the music and events field—to design its prospectus brochure. The school didn't want the starched, vine-covered aesthetic so often associated with academia. A casual, contemporary approach was needed to captivate the interest of relocating parents and kids from the United Kingdom and United States.

The Solution

Form partners Paula Benson and Paul West visited the school to discover a bright, modern, and lively environment with a strong technological bent. A new building featured open, airy architectural spaces with colorful interiors. The brochure needed to be equally vibrant, with ample imagery.

Kate Martin, a music and fashion photographer, was hired to capture the progressive vibe of the school on location. Photographs of buzzing classrooms and a diverse, upbeat culture tell much of the story.

Text is relegated to the front matter and printed on Consort Compliment uncoated stock. For contrast, Consort Brilliance gloss paper serves as the substrate for the main body of the brochure, which takes the reader on a photojournalistic journey through the school.

Determined to package the school's offerings in an unorthodox manner (while protecting the brochure from damage), the designers specified a neat box for mailing purposes. The fluorescent hue of the box makes it impossible to ignore.

UNITED WAY OF CENTRAL NEW MEXICO
The Real Deal

CLIENT: United Way of Central New Mexico channels funding to more than 50 local charitable organizations. **FIRM:** Rick Johnson & Company Advertising
CREATIVE DIRECTOR/COPYWRITER: Sam Maclay **DESIGNER:** Tim McGrath **COPYWRITER:** Tim Galles **PHOTOGRAPHY:** Michael Barley

MY NAME IS VALENTIN CHAVEZ.
I AM HOMELESS.
I AM HUNGRY.
I AM AN EX-CONVICT.
I AM AN ALCOHOLIC.
I AM ALONE.
I AM DESPERATE.
I AM HUNGRY.
I AM SO HUNGRY.
I AM ASKING FOR A MEAL.
I AM ASKING FOR HELP.

MY NAME IS VALENTIN CHAVEZ.
I AM GETTING HELP.
I AM NOT HOMELESS.
I AM SOBER.
I AM GOING TO SCHOOL.
I AM GETTING A DEGREE.
I AM GETTING JOB TRAINING.
I AM WORKING.
I AM CONTRIBUTING.
I AM A SUCCESS STORY.

MY NAME IS VALENTIN CHAVEZ.
I AM NOT HUNGRY.
I AM FULL.
I AM FULL.

My name is Hannah, I am nine, I was born with a disease that will make me deaf when I get older. But right now, thanks to the United Way, I can hear. They helped me get my hearing aids. I picked the bright blue ones because I want people to know I can hear. My favorite sounds are the songs I make up on the piano, my big sister's giggles, and my mom's voice when she reads us stories. One day I won't be able to hear any of these things. But I don't think about that. I'm too busy listening.

The Challenge

In central New Mexico, one of every three people is helped in some way by the United Way Community Fund. This significant fact needed to be communicated in the nonprofit's annual fund-raising brochure. "United Way doesn't just help broken people," notes Sam Maclay, creative director at Rick Johnson & Company, who does the project pro bono every year. "There are some situations that could happen to any of us, like having a child born with a disease, being diagnosed with cancer, or getting in a car accident. We wanted donors to be able to relate and to know their dollars were really making a difference."

The Solution

What better way to show the impact of charitable giving than through the stories of those who benefit? "We wanted to show testimonials in an emotional way, and we wanted to make it plural," says Maclay. "United Way strengthens the fabric of the whole community by helping everyone—abused women, the elderly, the homeless, accident survivors, children, everyone."

With help from social workers in the various agencies United Way supports, true stories were collected from individuals who had benefited from United Way–funded services. Once the stories were edited, each person was asked to write his or her

story inside an 8½" x 5" (21.5 cm x 12.7 cm) box. "From there, these accidental, magical things began to happen," says designer Tim McGrath. "One little girl drew pictures inside the box, which we hadn't asked for. Another story that was typed on a typewriter had a place where the type was scratched out, which we decided to leave in."

Photography and design were donated, and color was kept to a bare minimum to keep printing costs low. United Way of Central New Mexico has experienced the highest growth in per capita donors in the country for the past two years. Much of that growth has been attributed to the *True Stories* brochure.

OREGON HEALTH & SCIENCE UNIVERSITY
Eat, Drink, and Be Informed

"MATTERS OF THE MIND"
Summer Series

As one of our special supporters,

you are invited to a series of small discussions on

multiple sclerosis, Parkinson's and Alzheimer's disease.

Please join us.

CLIENT: Oregon Health & Science University (OHSU) educates health and high-tech professionals, scientists, and environmental engineers, while simultaneously offering patient-care programs, community service, and biomedical research. **FIRM:** Dotzero Design **ART DIRECTORS:** Karen Wippich, John Wippich, and Tom Vandel **DESIGNERS:** Karen and John Wippich **COPYWRITER:** Tom Vandel **PRINTER:** B&B Printsource

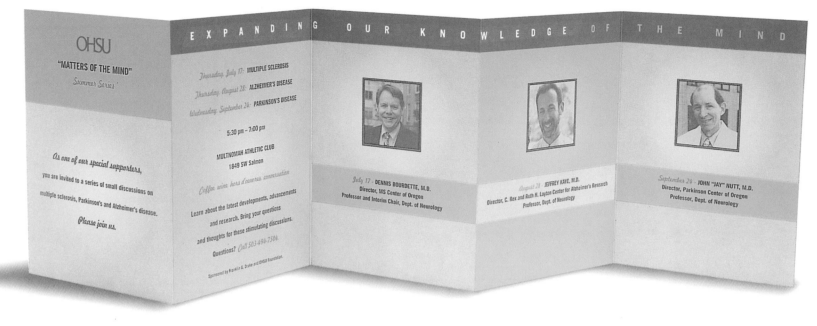

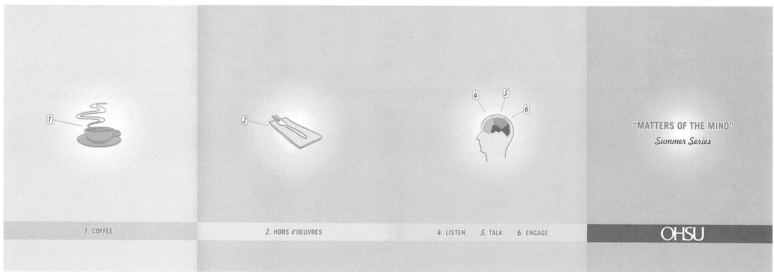

The Challenge

Oregon Health & Science University (OHSU) was planning a summer lecture series on multiple sclerosis, Parkinson's, and Alzheimer's for patients and their families, as well as for potential donors, but was worried that potential attendees would shy away for fear that the talks would be dry, boring, depressing, and overly technical. The series, deemed "Matters of the Mind," actually included food and drink in a casual atmosphere and was meant to inform people (in plain speak) about the latest treatments and therapies to combat diseases of the brain. The brochure announcing the series would be important in setting the tone.

The Solution

Fun, simple drawings and bright colors cast the event as an inviting, nonthreatening venue. "We looked at technical illustrations, but they made the piece feel too clinical," says designer John Wippich. "It was important for the brochure to feel friendly to the average person."

Printed on Cougar, a sturdy, all-purpose stock, the piece was specified as a three-color job with a decidedly summery palette (no black). Dotzero went with a bright melon scheme, making sure one of the colors could be screened dark enough to maintain contrast in mandatory photos of the lecturers. A simple accordion fold kept costs minimal and allowed the brochure to fold and fit in an 8" x 6" (20.3 cm x 15.2 cm) envelope. On the back, simple icons set the agenda. The illustrations were hand-drawn in pencil and then scanned into the computer.

UNITUS
Small Details, Big Impact

UNITE US

FOR A BETTER WORLD

unitus

EMPOWERING THE POOR

THE ECONOMIC MIRACLE OF
MICROCREDIT LOANS

unitus

CLIENT: Unitus is a global microfinance accelerator dedicated to increasing the lending capacity of microfinance institutions that support self-employed poor women.

FIRM: Belyea **CREATIVE DIRECTOR:** Patricia Belyea **DESIGNER:** Ron Lars Hansen **PHOTOGRAPHY:** Mesha Davis

FACING PAGE: A color photo converted to duotone and "passport stamped" (with a little Photoshop wizardry) makes for a handsome cover. A sister brochure—designed with a similar look and feel but printed on a much smaller budget—was created later to spark dialogue with potential donors.

RIGHT: Subtle production details give the brochure a weathered realism. Color fields on the inside front and back covers were distressed to create a subtle framing mechanism for a series of photos from around the world.

BELOW: Inside pages are brought to life with a rich, multihued palette, courtesy of an eight-color press. The entire brochure was printed on Starwhite Archiva, a warm, creamy, uncoated stock.

The Challenge

Some nonprofit organizations collect a dollar here and a dollar there to plump up their reserves. Unitus, a microfinance accelerator, works the opposite way. Major donors are asked to make commitments of $50,000 or more so that microcredit loans of $50 to $150 can be awarded to thousands of women entrepreneurs around the globe. "It's a big-ticket item for a donor to sign a commitment form," notes creative director Patricia Belyea. Unitus needed a compelling brochure for use in personal correspondence and face-to-face meetings and as a presentation leave-behind.

The Solution

Photos of people are important when you are telling stories of human empowerment, but Unitus didn't have an extensive library of images. Fortunately, key members of the organization were traveling to Mexico to initiate a new microfinance project, and the time was ripe to shoot photos.

The president's mother, a professional photographer, was enlisted to join the troupe on its journey. "Before she left, we talked with her about the style of images we wanted—full color and realistic, à la *National Geographic*," says Belyea. "It's a good

thing we talked to her, as she was planning to shoot romantic black-and-white images."

Powerful poignancy marks the front of the brochure, which tells the stories of small-business owners primarily with pictures and very little copy. For analytical types, facts and figures are spelled out in greater detail in the back half of the book.

GENOME CANADA
Doing a Double Take

Ceci est un dictionnaire.

GenomeCanada

CLIENT: Genome Canada funds Canadian genomics and proteomics research projects. **FIRM:** Iridium, A Design Agency **CREATIVE DIRECTOR:** Mario L'Écuyer **ART DIRECTOR:** Jean-Luc Denat **DESIGNER:** Mario L'Écuyer **COPYWRITERS:** David Lockhart and Anie Perrault **PHOTOGRAPHY:** Dwayne Brown, David Becker, Lloyd Sutton, and Diana Miller

FACING PAGE: Initially hired to create an annual report for Genome Canada, Iridium recycled the content into an institutional brochure by stripping away the financials. A split-spiral binding gives the cover extra flair and accommodates a belly-band that can be added to distinguish the annual report from the brochure.

ABOVE AND RIGHT: Close-up images and provocative copy entice the reader to reconsider the familiar. Photos are reproduced on Sappi Mountie Matte paper for a clear finish.

BELOW: The brochure can be read from two sides—one in French; the other, English. An appendix listing projects funded by Genome Canada is sandwiched in the middle on Fraser Papers Synergy Smooth, a complementary uncoated stock.

The Challenge

As a virtually unknown not-for-profit still in its infancy, Genome Canada wanted to position itself as a leader in developing and nurturing genomics research in Canada. Its target audience was broad, including venture capitalists, Canadian and foreign research institutes, universities, hospitals, and federal agencies. The problem was, Genome Canada was only in its second year of operation and wasn't yet prepared to cite results from specific research projects.

The Solution

In the absence of tangible data, Iridium developed a strategy to showcase the enormous potential of genomics. Five simple analogies put a familiar face on some otherwise arcane or misunderstood topics, such as how genetic research in livestock is informing revolutionary treatments for infectious diseases and how natural enzymes produced by fungi are providing clues in the development of nontoxic cleaning products.

"The idea was to present images and copy that seemed to be at odds, alerting the reader to the fact that things are not always what they seem," says creative director Mario L'Écuyer. "Of course, this idea is not new. The 20th-century artist René Magritte used this technique in his famous painting of a smoking pipe underscored by the phrase, *This is not a pipe.* But it was a powerful approach to this subject."

Because of time constraints, only half of the photos were shot as originals, and the rest were purchased from stock. "We later found that this vast array of images lacked uniformity, so we asked our photographer, Dwayne Brown, to output all of the photography on his color printer and then reshoot every print with the same settings for contrast and film grain," says L'Écuyer. "This second generation of images was then color-corrected to produce a consistent photojournalistic tone throughout."

PRIMO SIMPOSIO INTERNAZIONALE DI CERAMICA PROSPETTIVA
Process and Product

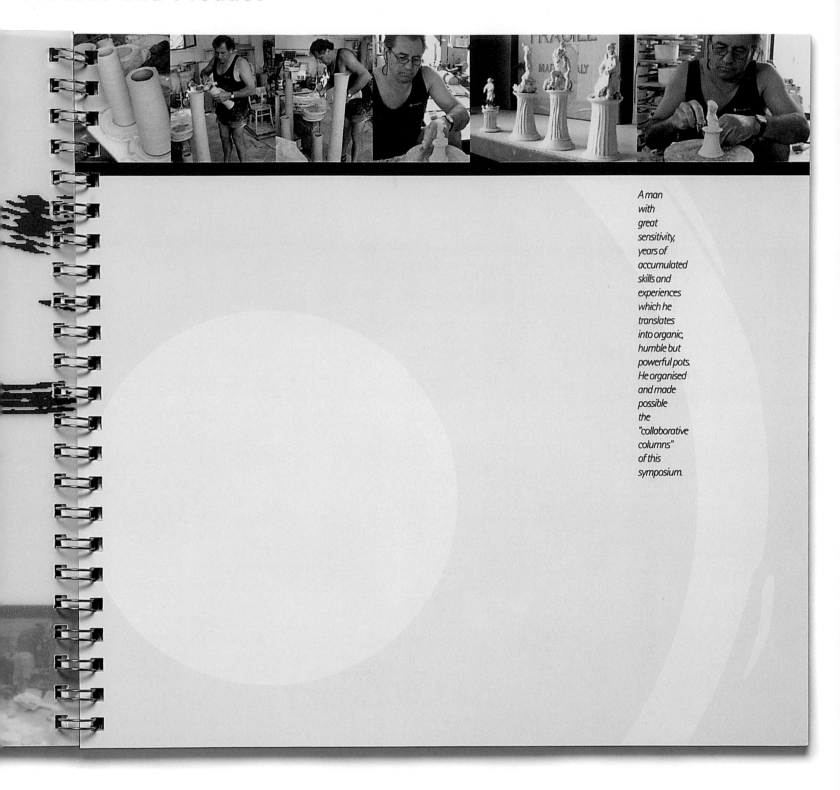

A man
with
great
sensitivity,
years of
accumulated
skills and
experiences
which he
translates
into organic,
humble but
powerful pots.
He organised
and made
possible
the
"collaborative
columns"
of this
symposium.

CLIENT: Located in Trieste, Italy, Cooperativa Sociale Prospettiva is a nonprofit cooperative that provides crafts laboratories and employment opportunities for people with disabilities and disadvantages. FIRM: R&M Associati Grafici DESIGNERS: Raffaele Fontanella, Maurizio Di Somma, and Marcello Cesar
COPYWRITER: Maurizio Di Somma PHOTOGRAPHY: Luca Gandini PRINTER: Tipolitografia Cesarano Enrico/Gragnano

FACING PAGE: Snapshots of sculptors at work get up close and personal. Brief biographical captions in the font Rotis are cast in thin, vertical columns.

BELOW LEFT: A rich, brown cover stock by Fedrigoni is the color of earth. Engraving creates the impression that the title text has been carved into the surface.

BELOW RIGHT AND BOTTOM: Artists' renderings on transparent vellum chronicle the transformation of raw ideas and materials into objects of meaning. The wispy sheets add a tactile dimension appropriate to the brochure's tactile subject matter.

The Challenge

The social cooperative Prospettiva produces and sells artistic pottery and wooden and natural-fabric handicrafts made by the disabled. To build awareness of its mission among ceramics enthusiasts, the organization invited eight renowned artisans from Europe and the United States to participate in a two-week cultural exchange and symposium. R&M Associati Grafici was hired to create a brochure and exhibition catalog highlighting the prolific artists who participated in the event.

The Solution

Each spread in the brochure highlights a different symposium participant. Photos arranged like film-strips provide intimate views of the artists at work in the studio, documenting a continuum from concept to clay to kiln. Sketches, notes, and sculptural models printed on vellum overlays further emphasize the artistic process behind each finished piece. A stylized rendering of a potter's wheel lends background texture to each spread, and subtle pastel tones evoke the colors of natural glazes. The brochure's square trim and geometric grid create a compelling tension against the organically curved pots, bowls, and totems on display.

and Freshness with an Italian Flavour

LAS CAMPANAS

SALES &
INFORMATION
OFFICE

CAMINO LA TIERRA

599

PORT ROAD

SANT

285 84

CANYON RD.

SANTA FE
PLAZA

TO DENV

CHAPTER FOUR:
Products

Products can be sexy, sleek, snarky, or downright subversive. Their physical and intellectual properties are as diverse as the day is long. What's certain is products have souls. A good product brochure isn't overloaded with heavy makeup and hyperbole. It gets to the root of the thing itself and celebrates its most basic, intrinsic strengths.

BASE LONDON CLOTHING
In the Flesh

CLIENT: Base London specializes in men's footwear and casual clothing. **FIRM:** Radley Yeldar Design Consultants **DESIGN DIRECTOR:** Robert Riche **DESIGNER:** Robert Riche **PHOTOGRAPHY:** John Edwards **PRINTER:** First Impression

FACING PAGE AND FAR RIGHT: A Tyvek tag bearing the Base logo was stitched into the cover binding with a sewing machine.

RIGHT: In one instance, the model's skin really was debossed (temporarily). He lay on top of a rubber stamp for about 10 minutes before the photo shoot.

BELOW LEFT AND BELOW RIGHT: Fortunately, no models were harmed in the making of this brochure. Temporary adhesives and photo retouching create the illusion of rivets, seams, and stamps.

The Challenge

Base London established its reputation as a maker of men's footwear for hip urban dwellers. Thus grounded, the manufacturer hoped to leverage its brand equity with a line of clothing in 2002. Radley Yeldar was hired to engineer a campaign that would build excitement about the new venture among retailers. The idea was to reinforce the brand's edgy persona and fuel anticipation for the impending launch. But there was one small catch: not a stitch of clothing had been made when it was time to create a product brochure.

The Solution

In the absence of actual product, designer Robert Riche zoned in on Base London's prime asset: its attitude. Borrowing the vernacular of fashion merchandising, the brochure literally brands various male body parts with the Base logo, mimicking the various ways in which manufacturers' logos are affixed to clothing, shoes, and accessories. The only things adorning the booklet's bonanza of beefcake models are tags, stamps, and leather badges bearing the Base name.

Hanno Art gloss paper ensured that the muscular images really packed a punch. The entire clothing collection sold out to retailers when it launched three months later, only to be surpassed by demand for the 2003 collection.

STORA ENSO
Gallery on Paper

THE DESIGN OF CULTURE VOLUME 2 NUMBER 1

THE STORA ENSO INSPIRATION SERIES

CLIENT: Stora Enso is an integrated paper, packaging, and forest products company with manufacturing facilities in Europe, North America, and Asia. **FIRM:** Heller Communications **CREATIVE DIRECTOR:** Cheryl Heller **DIRECTOR OF PHOTOGRAPHY:** Alice Rose George **SENIOR EDITOR:** Ingrid Caruso **PHOTO EDITOR:** Jennifer Miller` **CONTRIBUTING EDITOR:** Kimberly Cranston **PROJECT DIRECTOR:** Ned Heidenreich

FACING PAGE AND THIS PAGE TOP: Ancient maps and contemporary photographs depict water as integral to Turkish lifestyle and commerce.

FACING PAGE INSET: A similar juxtaposition demonstrates how one contemporary Turkish fashion designer was inspired by the sartorial style of the Ottoman Empire.

BELOW LEFT: History repeats itself. Deft art direction draws parallels between modern type treatments and ancient times, when "a calligrapher was considered a kind of holy man."

BELOW RIGHT: Layered imagery recounts stories of the country's nomadic ancestors, its famous Iznik tiles, and the emotional devastation of the 1999 earthquake.

The Challenge

Paper manufacturer Stora Enso believes its premium white Centura stock speaks for itself, which explains, in part, why the company offered up its paper for a series of brochures promoting something else entirely—the design sensibilities of various cultures around the globe. The first iteration of *C: The Design of Culture* chronicled the dual aesthetics of Finland and Sweden, followed by a survey of Mexico, and, most recently, Turkey. The monumental task with each excursion, says creative director Cheryl Heller, was amassing centuries' worth of photographs, graphics, and applied arts and then paring down the selection to arrive at a succinct visual portrait of each place and its people.

The Solution

Each brochure serves as "an investigation of those commonalities and idiosyncrasies that distinguish one country's art and imagery from another's." For the latest piece, the design team spent 10 days in Turkey absorbing its sights, smells, flavors, and history. Thousands of images were collected during meetings with gallery owners, curators, museum archivists, designers, and local studios. "I returned with so much material on CDs that it took me two days to download everything," says Heller.

Although the trim size of the newest brochure is consistent with its precursors (10" x 14" (25.4 cm x 35.6 cm)), the interior layout is utterly germane

to the subject. "We ended up specifying a lot of smaller, overlapping pages inside the Turkey book, because we witnessed so much layering of civilization on civilization, pattern on pattern, and culture on culture," says Heller. "This was a way of providing context between old and new—which is so much of what this country is about."

For thousands of years, Turkish books were designed to be read from right to left. As such, the brochure is laid out so that it can be read from back to front or front to back. Content is arranged thematically rather than chronologically.

TASMAN BAY OLIVES
Homegrown Antiquity

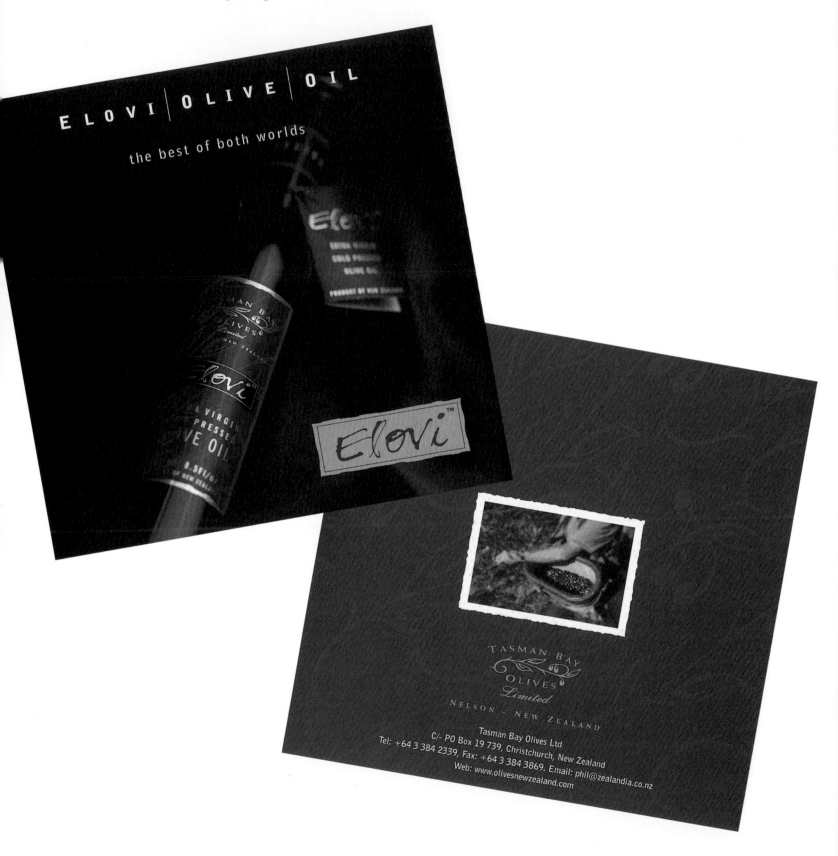

CLIENT: Tasman Bay Olives processes and markets olives from three groves in the Nelson region of New Zealand. **FIRM:** Lloyds Graphic Design & Communication.
ART DIRECTOR/DESIGNER: Alexander Lloyd **COPYWRITER:** Alexander Lloyd **PHOTOGRAPHY:** Japp Van der Stoel **PRINTER:** Blenheim Printing Co.

FACING PAGE: The cover photo was staged with dramatic lighting reminiscent of the chiaroscuro seen in the old masters' paintings. A filigree pattern embellishes the back cover with European flair.

RIGHT: Ghosted back type in the font Carpenter reads like antique script, reinforcing the handcrafted nature of the product.

BELOW: Each panel has a lyrical quality, reinforced by the brochure's square symmetry. Inside copy is fleshed out in Bell Gothic, a clean font that is easy to read in small point sizes.

The olive tree is typical of the Mediterranean lands, and

provides a valuable source of health enhancing vegetable oil.

A handful of olives, a hunk of bread and some wine are often

a complete meal to the people of these lands where the

summers are hot, dry and seemingly endless... somewhat

like the Tasman Bay region, home to Elovi quality olive oils.

Tasman Bay Olives Ltd incorporates three olive groves - Beulah Olives, Nelson Olive Grove and Bethany Olive Grove, all situated on the Moutere clays in the Tasman Bay region of New Zealand. The Moutere clay is gaining increasing recognition for producing superior flavour for many types of horticultural crops such as wine, apples, and olives. The combination of these ideal growing conditions and high sunshine in the Nelson area results in a premium quality olive oil.

Tasman Bay Olives is primarily focused on the premium Italian varieties. Tests by the Cawthron Institute on Elovi Olive Oil show low acidity levels of between 0.05% to 0.17%.

New Zealand Freshness with an Italian Flavour

The Challenge

Olives were first planted in New Zealand by European settlers in the early 1800s. Tasman Bay Olives, a premium olive oil producer, wasn't established until the end of the 20th century, but the company nevertheless wanted to convey a sense of Old World quality and tradition in its marketing materials. Lloyds Graphic Design was asked to cultivate a small brochure that could be used as a point-of-sale piece, as well as a direct-mail pitch to potential product resellers.

The Solution

Alexander Lloyd, principal of Lloyds Graphic Design, began his research by consuming a stack of food and wine publications, keeping an eye out for traditional European imagery. To convey an immediate feeling of earthiness in the brochure, he selected Sundance Ultra White, an uncoated stock with a toothy, pebbled surface. Rich, saturated photos of the product and process were supplied by the client, although the shoot for the cover image was coordinated by Lloyd.

A simple, sensual brochure proved the right approach in reaching consumers at the point of purchase, as well as in boutique wine and food outlets. Tasman Bay is now pursuing exports outside New Zealand in response to interest from foreign buyers.

PRISMATIQUE
RetroFit

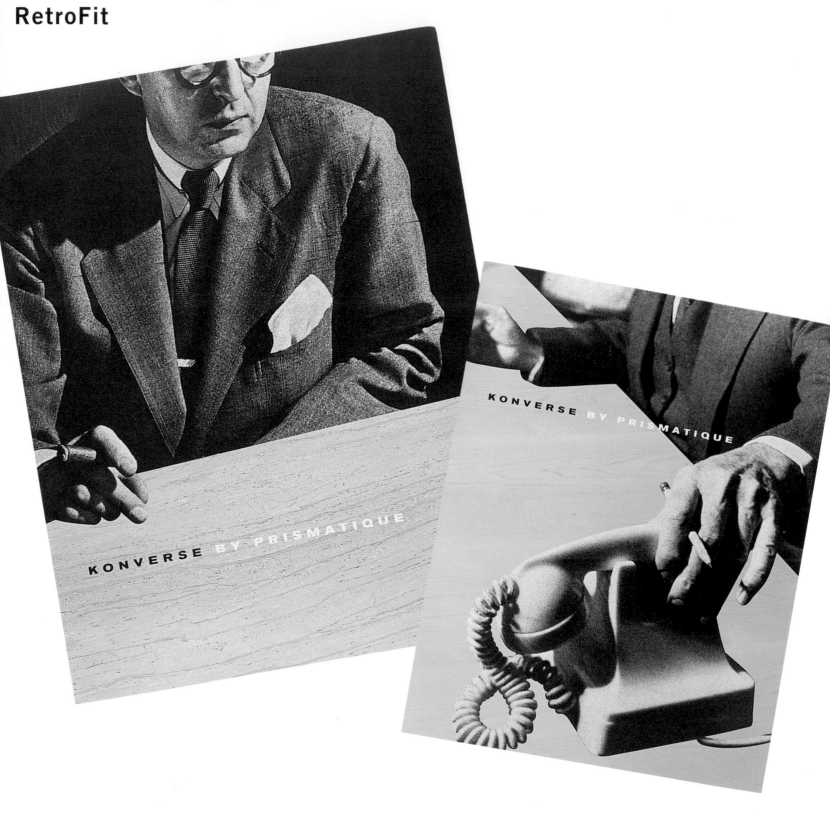

KONVERSE BY PRISMATIQUE

KONVERSE BY PRISMATIQUE

CLIENT: Prismatique is a Toronto-based office table manufacturer. **FIRM:** Dinnick & Howells **CREATIVE DIRECTOR/ART DIRECTOR:** Jonathan Howells
DESIGNERS: Tracey Hanson and Brian Marchand **PHOTOGRAPHY:** Pete Paterson **PRINTER/PREPRESS:** Colour Innovations

EACH CITY RETREAT COMBINES RESIDENTIAL, BUSINESS AND LEISURE FACILITIES WITH A DISTINCTIVE RESTAURANT AND IS DESTINED TO BECOME AN INTEGRAL PART OF THE CITY'S CULTURAL LIFE. AS A RESIDENT, YOU ARE FREE TO ENJOY THE AMENITIES AVAILABLE IN YOUR BUILDING OR TAKE ADVANTAGE OF THOSE FOUND IN OTHER CITY RETREATS. YOU CAN MAKE USE OF PRIVATE MEETING OR DINING ROOMS, VIDEO CONFERENCING SUITES, IN FACT EVERYTHING YOU NEED TO EASE THE DEMANDS OF YOUR WORKING LIFE. AND WHEN YOU NEED TO UNWIND, WORK OUT IN THE FULLY EQUIPPED GYM OR REVITALISE YOURSELF IN THE SUMPTUOUS SPA, COMPLETE WITH EVERYTHING YOU MIGHT EXPECT FROM AN EXCLUSIVE RESORT. OR SIMPLY RELAX WITH FRIENDS AND COLLEAGUES OVER A DRINK IN THE STYLISH COCKTAIL LOUNGE OR BAR AND, FOR THE VERY BEST IN EATING OUT, SAVOUR THE CUISINE AT ONE OF OUR FINE RESTAURANTS. WHATEVER YOU WANT, WHENEVER YOU WANT IT, CITY RETREATS AFFORDS A LIFESTYLE THAT REPRESENTS NOTHING LESS THAN COMPLETE LUXURY.

The Challenge

In conceiving the idea for City Retreats, a brand of luxury-serviced apartments, developer City Fusion envisioned sumptuous living spaces offering a calm and tranquil escape from the chaos of city life. The developer planned to introduce its concept in Leeds, with additional properties slated for Manchester, Glasgow, Birmingham, and Edinburgh. Construction crews broke ground on the first complex in early 2003, but this development had no bearing on the design of a launch brochure. The initial concept needed to be simple, focusing more on brand strengths than building details.

The Solution

Each City Retreats location would be billed as a sanctuary free from extraneous stresses. Creating a sense of space without showing actual environments was nevertheless a conundrum. Radford Wallis reduced the brand promise—sanity in the midst of insanity—down to its soulful core. A series of Zen garden images conveys the peaceful serenity of the City Retreats experience, encouraging viewers to use their imaginations to fill in the details. Each garden comprises a single, sculpted icon with symbolic meaning: a star for service, an infinity symbol for amenities, a pyramid for infrastructure.

"To create the sense of scale found in a real Zen garden, the whole studio floor was used as a set," explains creative director Stuart Radford. "Both designer and photographer worked in partnership to craft a series of images from gravel, literally starting in the center and working outward."

GARY FISHER
A Wild Ride

GARY FISHER RIDE BIKES

The sun is out. RIDE BIKES. The sky is blue. RIDE BIKES. It's cold and raining. RIDE BIKES. Leave the car in the garage. RIDE BIKES. It beats walking. RIDE BIKES. Lose a few. RIDE BIKES. Life is short. RIDE BIKES. The trail is long. RIDE BIKES. Call in sick. RIDE BIKES. Call in sick again. RIDE BIKES. Get off the couch. RIDE BIKES. Get on with life. RIDE BIKES. Have a ball. RIDE BIKES. Burn calories. RIDE BIKES. Feel the burn. RIDE BIKES. Show off your calves. RIDE BIKES. Eat some mud. RIDE BIKES. Befriend the dirt. RIDE BIKES. Find yourself. RIDE BIKES. Lose yourself. RIDE BIKES. Go to the store. RIDE BIKES. Get in shape. RIDE BIKES. Go to work. RIDE BIKES. Clear your head. RIDE BIKES. Scrape a knee. RIDE BIKES. Bruise a thigh. RIDE BIKES. Make friends. RIDE BIKES. Leave them in the dust. RIDE BIKES. Visit Mom. RIDE BIKES. Visit Betty. RIDE BIKES. Skip lessons. RIDE BIKES. Push yourself. RIDE BIKES. Be yourself. RIDE BIKES. Gary says: RIDE BIKES.

CLIENT: Gary Fisher is a leading bicycle manufacturer.
FIRM: Planet Propaganda **CREATIVE DIRECTOR:** Dana
Lytle **DESIGNER:** Michael Byzewski **PRODUCTION
DESIGNER:** Angie Medenwaldt **PRODUCTION MANAGER:**
Ann Sweeney **BRAND MANAGER:** Rob Sax **WRITER:**
James Breen **PHOTOGRAPHY:** Scott Markewitz, Steve
Milanowski, and Brian Bailey

FACING PAGE: Founder Gary Fisher and his famed soul patch
figure prominently in the narrative.

RIGHT: Catalogs usually aren't read in a linear fashion. Funky
borders identifying different bike models make navigating
easier.

BELOW: Crisp photography creates a "being there" effect.
Snarky montage images portray a brand that is steeped
in contemporary culture yet doesn't take itself too seriously.

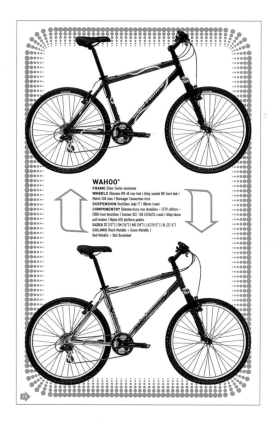

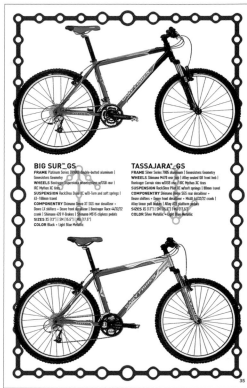

The Challenge

The big story in Gary Fisher's 2003 bike catalog was
the introduction of 29" (73.7 cm) wheels on Sugar
full-suspension models and Genesis Hardtails, prom-
ising faster speeds and greater flexibility. But design-
ers at Planet Propaganda needed to serve up more
than a clear and concise presentation of the product
offerings. To create true lust for muddy trails, rugged
adventure, and the thrill of "being Fisher," the
brochure needed to capture not just the brand's me-
chanical advantages but also its anarchic flavor. And
it had to do so while targeting two distinct audiences:
inexperienced riders and die-hard fanatics.

The Solution

To give the brand a test ride, Planet Propaganda
visited bike shops, talked to dealers nationwide,
and audited competitors' materials. Then they hit
the trails with Gary. There was never any question
that company's eponymous and colorful founder
should play a starring role in the brochure concept.
"Gary is the brand. It was especially important to
play him up in this category because none of the
competitors has anyone like him," says creative
director Dana Lytle.

Although the catalog is teeming with collaged
ephemera, all of the pages are straight process

builds. To accommodate German and Japanese ver-
sions, text was limited to black so that translations
could be achieved with a single plate change on the
press. "We had to work in 20 percent more space
than the English took up to allow for the additional
length of the translated text," notes Lytle.

In the end, says Lytle, "the design was about cap-
turing the essence of Fisher culture, which is inher-
ently linked to mountain biking culture. Gary has
always been known as an innovator, and Fisher is
constantly pushing technology. The design had to
reflect these qualities. And it had to be fun."

JAMES MCNAUGHTON PAPER
Paper and Scissors Rock

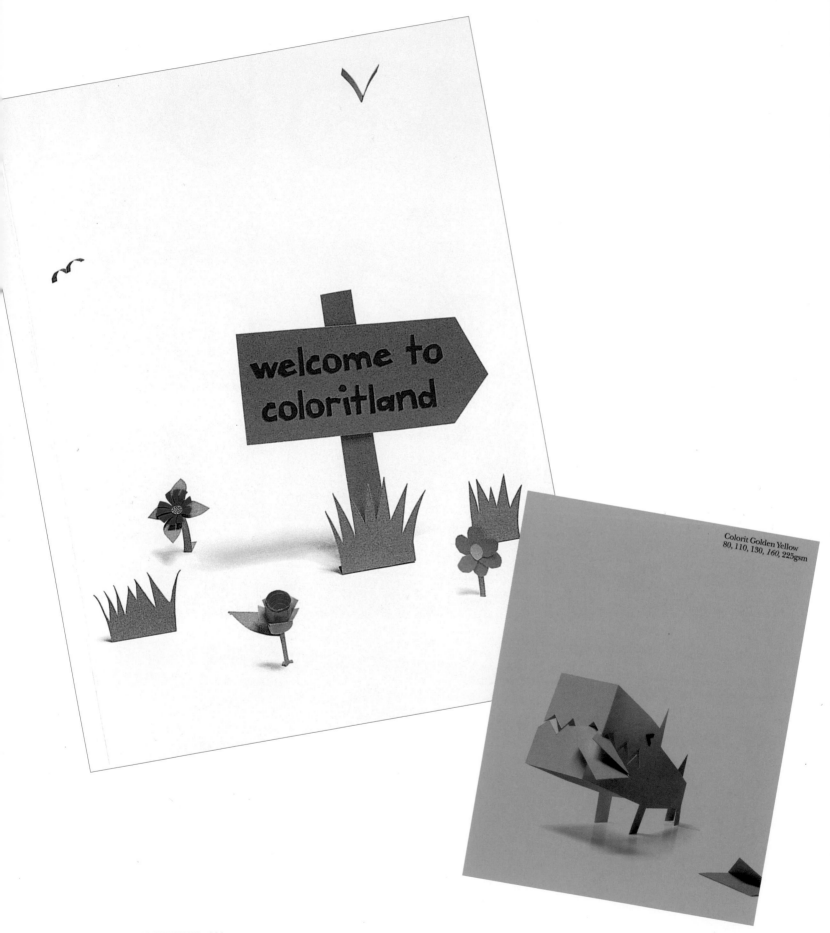

Colorit Golden Yellow
80, 110, 130, 160, 225gsm

CLIENT: James McNaughton Paper Group Ltd. is a British paper manufacturer. FIRM: Radley Yeldar Design Consultants DESIGN DIRECTOR: Robert Riche DESIGNERS: Darren Barber and Robert Riche ILLUSTRATOR: Darren Barber COPY CONCEPT: Darren Barber and Robert Riche COPYWRITER: Ben Whalley PHOTOGRAPHY: John Edwards

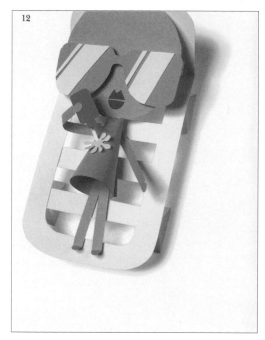

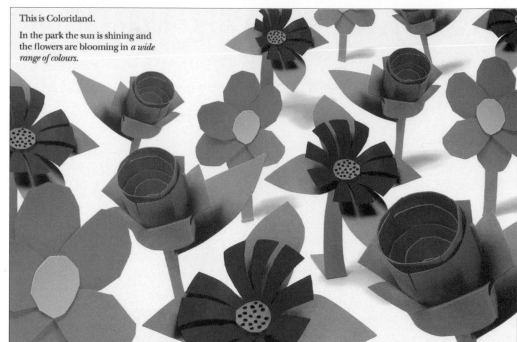

This is Coloritland.

In the park the sun is shining and the flowers are blooming in *a wide range of colours.*

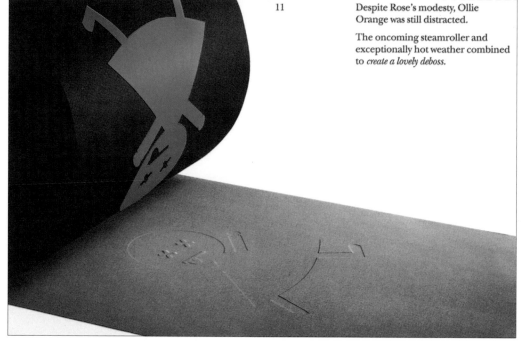

Despite Rose's modesty, Ollie Orange was still distracted.

The oncoming steamroller and exceptionally hot weather combined to *create a lovely deboss.*

FACING PAGE: Perfect binding and an intimate trim size (6" x 8" (15.2 cm x 20.3 cm)) create a storybook feeling. The binding method also made it possible to tip in a few colored paper samples in the back of the book.

ABOVE LEFT AND ABOVE RIGHT: Colorit papers come in 35 hues and a range of weights and sizes. The inhabitants of Coloritland illustrate the substrate's vibrancy, flexibility, and sturdiness.

RIGHT: The episode in which Ollie Orange gets hit by a steamroller could have featured an actual deboss, but that method would have cost a pretty penny. Instead, the design team debossed a single sheet for its stage set and photographed the image, keeping costs to a minimum.

The Challenge

Paper promotions are often high-end pieces that pull out all the stops, featuring debossed motifs, die cuts, foil stamps, engraving, multiple varnishes—the works. But the design marketplace is a cluttered arena in which production acrobatics are common-place. To reinvigorate interest in McNaughton Paper's Colorit line of uncoated stock, Radley Yeldar needed to craft an alternative to the typical produc-tion bonanza—that is, a concept that wouldn't break the bank. The budget and time frame (about eight weeks) were extremely tight.

The Solution

A perfect-bound storybook introduces readers to Coloritland, a fictional world in which everything is made from Colorit paper. The aesthetic is childlike, but the cheeky narrative is embedded with adult wit and not-so-subtle sales plugs. (When construction workers whistle at Rose—a paper doll babe—Rose is relieved that her dress has "superb opacity.")

"Having been heavily promoted in the past, the Colorit brand was already widely recognized among designers and printers. Our idea was to create

something more engaging than a straightforward paper swatch but which still communicated the key features of the paper," says designer Darren Barber, who fashioned an entire cast of characters and prop models out of colored paper—from flowers to farm animals to utility trucks. A clever storyline keeps readers glued to the very end.

LAS CAMPANAS
Traveling Back in Time

CLIENT: Las Campanas Santa Fe is a luxury real estate development for people with a net worth of $5 million and above. FIRM: Rick Johnson & Company Advertising
DESIGNER: Tim McGrath CREATIVE DIRECTOR/COPYWRITER: Scott Johnson ILLUSTRATORS: Tom Slampyak and Greg Tucker PHOTOGRAPHY: Steve Wrubel
PRINT PRODUCTION MANAGER: Jenny Jensen

FACING PAGE: Toothy linen stock gives the booklet an antique, tactile quality. The wrapped, hole-punched cover was applied by hand—just like in the old days.

RIGHT: Imagery hearkens back to an era when folks traveled in style. Skies were completely stripped out, retooled in Photoshop, and colorized by hand to heighten a sense of romanticism. The typeface of choice: Adobe Serifa.

BELOW: Many cards sport a deliberately muddy pastel palette—an homage to the effect that was once unavoidable when layering color over black-and-white prints. Old-style maps were drawn freestyle and hand lettered.

GOLF AT LAS CAMPANAS SANTA FE

THE LOG CABIN–DINING AT LAS CAMPANAS SANTA FE

ROADMAP TO PARADISE
A.K.A. LAS CAMPANAS SANTA FE
LAS CAMPANAS SANTA FE OVERVIEW

The ENCHANTED DESERT DRIVE
TO LAS CAMPANAS SANTA FE
DRIVING DIRECTIONS TO LAS CAMPANAS SANTA FE

The Challenge

Real estate developments catering to millionaires don't advertise in mainstream channels. For Las Campanas, referrals from existing property owners are a primary source of lead generation. But there's a catch: Property owners don't like being treated as a sales force. The design team at Rick Johnson & Company needed to somehow create a fun and compelling portrait of Las Campanas that property owners would actually want to give to their friends.

The Solution

A campy booklet of vintage-style postcards paints a romantic picture of the development. Rendered in the style of early 20th-century travel posters, the cards use a nostalgic vernacular to highlight the property's sexiest features, including its massive equestrian center and two Jack Nicklaus golf courses.

"One thing that worked to their advantage is that rich guys do care who their neighbors are going to be," notes creative director Scott Johnson. "But they needed an approach that would fly under the radar and generate sales without looking like a sales piece."

The idea for the booklet emerged after designer Tim McGrath unearthed a pile of vintage travel postcards at a Santa Fe flea market. Photos are framed the old-school way, with focal points dead center. McGrath grayscaled and screened back shots of the property before handing them off to an illustrator for colorizing and hand detailing.

The postcard booklet was ultimately distributed to existing homeowners in a gift package along with personalized letterhead and an engraved pen. Individual postcards are also sold on racks in the pro shop. The design team at Rick Johnson is now developing a pilot program inviting property owners to commission custom postcards of their own homes.

NIKE MEXICO
Shoe-In

CLIENT: Nike Mexico FIRM: Bløk Design CREATIVE DIRECTOR: Vanessa Eckstein DESIGNERS: Vanessa Eckstein and Mariana Contegni
PRINTER: Artes Graficas Panorama

FACING PAGE AND THIS PAGE TOP: An embossed insignia makes the passport cover feel more official. Personal data can be recorded on the first page above the serial number.

BELOW LEFT: A graph motif resembling soccer netting (a sight that triggers involuntary salivation among most *futbol* fanatics) builds texture throughout the brochure. Customers attending Nike events can have their passports rubber-stamped, adding a new dimension to the layout.

BELOW RIGHT: Sophisticated renderings and prototypes highlight product features and feed the consumer's insatiable craving for high-tech gear.

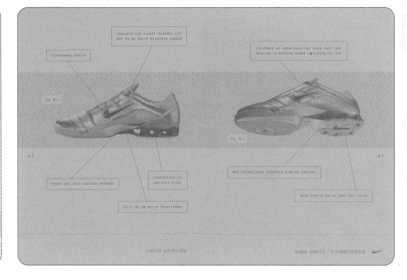

The Challenge

Nike planned to launch a new indoor soccer shoe in Mexico and wanted to kick things up a notch. Its target: 12- to 18-year-old *futbol* junkies who play the sport three times a week or more—any place, any time. "These soccer-crazy kids know all about the latest soccer products and are constantly searching for innovation," says Vanessa Eckstein, creative director at Bløk Mexico. The goal was not only to score interest in the shoes themselves but also to drive potential customers to the Internet and to Nike-sponsored events. Most important, the brochure needed to fuel a hunger for the latest gear and sports technology.

The Solution

Welcome to the Republic of Futbol. To create an air of exclusivity and promote individual relationships with the brand, Bløk devised the "Total Magia" passport. Official passports handed out to consumers at events and in Nike stores are serialized, so no two are exactly alike. Customers can use their booklets to access exclusive, web-based dish; special-event privileges; and discounts and promotions. The back of the passport brochure provides dates and other key information about upcoming Nike-organized club team tournaments. But for the most part, graphics do the talking.

Of course, the best passports are those espousing colorful evidence of their owners' adventures. That said, customers who bring their passports to Nike stores, soccer matches, and other events can have their books rubber-stamped with an insignia that looks like the sole of the soccer shoe. Stamp color: official Nike orange.

Granted, the Total Magia passport is a bit more edgy than your standard government-issue document. The blue-and-silver color scheme mirrors the space-aged colors of the actual footwear, and the paper stocks—Fox River Star White Sirius Smooth and Curious Metallics Lustre—are beyond utilitarian. "We believed the passport was as much about experience as information, so we expressed change not through colors but through textures—in the paper transitions and embossing," says Eckstein. "The product shots on metallic paper have a shimmer that feels deeper than what we could have achieved with a simple four-color reproduction of the shoe. The piece works as a loyalty program and information source all in one."

FREEMOTION
A Moving Experience

MOVING BEYOND **MYTHS**

Today, club members want more than a great body. They want a body that works. And happens to also look good.

ABOVE LEFT: The original Ground Zero brochure relied on gestural photos with calligraphic effects to suggest movement.

Why Redesign?

Ground Zero Design was founded in 1999 with the launch of a revolutionary piece of exercise equipment by the same name. Unlike standard weight-training equipment, which isolates individual muscles, Ground Zero's proprietary "FreeMotion" system simulates movements involving complex muscle groups—actions that are inherent in everyday human activities, such as pushing, pulling, twisting, lunging, and squatting. In late 2001, Ground Zero was acquired by ICON Health & Fitness, Inc., the world's largest manufacturer and marketer of fitness equipment. Following the merger, ICON planned to retain Ground Zero as the brand name for the equipment. The words *ground zero,* however, took on a whole new meaning after September 11, 2001. In January 2002, the equipment was officially renamed FreeMotion. The name change necessitated a new identity, which, in turn, led to a complete overhaul of the brand's collateral.

CLIENT: FreeMotion Fitness Inc. provides cutting-edge fitness equipment that changes the way people exercise. **FIRM:** Hornall Anderson Design Works **ART DIRECTOR:** Jack Anderson **DESIGNERS:** Kathy Saito, Sonja Max, and Henry Yiu **PRODUCTION:** Alan Copeland **ILLUSTRATOR:** Shawn Ogle **COPYWRITER:** Tyler Cartier **PHOTOGRAPHY:** Darrel Peterson **PRINTING:** Rainier Color

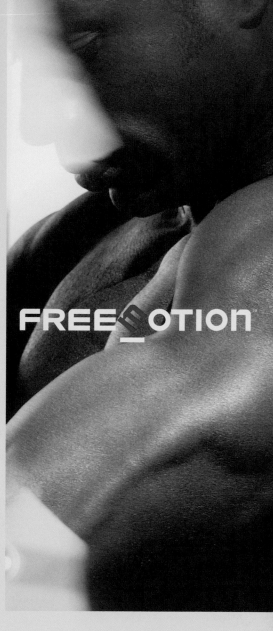

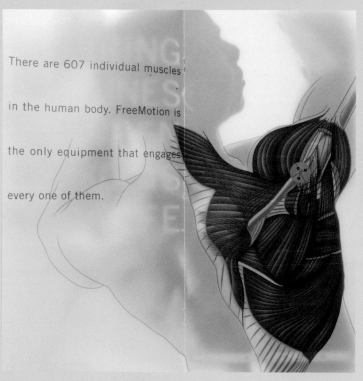

There are 607 individual muscles in the human body. FreeMotion is the only equipment that engages every one of them.

The Transformation

Ground Zero's original identity and brochure, created by Hornall Anderson Design Works, featured vibrant colors and kinetic photographs of athletes in motion. With the corporate name change, however, the design team capitalized on the opportunity to tighten the connection between the product's physical form, function, and brand image. Whereas the original Ground Zero logo was a compact, muscular mark, the new FreeMotion logo is elegant and sophisticated, assuming a streamlined, monolithic form similar to the shape of the FreeMotion equipment itself. A canted red *m* bisects the white type, representing the range of motion that equipment users achieve.

From the logo, a bolder, simpler product brochure evolved. "The idea was to reach the club owners who make purchasing decisions and make them realize that fixed-plate equipment isn't where today's consumer wants to go," says art director Jack Anderson. "The growing popularity of Pilates, yoga, and similar workouts are evidence of what the consumers really care about—being able to hold their grandson over their head or pulling 25 pounds of groceries out of their trunk without throwing out their back. Only a small percentage of people who go to the gym are the bulky guys with the six-pack abs." Echoing the palette and anatomy of the FreeMotion equipment itself, the brochure has a vertical orientation and unfolds in an arresting combination of black, white, red, and metallic silver. "Some of the equipment parts, such as the wires,

nuts, and bolts, are silver, so we picked silver metallic ink to reflect that," says designer Henry Yiu.

As in the original brochure, the revamped piece relies heavily on photography to convey a sense of movement—only this time on a more intimate scale that celebrates body forms. Photos were not manipulated but rather art-directed on location to simulate motion. "The photographer opened up the shutter speed on the camera and had the models move through the shot," says Yiu. "The shots illustrate what the equipment can help people achieve—everyday strength, not just gym strength. This brochure has really helped the salespeople pitch to gym owners. Usually once the owners understand the philosophy behind the product, they buy it."

VIA MOTIF
It's Elemental

CLIENT: Via Motif is an upscale home accessories manufacturer in Northern California. **FIRM:** Vrontikis Design Office (35k.com) **CREATIVE DIRECTOR:**
Petrula Vrontikis **DESIGNERS:** Petrula Vrontikis and Ania Borysiewicz **PHOTOGRAPHY:** Jason Ware and Jon Clayton **PRINTER:** Heinz Weber, Inc.

FACING PAGE LEFT: Appleton Curious paper in Keaykolour Metallics Rusted forms a shimmering, self-closing cover. Printing on the dense substrate would have been an exercise in futility, so the Via Motif logo is artfully embossed.

BELOW: Calligraphic symbols of the *I Ching,* rendered in the style of the Via Motif logo, serve as product category markers. Tiny brushstrokes bearing a similar aesthetic are used to accent page numbers.

FACING PAGE RIGHT AND TOP RIGHT: Visual layering lends a poetic quality to lush still-life shots. Subtly tinted overlays celebrate the inherent forms of nesting pandan boxes and cast-brass candleholders.

TOP RIGHT: Fold-out pages on Sappi Vintage text get practical with clean shots and product specifications.

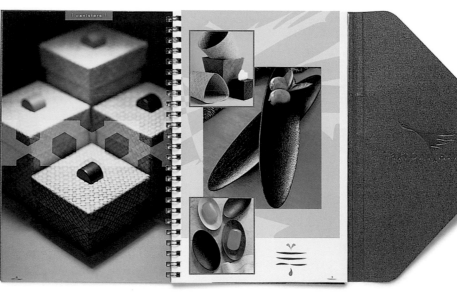

The Challenge

Via Motif made its debut in the home decor market with a collection of elegant accessories celebrating natural forms. When the company expanded its product lines, its brand image needed to grow accordingly. Vrontikis Design Office was commissioned to upgrade the original logo and to create an overall brand look and feel for print, packaging, and digital applications. These changes applied to a catalog brochure heralding the breadth of the new product line to distributors and retailers.

The Solution

Because Via Motif owner Cathy Steinberg was expanding the number of products in her basket, categories were needed to make the catalog functional. "We started thinking about innovative ways to build new categories and arrived at the *I Ching* symbols, which represent natural elements and their relationships with each other," explains creative director Petrula Vrontikis. "For example, a candle holder would be fire over earth. A bath product might be wood over water. This was a unique way of categorizing and reinforcing not just what the products are

but also the interesting dynamic or energy that is created when elements are combined."

Inspiration for page layouts emanated from the products themselves, which are beautifully crafted from Indonesian woods, grasses, stones, metals, and fabrics. Therein lay a bounty of interesting textures and shapes that could be woven into the design like a rich tapestry. Product forms, distilled to their bare essence, are thus layered over photographs as screen tints, giving objects an iconic significance.

XINET
Show and Tell

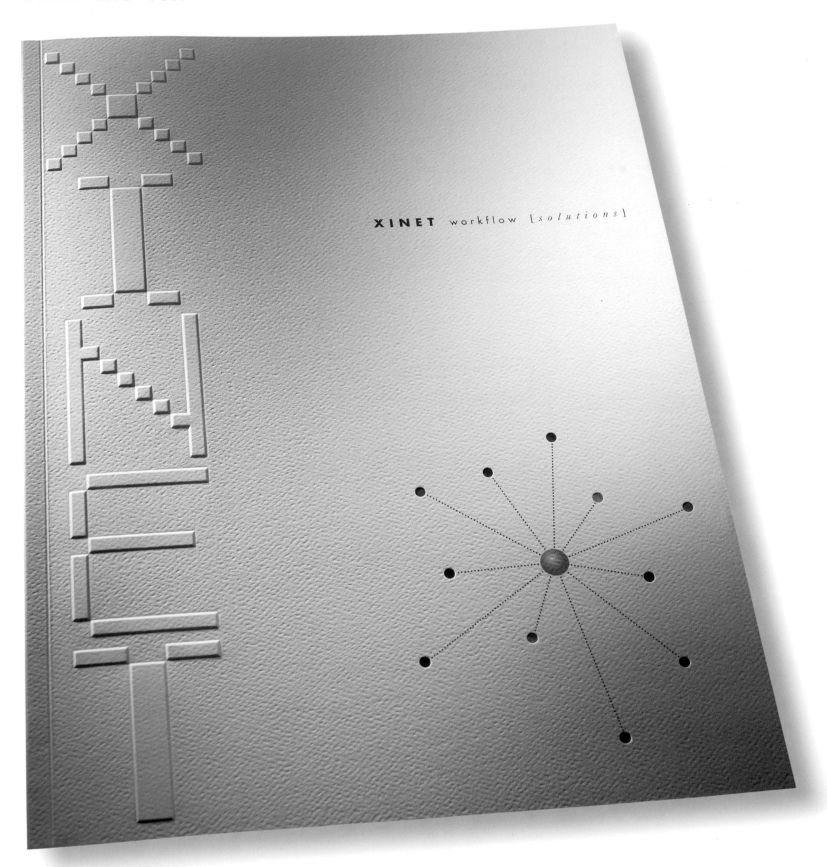

XINET workflow [solutions]

CLIENT: Xinet, Inc., is a developer of high-end networking server software for the prepress, printing, and publishing industries. **FIRM:** Gee + Chung Design
CREATIVE DIRECTOR: Earl Gee **DESIGNERS:** Earl Gee and Fani Chung **PHOTOGRAPHY:** Kevin Irby **PRINTING:** Anderson Lithograph/SF

FACING PAGE: The cover stock has a slight grain, in contrast to the interior, which is smooth.

RIGHT: Text imitates art in this spread illustrating the software's advantage in preventing production delays.

BELOW: Pull the tab and the icons in the windows change to represent different industry needs.

BELOW RIGHT: A rotating wheel demonstrates the software product's versatility by allowing the reader to change the words and images appearing behind die-cut windows. The movable wheel was accomplished without a visible metal rivet, which would have marred the pages in front and back of the diagram. Instead, the wheel rotates around a paper dot that's glued and hidden from view inside French-folded pages.

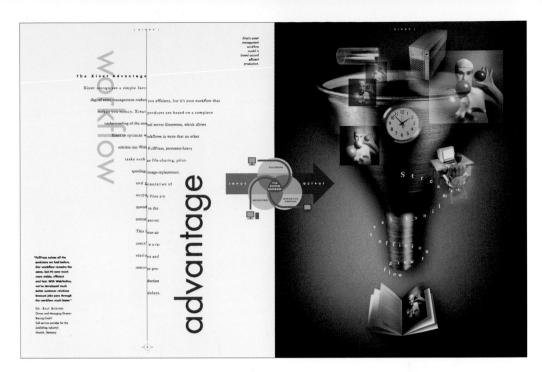

The Challenge

Xinet wanted to share its robust product attributes with a seasoned audience of chief technology officers and print production managers. But showcasing the company's dynamic server software in a static medium (print) was no small task. Because the piece would cater specifically to the printing industry, Xinet wanted to incorporate interesting print production techniques into the brochure wherever possible. The company also needed a design that could accommodate French and German language versions for European markets. This proved difficult, considering French tends to run about 25 percent longer than English and German 33 percent longer.

The Solution

Gee + Chung incorporated various unusual production techniques to illustrate the benefits of Xinet software. An interactive die-cut diagram controlled via a sliding pull tab conveys the availability of different applications for different industries. A rotating paper wheel demonstrating product versatility can be manually turned to reveal various stages of Xinet's digital asset management system through die-cut windows. Although these features were pricey, unnecessary expenses were avoided to accommodate them. For example, multiple language versions of the brochure were produced economically with a single black plate change for the type.

The brochure is logically organized into a front section highlighting product benefits and a back section detailing product specifications. "Metaphors for efficient time management, streamlined workflow, and versatility are used to communicate key product attributes," says creative director Earl Gee. "Text blocks are sculpted into shapes that reiterate visual elements on each spread." A white-on-white cover provides contrast to colorful inside spreads. "The essence of digital color is the pixel, so we created a cover with the word *Xinet* composed of blind-embossed squares on a richly textured stock," he explains. Round, die-cut holes on the cover symbolizing an interconnected network become square pixels when you open the cover.

In the end, the piece proved successful, both as an interactive sales tool for one-on-one sales presentations and as a memorable leave-behind for prospective customers. "Equally important, the brochure had the same 'How did they do that?' quality that Xinet engineers strive to integrate into their software," says Gee.

FLIX BUFFET SYSTEM
Easy to Digest

CLIENT: Buffetissimo makes modular buffet tables for the upscale culinary market. FIRM: form fünf DESIGNER: Daniel Henry Bastian PHOTOGRAPHY: Alasdair Jardain

Whether at conferences, receptions, trade fairs or weddings, buffets have enjoyed over many years an international increase in popularity.
And not without reason: this stylish culinary experience, that is today more than just a trend, allows quick and varied enjoyment. In order to give this modern zeitgeist an expression, Buffetissimo has developed a new form of food presentation. Flix: the future of buffets.

A system with brains

Flexibility and speed have a name: Flix – an innovative buffet system of unsurpassable quality. In less than 10 minutes it is ready and fitting to any occasion. Thanks to its modular design, Flix effortlessly matches the individual characteristics of every event.

One person can conjure, with a flick of their hand, a culinary landscape where food is exquisitely presented, and can be obtained from all sides. It is possible to feed a large number of guests within a short period of time – without queuing!

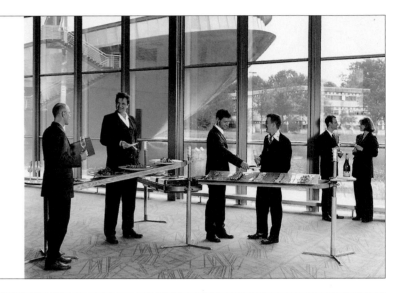

facts

What is most important? During development we asked top companies which qualities a future buffet system should have. Their answer: speed, flexibility, simplicity and efficiency. Flix fulfils exactly these requirements with bravado.

1. Just like magic

Set-up time in minutes
Buffet for 100 people

(60) (10)
others flix

= quick set-up throug easy handling

One person can erect and lay out a complete buffet, for example for one hundred people, including food and lighting within ten minutes.

P-05C-RIGHT-BMSI.FPO

2. Faster, faster...

Time required in minutes
100 people help themselves to food three times

(60) (17,5)
others flix

= no queuing

One of the most important trends in gastronomy is the faster enjoyment of food. Flix makes this possible. Thanks to its special construction our system can be accessed from up to six sides simultaneously. Frustrating queues are now a thing of the past.

The Challenge

In the culinary world, presentation is paramount. So when Buffetissimo launched its Flix Buffet System, an elegant assemblage of serving tables for catered events, it needed a promotional brochure that would make first-class hotel managers and highbrow catering services hungry for details. The modular system, complete with tony lighting and frosted-glass platters, can be assembled in less than 10 minutes. The brochure needed to reflect the product's intuitive design with similar brevity—particularly if it was to gain attention as a direct-mail piece and as a handout at bustling trade expos.

The Solution

Flix is sleek, minimalist, and functional; so is the brochure. The piece was printed in both English and German versions, although photographs tell much of the story, depicting the product in various configurations and environments and (of course) bearing exquisite gastronomic feats. Two sans serif typefaces, Caecilia and Officina, "support the modern-but-not-fancy personality of the brand," says designer Daniel Bastian, who created the brochure as part of an overall corporate-identity package. Proof that the brochure resonated with its intended audience? Flix Buffet Systems are now used for events at the Bundestag in Berlin and the Kremlin in Moscow, among other locations worldwide.

FRAMINGHAM WINES
Screwed Up Is Good

CLIENT: Framingham Wines is a vintner in the Marlborough region of New Zealand. **FIRM:** Lloyds Graphic Design & Communication **ART DIRECTOR/DESIGNER:** Alexander Lloyd **PRINTER:** Blenheim Printing Co.

ABOVE: Lloyd specified a combination of classic serif and contemporary sans serif fonts. This marriage reflects a blending of the time-honored craft of winemaking with the latest preservation innovation in the industry.

The Challenge

Because corked wine can suffer from cork taint, leakage, and oxidation, many vintners have introduced twist-top wine bottles in recent years to ensure their wine reaches the customer in peak condition. However, some wine purists continue to turn up their noses at the screw-cap concept, mistakenly equating this form of packaging with cheap quality. When Framingham Wines introduced Stelvin twist caps to its family of wines, a small brochure was needed to convince traditionalists that this modern twist on an ancient culinary tradition was a good thing.

The Solution

The phrase *A Fresh Twist on Quality* served as a springboard for a punchy, eye-catching design. Art director Alexander Lloyd experimented with pen on paper and digital doodling to arrive at a simple, tornadic graphic that reinforces the message.

The brochure is designed to fit inside a standard envelope, but its landscape orientation is a fresh departure from the vertical status quo. Colors were chosen to underscore the "fresh" theme while echoing the colors of grape leaves and the lush hillsides on which grapes are grown.

The brochure was well received by the wine-buying public. Most important, so was the screw-cap concept, notes Lloyd. Biases are down and sales are up.

SUNPROTEX
Cool in the Shade

CLIENT: Sunprotex develops and manufactures quality fabrics for sun-protection products such as roller blinds and vertical and pleated blinds. **FIRM:** BRAUE: Branding & Corporate Design **CREATIVE PEOPLE:** Kai Braue and Marçel Robbers **WRITERS:** Kai Braue and André Weiss **PRINTER:** Druckhaus Wüst

ABOVE: Trade shows are chaotic events, but in this case, blinding colors weren't the best way to garner attention. A tranquil palette communicates the brand promise most effectively.

The Challenge
Sunprotex was gearing up for its first appearance at R+T 2003 in Stuttgart, the world's largest trade show for home decor and sun-screening products. The young company needed a brochure that would put it on the international map and pique the interest of blinds manufacturers and interior designers.

The Solution
Research showed that 99 percent of the established fabric makers in the blinds business play it safe when it comes to promoting their wares. Braue recommended that Sunprotex leverage the trade show to position itself as a forward-thinking supplier of next-generation fabrics. That meant expressing its product in an unusual way.

Rather than depicting actual window treatments, the brochure recreates the serene, otherworldly effect one might see by peering through quality window fabrics. Images are gently and colorfully abstracted to create the illusion of filtered light. "The highly scientific process we used to achieve this effect was called trial and error, or endless tweaking," says strategist Kai Braue. "In other words, printing out and correcting, printing out and correcting. It was hard to tell how the digital fabric structure we created would turn out in print—or at least it was impossible to judge by looking at the computer screen."

The elegant, undulating form on the brochure cover is actually a swath of Sunprotex fabric photographed in an exciting way.

ARJO WIGGINS
In the Gutter

in the **gutter**
is
a
collection
of
photographs
and
illustrations
that
attempts
to
bring
into
greater
focus
the
preoccupations
and
concerns
inherent
in
the
design
process,
namely:
fingers
faces
floors
feet
figures
hair
logs
legs
moustaches
noses
nobs
nudes
prayers
prickly pears
peters
parts
tattoos
tutus
teeth
torsos
tongues
toes
underwear
walls
and
zippers
presented
by the people
at
the
curious collection

CLIENT: Arjo Wiggins is the second-largest paper manufacturer in the world. **FIRM:** Viva Dolan Communications and Design **ART DIRECTOR:** Frank Viva
DESIGNER: Frank Viva **ILLUSTRATOR:** Frank Viva **COPYWRITER:** Frank Viva **PHOTOGRAPHY:** Ron Baxter Smith **PRINTER:** Vasti

FACING PAGE: The cover—a shell of Curious Touch Soft Blanc Neige stock—provides a visual and verbal preview of what's in store. The flush-left type is set in the font Grotesque MT.

RIGHT AND BELOW: Robust images—some with a touch of naughty innuendo—show off the curious qualities of a litany of paper stocks.

BELOW RIGHT: HB pencil drawings sprinkled between photo spreads add wit and pacing while resolving a production problem on spreads that start with one paper stock and end on another.

The Challenge

Viva Dolan has been working with Arjo Wiggins for 10 years and handles branding for the manufacturer's line of Curious Papers worldwide. The client sought a cheeky promotion that spoke in the vernacular of designers and paper specifiers in the European market. The promo needed to entertain, while simultaneously showing off as many substrates as possible from the Curious collection.

The Solution

Being a designer himself, it was easy for art director Frank Viva to put himself in the audience's shoes. "I was looking for themes that would appeal to the creative community. And because the largest market for Curious paper is in Britain, I wanted a piece that was a bit dry," he says. "I know designers—including

myself—spend a lot of time thinking about how to avoid the gutter when designing a grid for a perfect-bound book. I thought it would be fun to flip the whole thing around and celebrate the gutter—to use it as an actual physical aspect of the whole piece."

Viva threw his mind in the gutter and brainstormed ways to use the dreaded crease to his advantage. A laundry list of things that were bifurcated and symmetrical (including more than a few anatomical parts) gave added momentum to the "mind in the gutter" concept. Armed with a wish list of images, photographer Ron Baxter Smith rounded up props and models.

Incorporating 23 different paper stocks into the brochure required some production ingenuity. "We

wanted to show a variety of papers and surfaces but didn't want the photography to suffer," says Viva. Integrating illustration into the mix solved the problem. Wherever there's a crossover from one stock to another on one spread, the image on the spread is line art. "I didn't want the photos to travel from one paper to another, because that would have looked weird," he explains.

Another subtle but critical production detail—the binding. Recognizing that users would naturally be inclined to press the book open to eyeball the gutter more closely, Viva specified a Smythe-sewn binding to prevent the book from falling apart when flattened out.

BLUE RIDGE COMMERCIAL CARPET
Ingenuity Squared

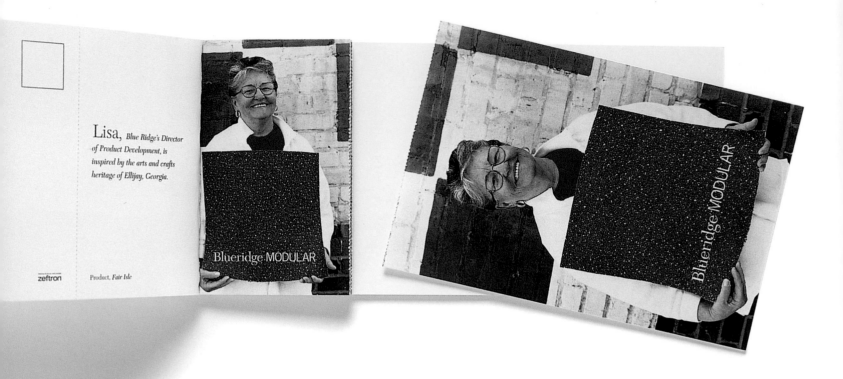

Lisa, *Blue Ridge's Director of Product Development, is inspired by the arts and crafts heritage of Ellijay, Georgia.*

zeftron Product, *Fair Isle*

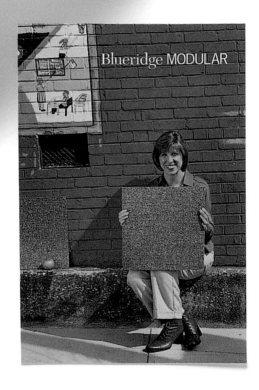

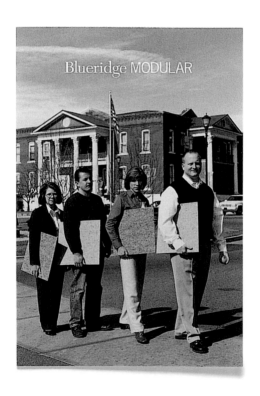

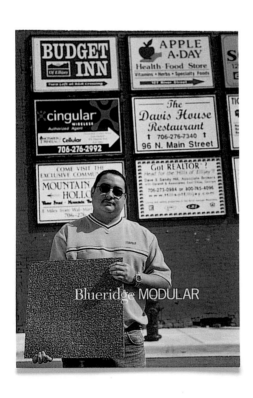

CLIENT: Blue Ridge is a commercial carpet maker located in the foothills of the Blue Ridge Mountains. FIRM: Grant Design Collaborative ART DIRECTION AND DESIGN: Grant Design Collaborative PHOTOGRAPHY: Maria Robledo PRINTER: Seiz Printing

FACING PAGE, TOP: Every card in the deck is perfed and ready for postage. But postcard pass-along doesn't mean out of sight out of mind. Each time a postcard is torn out of the booklet, a miniature version of the image remains (with product info on the back).

FACING PAGE, BOTTOM: Photos of tile-toting Blue Ridge employees in their comfortable locale underscore the company's unpretentious personality and sense of humor. The Abbey Road spoof, touting a natural wool tile called "Cotswald," was a hit.

THIS PAGE: When Blue Ridge says "modular," it means business. A perforated brochure cover and detachable postcard inserts carry the concept to print.

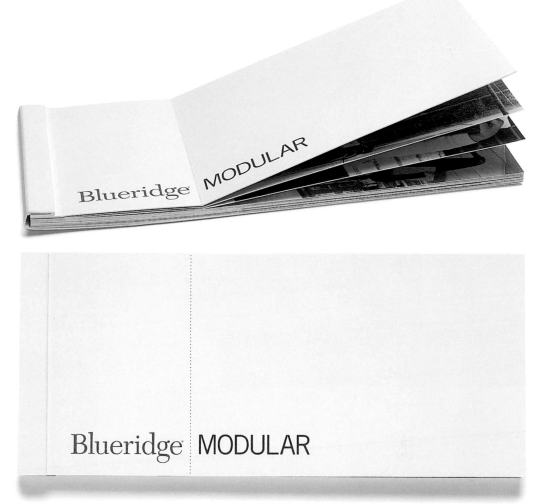

The Challenge

Responding to the evolving environmental and functional demands of architects, interior designers, facility managers, and corporate end users, Blue Ridge expanded its product offerings in 2003 to include not just broadloom floor coverings but also carpet tiles. This new modular line was set to launch at the 2003 NeoCon show in Chicago. The company's goal was to promote the line with panache while leveraging a longstanding reputation for quality craftsmanship.

The Solution

Blue Ridge has always used its own people in ads and promotions to convey a genuine, homespun approach to product design. Maintaining this continuity was important, and Grant Design Collaborative devised a way to resurrect the tactic without reinventing the wheel. A troupe of Blue Ridge employees headed down to the town square in Ellijay, Georgia (the company's home base), for a photo shoot, and "Postcards from the Square" was born. The concept forms a double entendre, alluding not just to the geographic coordinates of the small town square but also to the quadrangular shapes of the modular carpet pieces.

But wait, there was another set of criteria. Blue Ridge needed not just a brochure but also advertising inserts and direct mail. And its budget was tight. Herein lay an opportunity to further underscore the carpet product's best attribute—flexibility. "Modular tile is sustainable and can be configured in all different ways," says principal Bill Grant. "In this same vein, we ended up using the photos we shot as modular products themselves for a whole range of promotional materials."

The launch brochure is a bound booklet of postcards that can be torn out and mailed (thus encouraging viral proliferation of the message). But the postcards, which were all ganged up on one press form, have alternative uses to boot. Blue Ridge account reps send them out with sample orders and as appointment reminders and lunch invitations. Cards were also commandeered as advertising inserts during the NeoCon show. All told, the print run covered 5,000 brochures, 40,000 advertising inserts, and an additional 5,000 overrun of each postcard for individual direct-mail use. Finch heavyweight, a durable, economical paper stock, provided solid ink fidelity without breaking the bank.

"We had a very small budget, but this was a major product launch," says Grant. "It was important for them to get some attention." And they did. One of the Blue Ridge tiles won a "Best of NeoCon" award its first year out of the gate. The company was floored.

CPP, INC.
Hide and Seek

▲ Myers-Briggs Type Indicator® Assessment

THE DIFFERENCE OF
A LIFETIME

mbti™

CLIENT: CPP, Inc., is a leading provider of assessment and training tools for organizational development professionals. FIRM: Mortensen Design Inc.
ART DIRECTOR: Gordon Mortensen DESIGNER: Helena Seo COPYWRITER: Mark Margolin ILLUSTRATOR: Jud Guitteau

FACING PAGE: A square trim size makes the piece a standout among standard 8½" x 11" (21.5 cm x 27.9 cm) product brochures.

BELOW: Friendly illustrations render the narrative less scientific and more people oriented.

BOTTOM LEFT AND RIGHT: A mini gatefold both hides and calls attention to the client's MTBI products.

The Challenge

CPP isn't a household name, but some of its products are. Nearly 89 percent of Fortune 100 companies use its organizational development training tools to create more effective teams. One renowned tool is the Myers-Briggs Type Indicator instrument (MBTI), a personality assessment method with considerable tenure in the workplace. Despite MBTI's venerable track record, CPP needed a fresh brochure to revive excitement about this 60-year-old product. The brochure would be distributed at conferences as an educational and awareness piece for organizational trainers, human resources managers, and consultants.

The Solution

MBTI has an illustrious history in the organizational development arena, but retro wasn't the way to go with the brochure design, notes art director Gordon Mortensen. The concept needed to be freshened up to proclaim its continued relevance. Crisp, white pages and punchy colors thus give the brand a facelift. Warm, humanistic illustrations explain the different personality types in the MBTI model without appearing too clinical.

The biggest challenge for the design team was incorporating requisite cover shots of the client's

MBTI publications into the layout. "We needed a way to both show off and hide the product at the same time," says Mortensen. "The product's visual appeal is limited and does not family with the company's fresh, new look and feel. Therefore, we created a gatefold flap to initially hide the product. The flap integrates a surprise/importance factor into the design when it is turned to reveal the product."

MATTHEW WILLIAMSON LIFESTYLE
From Runway to Retail

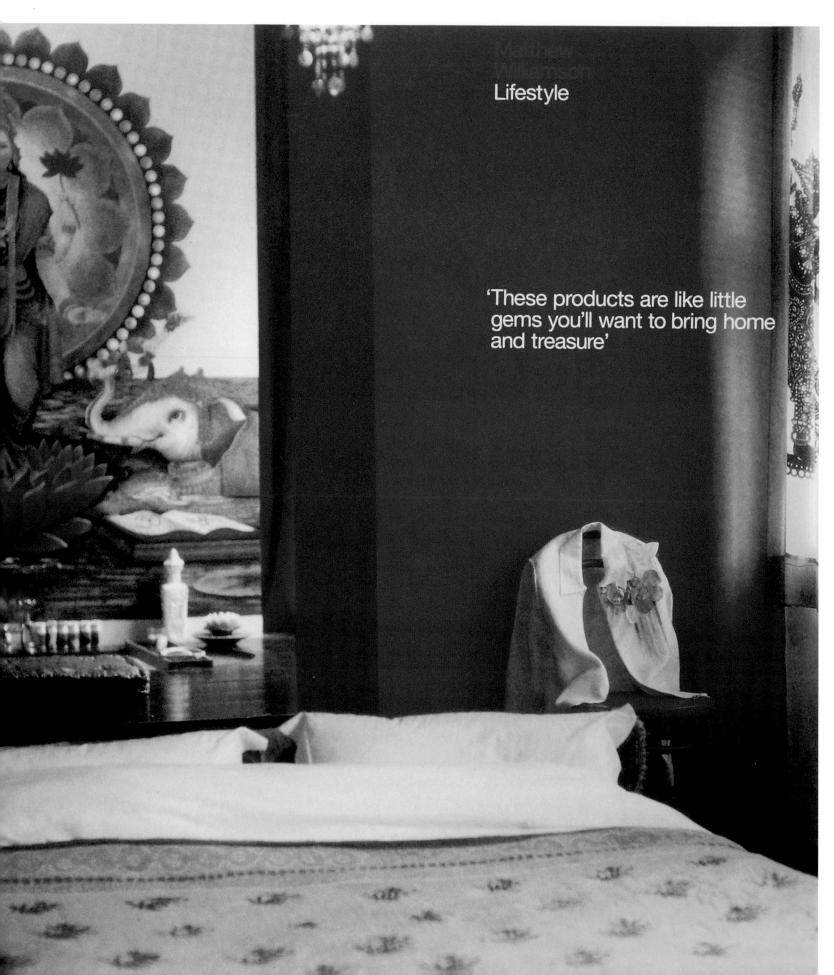

Matthew
Williamson
Lifestyle

'These products are like little gems you'll want to bring home and treasure'

CLIENT: Matthew Williamson is an independent fashion house based in London and known for fantastical evening wear with serious glam appeal. FIRM: SEA Design DESIGNER: Bryan Edmonson COVER PHOTOGRAPHY: Tim Evans-Cook PRODUCT PHOTOGRAPHY: John Ross PRINTING: Moore

FACING PAGE: On the cover, a peek inside Williamson's own boudoir puts department store retail buyers in the mood to see more. The electric colors and Asian-inspired aesthetics of the designer's clothes carry over into his lifestyle palette.

THIS PAGE: Every page was printed in CMYK with two spot colors in Williamson's signature hues—hot pink and metallic bronze/gold. A special bindery technique was used to produce intertwined stitching that runs gold along the outside spine and pink down the inside center spread.

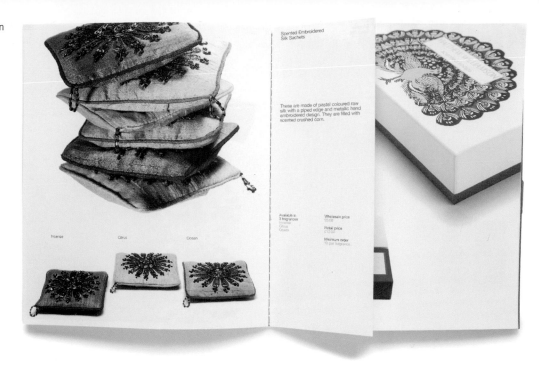

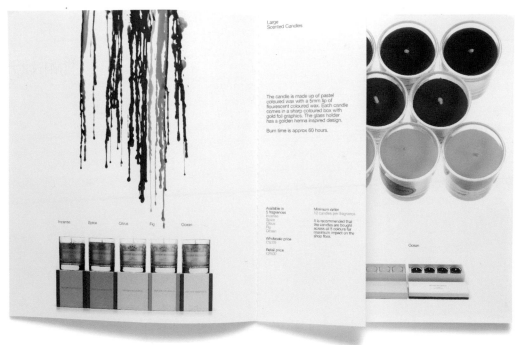

The Challenge

In 2001, fashion designer Matthew Williamson made his first foray into lifestyle products by introducing a line of aromatherapy candles. The collection quickly expanded to include scented soaps, bath jewels, sachets, and eau de parfum, with fragrances specially formulated by the London perfumery Miller Harris. Williamson's reputation as an arbiter of high style already held considerable currency in fashion circles. The design team at SEA needed to convey the exotic allure of his runway shows in an enticing product brochure for retail buyers but without the advantage of well-known faces like Kate Moss and Naomi Campbell. "The parameters for this project were typical of fashion, in that we really didn't have much direction at all," says Bryan Edmonson, a partner at SEA.

The Solution

How best to celebrate the designer's brave and experimental style in the context of home? "Retail buyers are familiar with Matthew Williamson's trademark clothing, so we needed to reinforce that connection," says Edmonson. "His personality is reflected in his clothes, which are very feminine, with a lot of bright pink." And, as it turns out, that same aesthetic carries over into the fashion trailblazer's inner sanctum. Photographs of Williamson's bedroom—rich with vibrant colors and Eastern influences—proved ideal for the brochure's front and back covers. Inside, liberal white space, crisp layouts, and deft cropping transform wax drippings and scattered bath salts into precious objects of desire. Product and pricing details are relegated to offset demi-pages in clean, sans serif type so as not to detract from the artistry of the product presentation. "The idea for the short pages came from an old art catalog," says Edmonson. "It's a format that allows more space for the images." A smooth, uncoated paper stock gives the piece the tactile luxuriousness of fine bed linens and ensures that the pages remain fingerprint free. Retail buyers at British and American department stores were amply seduced.

You'll call a specialist when you have a medical problem.

Why won't you call one for your practice?

aggregate

CLIENT: Miami-based Aggregate Corporation provides a web-enabled electronic archival system to help medical practices maintain records and streamline insurance claims, billing, and collection. FIRM: And Partners Inc. CREATIVE DIRECTOR/DESIGNER: David Schimmel COPYWRITER: Beverly DeSoto PROJECT MANAGER: Nada Bibi STOCK PHOTOGRAPHY: Photonica PRINTING: Williamson

I have no choice but to work harder for less money.

We are inundated in a sea of paper.

Simply getting paid for claims has become a daily nightmare.

I can't remember the last time I took a day off during the week and didn't worry about collections.

Honestly, it is frustrating to have to concern myself with the day-to-day claims process of my practice, when that's not what I went to medical school for.

The Challenge

Try getting your foot in the door at a busy doctor's office—by way of the mailman. "Imagine you're a physician working 12 hours a day with no time to breathe. You're pulling in 30 percent less income than you were a few years ago, yet your practice seems to be running as efficiently as it possibly can," explains David Schimmel, president and creative director at And Partners. "On top of that, you're worried about new federal laws requiring that all your medical records be electronic by January 2004." Doctors don't have time to open the mail, much less ponder new technologies that might help streamline the administrative side of their businesses. Yet the office managers who do are likely to toss literature promoting the wonders of web-based record-keeping, for fear of losing their job to the Information Age. Aggregate needed to make a case for its technology in a way that appealed to physicians' concerns without coming across as a threat to gatekeeper staff.

The Solution

And Partners conducted intense interviews with Aggregate's founders—all experienced medical professionals—to arrive at a clear diagnosis of the pressures and frustrations plaguing the modern medical practice. In the end, the prescribed approach was a rational voice, free from jargon and high-tech imagery. "We needed to come across as honest, confident, intelligent, and not too slick," says Schimmel, noting that overdesigned marketing materials would only give doctors the impression that Aggregate's consulting fees were inflated. "Competitors in the field tend to use slick-coated stock and techie imagery to sell their services. Nobody knows what that stuff means. It's like the difference between Kodak selling film versus selling a way to preserve memories. Doctors don't care about equipment; they care about what you can do for them," he says.

Eschewing diagrams of computers, wires, and network servers, And Partners opted instead for a human approach. The first two-thirds of the brochure provide a quick read, using oversized type, inviting imagery, and empathetic statements to establish rapport with doctors. The fine print, detailing Aggregate's fee structure, services, credentials, and the like, is corralled in the back for those seeking further information. Because all the photo images were stock (and therefore shot by different photographers in varying locations and lighting conditions), the designers worked closely with the printer during the prepress process to achieve consistency in color, tone, and lighting.

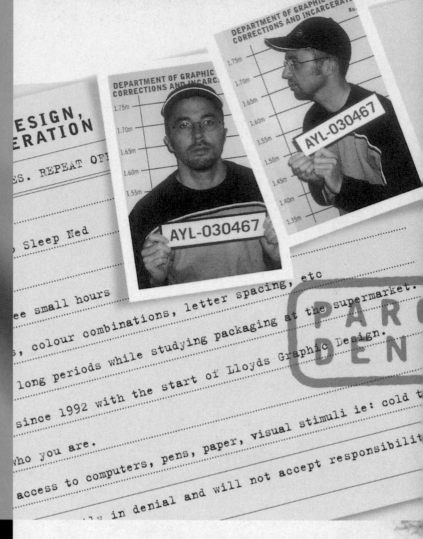

CHAPTER FIVE:
Self-Promotion

Oh, the agony of introspection. The torture of stretching a buck. The frenzy of making time to toot your own horn while juggling a million client jobs. The smug satisfaction of being fabulously clever and resourceful. The delirium of being loved and admired as the coolest firm on the block. The burden of coming up with that next big idea.

i.e. DESIGN
Function Follows Form

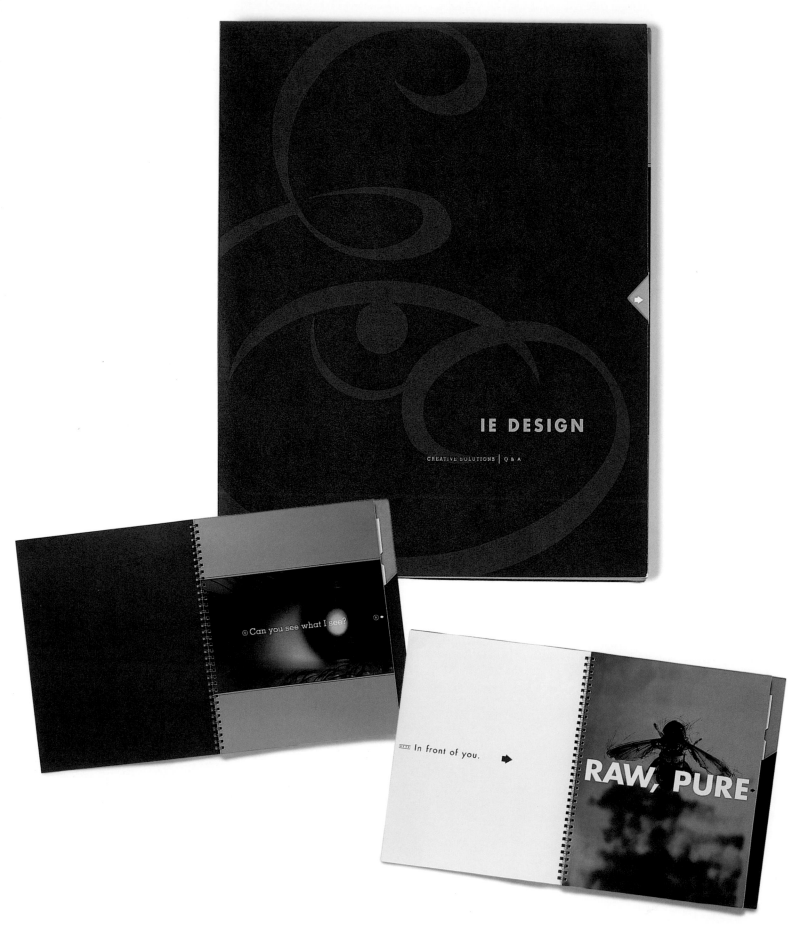

CLIENT: i.e. Design is based in Manhattan Beach, California. **FIRM:** i.e. Design **CREATIVE/ART DIRECTOR:** Marcie Carson **DESIGNER:** Cya Nelson **COPYWRITER:** Marcie Carson **PHOTOGRAPHY:** John Rubino (portfolio pieces) plus stock **PRINTER:** George Rice

FACING PAGE: A hypothetical Q&A dialogue connects each page to the next and propels the reader from front to back.

RIGHT: Artfully photographed portfolio pieces from the IE collection are used to illustrate the conversation, not just as showcase items. Full-bleed pages were printed CMYK plus silver on McCoy dull matte stock. Portfolio images were punched up with a hit of spot varnish.

BELOW, LEFT AND RIGHT: Short page inserts on uncoated stock add texture and interactivity to the layout. The blend of paper stocks necessitated a spiral binding.

The Challenge

"Designing a signature piece for oneself is the most difficult design hurdle a design firm will ever face," says Marcie Carson, principal of i.e. Design. "A direct-mail promo, holiday card, poster, or T-shirt? No problem. Design a corporate capabilities brochure for your own eclectic design firm? Forget it." Add to that a budget as tight as a drum.

"We wanted to tell a story, not just show pretty pictures of our work," says Carson. "Also we wanted the piece to be interactive and witty. We realized there would be value in including client testimonials, but we wanted to make them digestible and fun."

The Solution

After agonizing over the best approach, a light bulb lit up when the design team put itself in the reader's shoes. The simple question, "Can you see what I see?" became the catalyst for a string of anecdotes relating to talent, business, and inspiration. Each topic is supported by images from the firm's portfolio, along with interesting production techniques. For example, a series of short-sheet pages on uncoated stock peels away in layers, asking the audience, *What makes you...tick? Laugh? Inspired? You?*

Cost considerations shaped many of the design specs from the beginning. "Aside from the cover, we wanted to run the whole thing on one press form to make the most of our budget," says Carson. "The page count we ended up with when we filled one form is the page count we had to work with. We didn't waste any space on the press form."

Rich, full-size pages on gloss stock were printed at George Rice, a high-end printer in Los Angeles. To save money, the one-color, uncoated inserts that add cheeky pacing to the dialogue were printed and trimmed by a smaller mom-and-pop shop and then shipped to George Rice, where they were collated and bound into the big piece.

Ironically, i.e. Design may have been a little too shrewd in its cost containment. "A few potential clients have seen this piece and assumed that we are out of their price range," says Carson.

LISKA + ASSOCIATES
Fashion Statement

CLIENT: Liska + Associates, Inc., is a branding and communications design firm with offices in Chicago and New York. FIRM: Liska + Associates, Inc.
ART DIRECTOR: Tanya Quick DESIGNERS: Tanya Quick, Steve Liska, and Fernando Munoz PHOTOGRAPHY: Rodney Oman Bradley and Sadie Dayton (cover image)

FACING PAGE: Fashion houses and beauty companies are wooed by thousands of design suitors. To make a fast and fabulous impression, Liska went down to Manhattan's meat-packing district and bought an industrial food sealer, which it used to package each brochure in durable, transparent plastic. Mailing labels were applied directly to the sleeve.

TOP RIGHT: The brochure's crisp, white cover imagery opens to a bold splash of nail-polish red and electric tangerine.

BELOW: Most of the images in the promo were sourced from Liska's own files. A pixilated close-up of the Lancôme lips hints cleverly that the firm specializes in both print and interactive media.

Beauty +
Fashion
Branding

"In order to be irreplaceable one must always be different."
Coco Chanel

Moisturize The second shaving lubricant is a highly concentrated mixture of essential shave oils. This product was developed for the toughest beards, providing men with ultimate lubrication. Its transparent formulation allows men to clearly navigate around goatees, beards, and sideburns which proves impossible with conventional opaque foams. Adding essential oil to the male grooming regimen has also proven invaluable for conditioning and pushing back dry cuticles and shaving "occasionally sensitive areas" like the sides of the neck. We recommend you follow with our After Shave Moisturizer. In keeping with our anti-oxidant concerns, we mixed a blend of invigorating oils, humectants and moisturizers to create a product that works in direct opposition to the traditional clear, alcohol-based after shaves. We have found that the supposedly "refreshing" after shaves that many men use can actually burn and irritate the skin. The oils and moisturizers in our product actually soothe the skin and can be applied between shaves for men in drier climates or for those whose skin needs extra moisture.

The Challenge

Over the years, Liska + Associates has provided graphic makeovers and touch-ups to a range of enviable clients in the fashion and beauty industries, including Lancôme, Revlon, Tahari, and Avon. The firm wanted to attract more business from fashionistas but realized its work preceded its reputation. "The fashion industry is very much about who does what and who you know," says principal Steve Liska. "We needed to make sure people had heard of us."

The Solution

Liska's beauty secrets were revealed in a brochure mailed to some 400 prospective clients, from independent fashion houses to major apparel empires and beauty conglomerates. At first, the firm considered penning some text to chronicle its track record in the biz. But it quickly scrapped that idea in favor of a dazzling picture show. "We knew we'd be up against a case of short-attention-span theater but, at the same time, catering to an audience with a compulsion to be in the know," says Liska. So the brochure's cinematic imagery was chosen not only for its sensual allure but also for the sake of recognition. "People in the industry look at those lips and immediately know that's the Lancôme woman," says Liska. "Simply including that imagery in the brochure let people know that, hey, we did that."

LLOYDS GRAPHIC DESIGN
& COMMUNICATION
Bustin' Out

TEN YEARS HARD LABOUR

LLOYDS GRAPHIC DESIGN AND COMMUNICATION CELEBRATES ITS TENTH ANNIVERSARY

1992 → 2002

CLIENT: Lloyds Graphic Design & Communication specializes in corporate identity, branding, package design, and business collateral. **FIRM:** Lloyds Graphic Design & Communication **DESIGNER:** Alexander Lloyd **PRINTER:** Blenheim Printing Co.

FACING PAGE: Nothing says prison like orange—and chicken-scratch tally marks.

RIGHT: Lloyd's rap sheet sets the tone for what's to follow. The mug shot was a must.

BELOW: Exhibit A and so on: Lloyd's offenses are numerous and colorful.

The Challenge

Ten years after launching his own graphic design firm, Alexander Lloyd was a confirmed serial designer and addict. He was known to spend countless hours studying package design in the supermarket and critiquing the font choices on billboards, check stubs, and bus tickets. He needed more work to fuel his addiction, so he set out to share his story with the world.

The Solution

Few can resist the sordid details of a good prison story. So Lloyd (a.k.a. "Big Al") rounded up a body

of his best work and presented it as the end result of "ten years' hard labor." The front of the book offers "exclusive insight into the mind of a serial designer" and goes on to list a summary of convicted offenses in the realm of branding, packaging, and collateral. Naturally, what follows (and makes up the bulk of the brochure) is evidence.

"Given the prison theme, the brochure didn't want to look flashy or glitzy, so an uncoated stock seemed appropriate, teamed with a limited color palette of black and orange," says Lloyd. "The metal fastener was an easy way for us to collate and

bind cheaply in-house and, in doing so, to add to the handmade nature of the brochure—almost as if it was put together in a prison workshop."

Since his firm's inception, Lloyd has completed more than 2,000 design projects. Needless to say, he is a lifer with no chance of parole. "Without a doubt, this is the most effective promo we've completed to date," he says. "We sent out beanies, which are still seen around town, with the initial mailing, and the booklets have traveled the globe."

SUSSNER DESIGN COMPANY
Bark with Bite

CLIENT: Sussner Design Co. is a Minneapolis-based design firm specializing in identity systems, packaging, and print collateral. FIRM: Sussner Design Co.
DESIGNERS: Derek Sussner, Ralph Schrader, Brent Gale, and Ryan Carlson ART DIRECTOR: Derek Sussner COPYWRITER: Jeff Mueller is Floating Head
PHOTOGRAPHY: Ellie Kingsbury PRINTER: Reflections Printing Inc.

FACING PAGE: A layering effect was achieved by passing the cover through the press twice. The second run of silver ink is not trapped; it overlays the orange.

RIGHT: Where Sussner comes from, a handshake signifies a promise. Subtle fingerprints on the inside cover were added with a "contaminated varnish"—a clear varnish mixed with orange for a slight tint. The fingerprints were salvaged from a souvenir from a fourth-grade field trip to the police station.

BOTTOM RIGHT: Inside portfolio pages can be customized for different audiences.

BELOW: Bound into the brochure's hindquarters is a special treat—a perforated, foldout poster of the firm's mascot, Daisy.

The Challenge

Before overhauling its self-promo brochure, Sussner Design Co. was assembling capabilities pieces one at a time, using a velo-bind book system and color outputs from an in-house laser printer. The firm wanted a swankier piece with more pizzazz, but one that allowed customization on a case-by-case basis.

The Solution

Rather than producing a "one size fits all" capabilities brochure, the team stuck with the plan to tailor the guts of each piece, depending on whether the intended recipient was a packaged goods manufacturer, a corporation in need of a logo, or a student visiting on a studio tour. But they craved a clever way to wrap up the whole shebang. "We knew we needed something that would last a while and something that could evolve and change," says principal Derek Sussner.

The concept for the brochure's outer shell emerged during a brainstorming session in which Sussner, who grew up in a rural farming community, described his firm's work ethic as "an original shade of blue collar." He further likened the studio's personality to his bulldog, Daisy: "She's broad chested and loyal and would never hurt anybody, but she has a hidden strength," he says. Copywriter Jeff Mueller sunk his teeth into the metaphor.

Because the interior of each brochure can be reproduced somewhat inexpensively, the exterior is fully loaded. The cover is scored, embossed, and die-cut. A perforated trim (matching the studio's business cards) gives the edges a hearty tooth. And the lip that holds the covers together doubles as a perforated business card that can be torn off.

Tang fasteners (which Sussner refers to as "cool, metal, industrial flip thingies") enhance the blue-collar honesty of the piece. "Our office is in a warehouse district with exposed pipes and ceilings," he says. "Aesthetically, the utilitarian feeling of the fasteners fits with our company. And, from a functional standpoint, they make the piece easy to update." The final touch? A custom-embossed silver-foil seal, applied to each cover by hand.

A coupon accompanying each brochure invites the recipient to visit the Sussner website and enter a tracking number to get a free gift. Using this method, the team has surmised that the brochure generates a 10 percent response rate—a howling success by direct-mail standards.

HINGE
Three Parts Creativity, One Part Hardware

"BRIGHT IDEAS IN MARKETING"

Idea #10
Target Your Audience

"BRIGHT IDEAS IN MARKETING"

Idea #11
Eye-catching Graphics

"BRIGHT IDEAS IN MARKETING"

Idea #12
Everything but the Kitchen Sink

"BRIGHT IDEAS IN MARKETING"

Idea #13
Make Your Mark

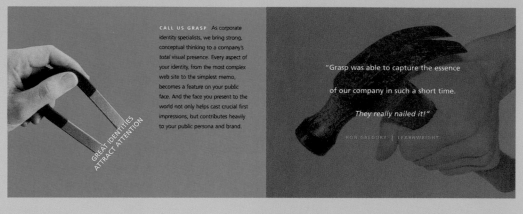

CALL US GRASP As corporate identity specialists, we bring strong, conceptual thinking to a company's total visual presence. Every aspect of your identity, from the most complex web site to the simplest memo, becomes a feature on your public face. And the face you present to the world not only helps cast crucial first impressions, but contributes heavily to your public persona and brand.

GREAT IDENTITIES ATTRACT ATTENTION

"Grasp was able to capture the essence of our company in such a short time. They really nailed it!"

RON GREGORY | LEARNWRIGHT

Spot Color responds to your wants and needs; we take your vision, add our creativity, and form a design reality.

SPOT COLOR
... because great design is not just fun and games

THIS PAGE: The merging studios had complementary strengths but distinctly different visual personas.

Why Redesign?

September 2002 marked the official date of the merger of Grasp Creative, Spot Color, and Bright Ideas Marketing Group. Shacking up and sharing a lunch table was the easy part for the three D.C.–area firms. Merging three distinct identities into a new visual brand was another matter.

CLIENT: Hinge is a graphic design and brand communications firm in Chantilly, Virginia. **FIRM:** Hinge **ART DIRECTORS:** Doug Fuller and Jennifer Sterling
DESIGNERS: Doug Fuller and Jennifer Sterling **COPYWRITERS:** Eric Stewart and Aaron Taylor **PHOTOGRAPHY:** Debbie Accame **PRINTER:** Advanced Color Graphics

BELOW: Measuring just shy of 7" x 5" (17.8 cm x 12.7 cm), Hinge's promotional brochure is supremely portable. The piece goes to trade shows, chamber of commerce meetings, and speaking engagements, as well as through the mail.

RIGHT: Interstate is the primary typeface for the brochure copy. Industrial-strength background textures were achieved by scanning a piece of wafer board salvaged from the dump.

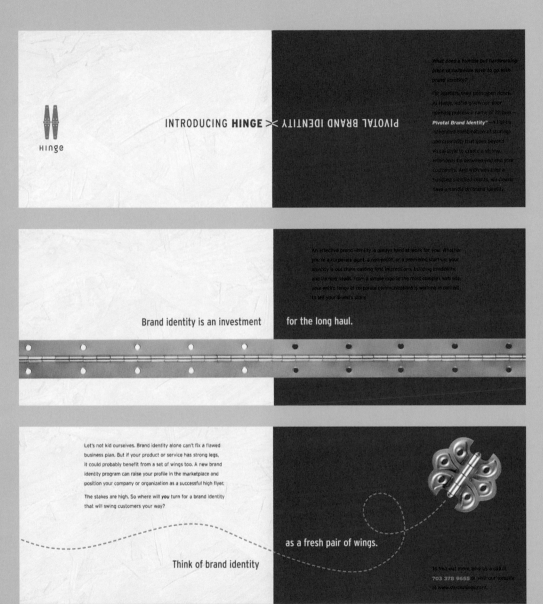

Under Construction

Actually, arriving at the firm's new name—Hinge—was a grueling and excruciating process. "It's hard enough being your own client, and we all had certain criteria," recalls principal Doug Fuller. One of the merging partners, Spot Color, had considerable equity in the color red, so retaining that color was nonnegotiable. Another requirement was a name that could be procured as a license plate. The list went on.

After a few months of creative gridlock, the team was nearly coming unhinged. Then Fuller had an idea. Having found the name for his previous firm, Grasp, by paging through the dictionary, he returned to the source. The word *hinge* popped off the page, and a concept began to gel. Red was retained as a signature color, and metallic accents were added for a stainless-steel effect. The letterforms in the logo are a modified version of the font Platelet.

Excited by the aesthetic potential of the new moniker, the partners raided a variety of hardware stores, catalogs, and antique shops and staged a BYOH (Bring Your Own Hinge) open house. It wasn't long before they had plenty of hardware to build a spate of brand collateral, including a capabilities brochure.

CARBONE SMOLAN AGENCY
Retrospect Is 20/20

CLIENT: Carbone Smolan Agency (CSA) is a full-service creative strategy and design firm in New York. FIRM: Carbone Smolan Agency PRINCIPALS: Leslie Smolan and Ken Carbone DESIGN DIRECTORS: Justin Peters and Carla Miller DESIGNER: Melanie Wiesenthal WRITERS: Frank Oswald, Leslie Smolan, and Amanda Neville PHOTOGRAPHY: Andrew Bordwin, Craig Cutler, Cliff Doerzbacher, Elliot Kaufman, Marco Lorenzetti, Peter Medilek, Philippe de Potestad, and Paul Warchol RETOUCHER: Michael Racz PRINTER: MacDonald Printing

FACING PAGE: A translucent polypropylene cover in "CSA green" is durable and waterproof and lies flat. CSA also uses plastic covers for its proposals and presentation books, so the brochure cover maintains the firm's consistent look and feel.

RIGHT: CSA brand colors are used as duotone spot colors on divider pages. Graphic "texture" was added as a new element in the brand system to keep the identity looking fresh and dynamic.

BELOW: Clever cropping of portfolio images and client brands varies the pacing and keeps case studies from appearing dull. Images are spot-varnished for punch.

The Challenge

Carbone Smolan Agency's (CSA's) promotional brochure had been in the works for over a year when the creative team changed direction in August 2001, starting over from scratch. Nailing the right concept was proving difficult, and the project kept losing momentum each time it was pushed to the back burner to accommodate billable work. Then came September 11. "After that, our efforts were redoubled. We never even considered not producing the piece, despite the fact that business was slow and the general economic climate, especially here in New York, was very bleak," says marketing director Amanda Neville. Convinced that the promo would become a beacon for more clients, the agency turned the project into an exercise in reaffirmation and resilience. "From a business point of view, it was definitely an act of courage but also one of hope," says Neville. "We all knew the studio still had a future. We just had to make it happen."

The Solution

For the most part, the brochure's skeleton serves as a blank canvas, with portfolio pieces as art. Content development was mostly a matter of curating and careful art direction. Alternating full-color bleeds and silhouetted images provide nice pacing, and ample white space encourages the eye to rest on brief case studies.

Utilitarian concerns were important, insofar as the piece was meant for CSA's business development team to use both as a direct-mail piece and during one-on-one sales calls. A spiral bind ensures the brochure will lie flat for presentation purposes, and a matte stock, donated by Sappi, lends tactile elegance. Trade Gothic, CSA's standard typeface, is simple yet playful.

Response to the brochure has proved overwhelmingly positive, as evidenced by leads generated from "cold" mailings and instant recall of the green cover among potential clients. "We've also found that the brochure almost always gets passed along to colleagues and superiors, providing us with greater penetration within the target company," says Neville.

CARTER WONG TOMLIN
Have Yourself a Merry Little Book

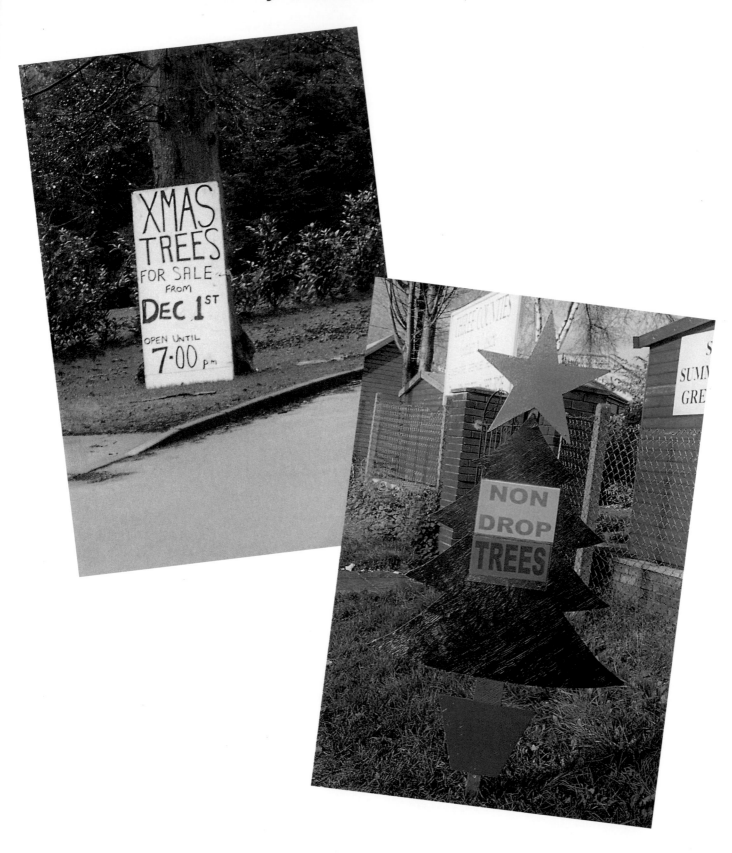

CLIENT: Carter Wong Tomlin is a London-based design and communications consultancy. FIRM: Carter Wong Tomlin ART DIRECTOR: Phil Carter DESIGNERS: Phil Carter, Nicky Skinner, and David Jones PHOTOGRAPHY: Phil Carter, Nicky Skinner, David Jones, Graham Jones, and Sarah Turner PRINTER: St. Ives Westerham Press

The Challenge

Carter Wong Tomlin (CWT) wanted to spread some cheer to its clients and friends during the 2002 holiday season. But the firm aimed to gift something more memorable than a standard Christmas card. Ideas weren't flowing inside the studio, so the creative team took a road trip.

The Solution

With cameras in tow, CWT went hunting for ready-made signs used to sell Christmas trees on the roadside. 'Twas the season for easy pickings. A wee book of observational photography celebrates folk designers and would-be typographers across the land.

The book is a sweet keepsake, offering more than just eye candy. Evergreen factoids are planted throughout the pages in festive silver type. Readers learn, for example, that *25,000 acres of Christmas trees are grown annually in the U.K.,* and *The average Christmas tree is a heavy drinker, consuming up to five pints of water in twenty-four hours.* Moreover, every acre of maturing trees *emits the daily oxygen requirement of eighteen people.* Who knew?

To give the volume a sturdier construction, found images were printed on French-fold pages of Hollander uncoated stock. The result is a rich, anthropological documentary of a centuries-old tradition—getting noticed.

COMMUNICATION VISUAL
Creative Clockwork and Orange

communicationvisual
CONTENT & CREATIVE

C.V

USER'S MANUAL

CLIENT: Communication Visual is a design boutique in Washington, D.C. **FIRM:** Communication Visual **ART DIRECTOR/DESIGNER:** Galen Lawson
ILLUSTRATOR: Galen Lawson **COPYWRITER:** Julie Lawson

FACING PAGE: The cover feels like a handbook or "user's manual," with tab shapes that are evocative of a binder or hole punch. A decorative navigational bar along the top provides an iconic preview of the key messages inside.

RIGHT, ABOVE AND BELOW: Large, dense type gets straight to the point. Headlines are Trade Gothic Bold Condensed, and body copy runs in the serif font ITC Galliard. French Paper in Butcher off-white reinforces the brochure's utilitarian function.

BELOW: Nearly all of the graphics in the book were created in Illustrator. Portfolio samples are neatly corralled in a grid on the second to last page.

The Challenge

When Galen and Julie Lawson launched their creative boutique, Communication Visual, they needed a captivating brochure mailer to proclaim their existence to the world. But they only had a month and $1,000 to create a signature piece and business cards.

The Solution

The two-color promo that clients now refer to as the "little orange book" is a mere 12 pages, but it leaves a lasting impression about how the duo thinks and works together. Tight copy and simple graphics marry to paint a clear portrait of Comm-Vis and its capabilities. Extraneous puffery is noticeably absent, and it isn't missed.

"We wanted a vehicle that would say who we were without being flashy," says Galen. Orange was chosen as a spot color because of its friendly, noncorporate vibe. And the handheld trim size (5½" x 7½" (14 cm x 19.1 cm)) feels comfortable, while allowing for nice cadence in the copy.

"We spend 23 hours a day together, so a lot of the content was stuff we'd said to each other a thousand times," says Julie. "We work like band members. Sometimes we start with the music, and sometimes the lyrics come first. In this case, we made a skeletal outline and worked from there."

GRANT DESIGN COLLABORATIVE
Small Wonder

There is enough clutter in the world, so why should GRANT DESIGN COLLABORATIVE design products? Primarily, we love *design* and the design *process*. It feeds our souls. We are passionate about creating *sustainable* ideas and products that *function* beautifully, and this is our MANIFESTO FOR PRODUCT DESIGN.

° grant.

We
are
what
we
make.

° grant.

CLIENT: Grant Design Collaborative is a branding design firm in Canton, Georgia. **FIRM:** Grant Design Collaborative **ART DIRECTION:** Grant Design Collaborative **PHOTOGRAPHY:** Maria Robledo **PRINTER:** Paradigm Printing

We
will
respect
the
environment.

Grant Design Collaborative will practice *sustainable* design. We believe great products respect both their users and the world in which they function. The *ecology* of design is complicated. Since most manufacturing systems were created to deliver mass-market products as quickly as possible, they have little tolerance for *reinvention*. We will pursue visionary partners and work with them to evaluate their product design process. From materials to applications to lifecycles, we will develop high quality products with lower environmental impact.

12 *product manifesto*

13

We
are
what
we
make.

We
will
discover.

Regardless of medium, our work is comprised of color, texture, pattern, type, composition and *meaning*. Often, it's what we don't know that leads us to successful discovery. We are not afraid to imagine design possibilities. The human centered needs of the consumer often exceed our partners' capabilities. This reality excites Grant Design Collaborative because it defines an opportunity to *innovate*. To ensure success, we will differentiate our partners' brands with *authentic* products that are well designed, and more importantly, relevant.

04 *product manifesto*

05

There is enough clutter in the world, so why should GRANT DESIGN COLLABORATIVE design products? Primarily, we love *design* and the design *process*. It feeds our souls. We are passionate about creating *sustainable* ideas and products that *function* beautifully, and this is our MANIFESTO FOR PRODUCT DESIGN.

The Challenge

Through its work for clients in the commercial furnishings sector, Grant Design Collaborative learned a thing or two about sustainable processes and materials. This knowledge base led to jobs involving environmental showrooms and interiors, and the firm started flirting with the idea of venturing into actual product design. Before taking the leap, however, the team thought it prudent to put some thought into the how and the why of its product design focus. "We realized that making a foray into this area could mean a whole new audience of potential clients, but we also knew that flying by the seat of our pants wasn't the way to go," says Bill Grant, principal of the eponymous studio. "Creating product design parameters would save us and potential clients a lot of time and money."

The Solution

A miniature manifesto spells out 15 principles governing the firm's approach to product design and sets the stage for discourse. "We considered that any product we created would feature our name, so we wanted to document the kinds of product we'd be interested in designing and establish some sort of filter to run ideas through," says Grant. "Would designing a monkey wrench for Home Depot fit our criteria? The manifesto helps to define which sandbox we're playing in when it comes to product design." Copy points spell out the firm's vows to, among other things, *make the ordinary extraordinary* and *move people*. The text also pledges allegiance to sustainable materials such as wool felt, chipboard, and 100 percent post-consumer waste.

That said, the credo not only talks the talk but also walks the walk. Clever packaging is made of 100 percent recycled chipboard with a bookcloth binding of 100 percent biodegradable cotton. Designed with functionality in mind, this outer shell is reusable as a business-card case. The diminutive size of the perfect-bound booklet inside (2⅝" x 3¹⁄₁₆" (6.7 cm x 9.4 cm)) is ecologically responsible and conveys a sense of intimacy. "We went small because we wanted to use the least amount of materials in making this," says Grant. "That's a question we ask with all of our work now. Do we really need a big, tabloid-size piece? What's the least amount of material we can get away with? We also wanted to make a precious statement. This was something that was very personal to us. It's like going inside and peeking into our soul."

CHAPTER SIX:
Services

Service is as much about experience as outcome. Portraying the service dynamic is a heady challenge in which emotion often takes a seat next to logic. What is the color, the texture, the weight of the customer experience? Is the experience delicately stitched or tightly bound? Is it loud or subdued? The best service brochures take storytelling to new levels. You have to be there.

MAHLUM ARCHITECTS
Balancing Act

CLIENT: Mahlum Architects is a mid-sized architectural design firm in the Pacific Northwest. **FIRM**: Hornall Anderson Design Works **ART DIRECTOR**: Jack Anderson
DESIGNERS: Jack Anderson, Kathy Saito, and Sonja Max **PRODUCTION**: Alan Copeland **COPYWRITER**: Pamela Mason Davey **PRINTER**: Rainier Color

FACING PAGE: Elegant, engraved type on the cover appears canti-
levered, foreshadowing the staggered typographic layouts
found inside the book. Mahlum's logo is foil-stamped on dull
matte stock.

RIGHT (TOP AND BOTTOM): Inside spreads were printed on satin stock
with more than eight colors (CMYK plus four PMS colors and
varnish). Each form features a different PMS combination,
specified to accentuate the photography.

BELOW: The brochure is an admittedly indulgent philosophical
manifesto, but it works in tandem with more utilitarian collat-
eral pieces, such as a customizable RFP template printed in
the same rich brown. To control costs, photographs shot for
the brochure were also used in the RFP template.

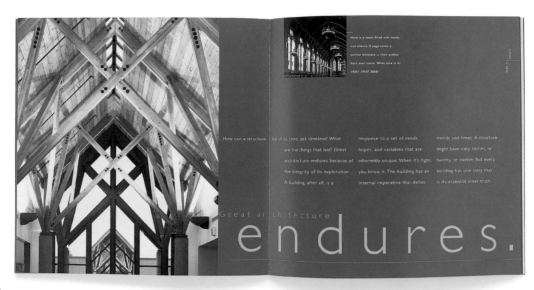

The Challenge
Mahlum wanted all of its print collateral to rein-
force the notion of balance—the play between vi-
sion and structure, spontaneity and order, intuitive
and rational, poetic and mathematical. It was up to
Hornall Anderson to capture these seeming di-
chotomies. "This was a matter of harnessing the ar-
chitects' creative, innovative, organic use of space
juxtaposed with glass, steel, and fiscal responsibil-
ity," notes art director Jack Anderson.

The Solution
Mahlum's logomark (created several years ago by
Hornall Anderson) features a fluid brushstroke with
a hard square knocked out of the center, reflecting
the yin-yang dynamic of logic vs. creativity. That
considered, a square format was only, well, logical
for the brochure. The design team mocked up
perfect-bound square booklets in several sizes
and paper stocks before deciding on 11" x 11"
(27.9 cm x 27.9 cm) dimensions—a format that
had presence and heft but wasn't overwhelming.

Inside the piece, imagery and type are laid out
asymmetrically to create a sense of movement.
"The type becomes an architectural and structural
element as well as a moving, storytelling element,"
explain designers Kathy Saito and Sonja Max. "This
treatment creates a much more dynamic effect.
Large words appear in a light typeface to convey
balance, whereas the small body copy anchors other
elements on the page. A visual hierarchy moves the
eye from photo to big word to smaller type." Big
floods of color and crisp, saturated imagery make
the piece a page-turner.

BUTTERFIELD & ROBINSON
Walk on the Wild Side

Wildlife & Wilderness Trips 2003

Butterfield & Robinson

CLIENT: Butterfield & Robinson is a high-end travel company and tour operator based in Ontario. FIRM: Dinnick & Howells CREATIVE DIRECTOR: Jonathan Howells DESIGNER: Pam Lostracco COPYWRITER: Troy McClure PHOTOGRAPHY: Pam Lostracco (wild lettering shots) PRINTER/PREPRESS: Andora Graphics

TOP RIGHT: Butterfield & Robinson's corporate typefaces—Mrs. Eaves and Trade Gothic or Din—were naturals for the body copy.

BOTTOM: Each panel describes a different way to "go wild"—from hiking in the Grand Canyon to whale watching on Vancouver Island to tracking wildebeest in Botswana.

FACING PAGE: An uncoated, environmentally friendly paper stock with a large percentage of post-consumer waste was a good choice in light of the subject.

How You go Wild is up to You

There is a wilderness for everybody. To find yours, we have divided our Wildlife and Wilderness trips into four distinct flavours: *Biking Journeys*, *Great Walks*, *By Sea* and *With the Kids*.

Our *Biking Journeys* and *Great Walks* are trips for adults that immerse you deep into the region. Each itinerary is carefully crafted to leave you with a barrage of lasting moments: that zen-like hot tub perched in the Rockies, Patagonia's bizarre version of the emu – the Nandú, locals who share with you their passion for the landscape and culture.

Our *By Sea* trips take you to remote, harder-to-reach places in boats that can only be described as floating hotels. They offer a seamless marriage of both onshore and offshore activities. Watch dolphins off the stern while breathing in the fresh sea air. On shore, search for cultural and geographical treasures, either by bike or on foot – and always by guide or local expert. And, of course, swim at every available opportunity.

Our *With the Kids* trips give families the perfect balance of time together and time apart by offering parallel itineraries: fun-filled, hands-on adventures for the kids and more grown-up endeavours for you. We offer a huge range of activities for all abilities and ages – in fact, we make a special point of grouping children into different age categories so they make friends (often lifelong friends) with kids their own age. The result is a trip that lives up to everyone's idea of the perfect wilderness adventure. What's more, it's safe and easy.

Each journey rewards you with a totally different wilderness experience and yet they all embody Butterfield & Robinson's trademark approach to travel: that sense of delving deep, getting the insider's perspective and seeing the region in new ways. In fact, you'll come back seeing yourself and the world in new ways – which could be why you went in the first place.

The Challenge

Butterfield & Robinson is a Canadian company, but its audience is 95 percent American. Customers are primarily wealthy travelers interested in active (biking and walking) vacations where learning and immersion are as important as luxury. The client needed a captivating brochure to use as a direct-mail piece to promote not only distant destinations but also "safe zone" trips closer to home. Most important, the piece needed to cater to the audience's love affair with the great outdoors.

The Solution

Elements from nature were literally co-opted as design tools, with twigs, leaves, and grasses serving as the basis for a custom typeface. To achieve this effect, Dinnick & Howells sculpted an entire alphabet (with multiples of each letterform) of found natural objects. The letters were then used to spell out titles, and the designers made digital adjustments to leaf and twig angles to "typeset and kern" each letter combination. The original design plan was to use natural lettering for every trip name, but the application of the custom font was later reduced to the cover and inside headline to avoid overkill.

For consistency, many Butterfield & Robinson travel brochures fold to 6" x 8" (15.2 cm x 20.3 cm). Other pieces created by Dinnick & Howells have been sized the same but are specified as saddle-stitched booklets. In this case, however, a poster format seemed best. "The featured trips were 60 percent family oriented, so the design needed to appeal to all age-groups," says creative director Jonathan Howells. "We envisioned something that would hang on the fridge for everyone to see and talk about."

The foldout poster format takes its inspiration from folded maps, which are integral to the travel experience. Fine touches in the production make for easy navigation; nearly invisible perforations allow air to escape when the panels close in on each other, rendering the folding pattern tighter and more intuitive. "This was a last-minute decision that greatly helped with handling by the end user," says Howells.

BUTTERFIELD & ROBINSON
Border Crossing

Butterfield
&Robinson

EXPEDITIONS 2003
BIKING TRIPS WALKING TRIPS MULTI-ACTIVE TRIPS
ASIA-PACIFIC AFRICA LATIN AMERICA

CLIENT: Butterfield & Robinson is a high-end travel company and tour operator based in Ontario. **FIRM:** Viva Dolan Communications and Design **ART DIRECTOR:** Frank Viva **DESIGNER:** France Simard **COPYWRITER:** Doug Dolan **COPYEDITOR:** Harry Endrulat **PHOTOGRAPHY:** David Farnell, Paolo Fietta, Mark Gilbert, David Gluns, Cari Gray, Lori Grossman, Rob Howard, Norman Howe, Robert Minnes, Greg Sacks, Charlie Scott, Happy Streeter, and Christopher Wahl **PRINTER:** Transcontinental O'Keefe

FACING PAGE: The cover photo was chosen to capture both the biking and far-flung aspects of the Expeditions program. Compositionally, the angle of the hat emphasizes the logo.

TOP LEFT: End-pages are brought to life with the vibrant patterns of a Moroccan rug.

TOP RIGHT: Pungent colors are reproduced with straight CMYK builds.

BELOW: Delicate backgrounds imitating indigenous motifs add texture and depth to each spread.

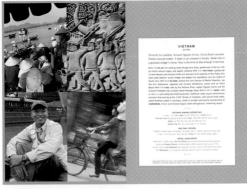

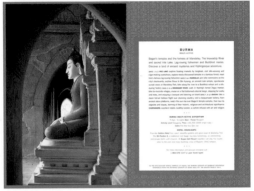

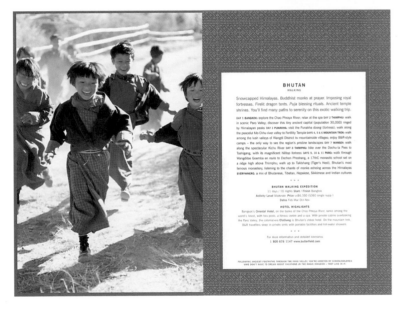

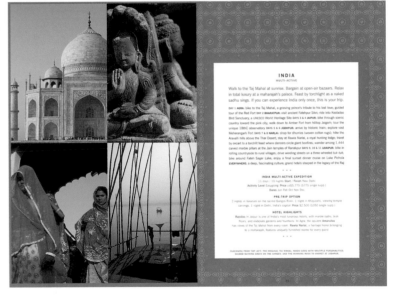

The Challenge

Butterfield & Robinson specializes in upscale walking and biking tours for active travelers. Because the pace is slower than alternate means of travel, these immersive experiences allow participants to savor not just major landmarks but also the cultural nuances and fine sensory details of specific locales. The design for the tour operator's Expeditions 2003 brochure needed to somehow capture this unique advantage.

The Solution

As befits a luxury travel promotion, the brochure is bountifully laden with photographs depicting the sights, smells, and traditions of exotic destinations such as India, Burma, and Morocco. Intensifying the flavor of each spread is a spicy page border.

Inspiration for the border designs (each of which were painstakingly constructed in Illustrator) came from an exhaustive collection of pots, tapestries, rugs, fabric, and ephemera collected from specific geographic regions. The China spread, for example, samples a stonework border at a temple, and the Indian texture was culled from a batik swatch of fabric.

Although the Expeditions 2003 catalog had no budget for original photography, sourcing imagery wasn't a problem. As a sibling piece to a larger brochure highlighting all of the programs Butterfield & Robinson offers (also designed by Viva Dolan), Expeditions was able to piggyback on the big shoot. "For this brochure, there was no photo shoot commissioned, so photos were culled from archives and stock," says Viva. "In this case, a large proportion of the images were taken by actual tour guides."

DOUGLAS HOERR
LANDSCAPE ARCHITECTS
A Cultivated Aesthetic

At DHLA, we create architectural spaces in collaboration with nature.
This is the spirit of Douglas Hoerr Landscape Architecture.

D
H
L
A

CLIENT: Douglas Hoerr Landscape Architects (DHLA) creates architectural spaces in collaboration with nature in urban, suburban, public, and private locations.
FIRM: THIRST **DESIGN DIRECTOR:** Rick Valicenti **DESIGNERS:** Rick Valicenti and Gina Vieceli **PRINTER:** Graphic Arts Studio (G.A.S.)

FACING PAGE: A die-cut window in the brochure cover suggests that the reader is about to experience a precious glimpse inside the DHLA mindset.

TOP LEFT: The deep texture and minimal color of the "Direct" section depicts garden design in progress—at the point where architectural plans are handed off to contractors and dirt starts flying.

TOP RIGHT: To illustrate the "idea stage" of landscape design, gestural drawings on Gilclear resemble architectural sketches on tissue. The last sketch overlays an image of a completed landscape, showing how one idea translated into reality.

BOTTOM RIGHT: In interviews, Doug Hoerr described his process as "painting with plants." Photos were manipulated with a washy effect to resemble watercolor paintings.

BELOW: The final section, "Enjoy," hits full force with a dazzling symphony of color on coated stock.

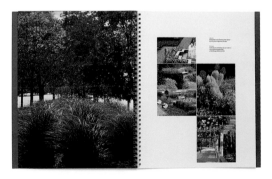

The Challenge

Douglas Hoerr Landscape Architect's (DHLA's) reputation has been firmly rooted for some time. The studio's high-profile work in the Chicago area includes seasonal plantings on Michigan Avenue's Magnificent Mile and special teaching gardens for the Chicago Botanic Garden. But the firm needed a brochure that would function as a selling tool for younger associates.

The Solution

To seed the project, THIRST designers Rick Valicenti and Gina Vieceli sifted through countless slide carousels of verdant vistas and horticultural delights, asking detailed questions about specific DHLA projects and their histories. By February 2003, the brochure concept was ready for one last approval, but Douglas Hoerr still wasn't convinced the piece said what it needed to say. "Again, we listened and realized that our initial concept was focused on the wrong aspect of DHLA," says Vieceli. "We needed to highlight the process to celebrate the result." The entire brochure format changed—its size, paper, printing, and binding.

The new concept germinated in a phrase the THIRST team had heard repeatedly in its interactions with DHLA—growing space. "Not only does this reference the landscape itself, but Doug used it to describe the behavior of landscape," says Vieceli. "Plants overgrow their boundaries and constantly change. In this brochure, paper, color, and textures never stay the same. The reading experience—like strolling through a garden—becomes a journey of visual and tactile impressions."

Nature provided the perfect visual metaphor for the brochure's anatomy. Sections are tiered like plants in different life cycles, creating a visual hierarchy with varying species of substrates. Whereas the first four layers of inserts, which detail the DHLA process, are printed on uncoated stocks for a raw, natural feel, the final section (showcasing finished projects) is printed on Centura Silk with a gloss varnish for a polished grand finale. Contents are sandwiched inside a cover of Oxford Profit, chosen for its rich, mossy hue and subtle grain.

DAVIES
Good Things Come in Small Packages

say something.

DAVIES

CLIENT: Davies is a strategic communications firm specializing in real estate, health care, nonprofit, energy, and natural resources. FIRM: Methodologie
DESIGNER: Minh Nguyen ACCOUNT DIRECTOR: Sarah Ryan COPYWRITERS: Minh Nguyen and Clark Heidegger PHOTOGRAPHY: Dan Langley, plus stock

The Challenge

Davies has a longstanding reputation as a smart, confident, thorough, and somewhat quirky company. Before contacting Methodologie, the PR consultancy was using a laser-printed, wire-o-bound proposal as its primary sales tool. Eventually it came time to upgrade with a succinct capabilities brochure that reflected this unique personality and differentiated the firm from the competition. Economy of space and budget were important considerations.

The Solution

Through interviews with staff and clients, Methodologie noted that Davies was "big on research compared to other PR firms," says designer Minh Nguyen. "From there, we came up with a creative concept that mimicked the investigative manner of their research. We created a series of questions that parallels their process of discovery with clients." Headline questions (such as *Can an organization have a soul?*) drive the narrative, and type plays a prominent role. This approach was important, considering the budget left no room for original art or fancy production techniques. The brochure's small trim size (5½" x 7" (14 cm x 17.8 cm)) came in response to the client's desire for a piece with a "handbook" feeling to it. "Plus, with a smaller book, you can have more pages, which creates better storytelling," says Methodologie principal Anne Traver.

DAVID DREBIN
Heavy Mettle

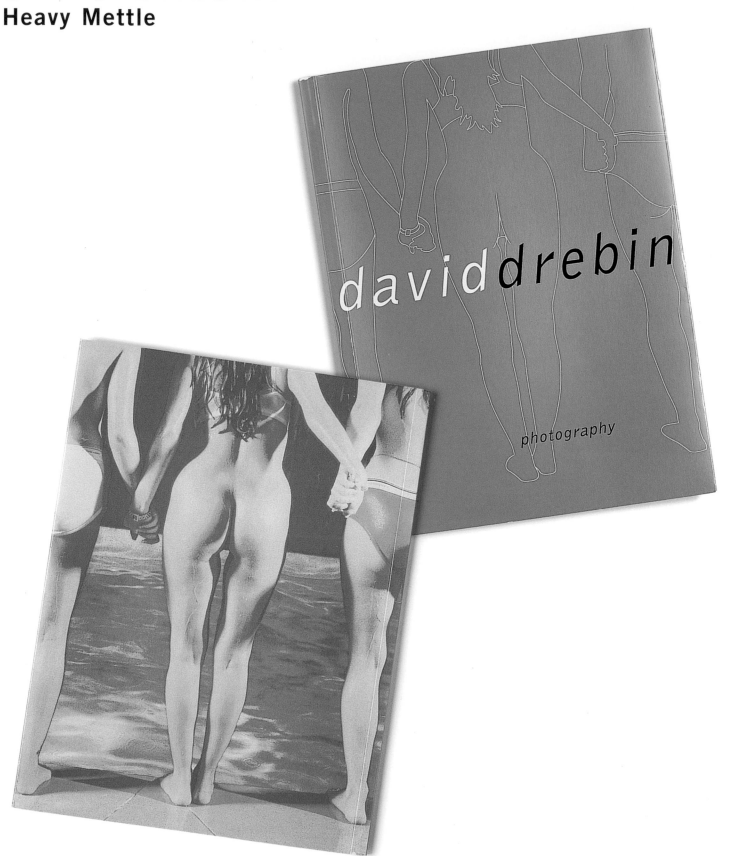

CLIENT: David Drebin is a lifestyle photographer. FIRM: Dinnick & Howells DESIGNER: Jonathan Howells COLOR SEPARATIONS: The Gas Company
PRINTER: C.J. Graphics Inc.

FACING PAGE: Drebin's work is voluptuous and hip, as evidenced by dual interpretations of the same shot on the front and back covers.

RIGHT AND BELOW: Silver highlights were printed first on Utopia One Gloss. CMYK builds were then dry-trapped over the silver. All colors were plated with stochastic screening for sharp intensity.

BOTTOM: For an artsy interlude, some images run back-to-back on 17-lb Chartham Translucent vellum, creating an illusion akin to double exposure.

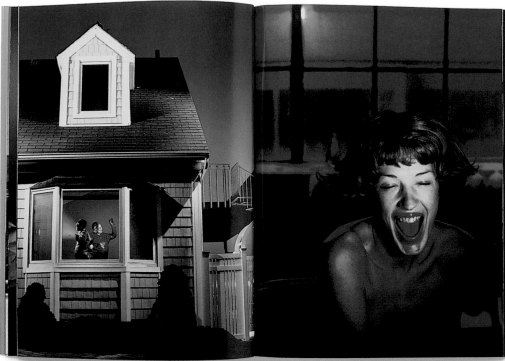

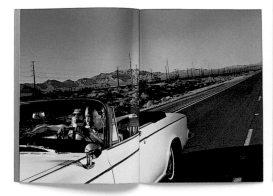

The Challenge

David Drebin's photo narratives have been described as "slice of life," although the slices are edgy, dreamlike, and very Hollywood. His cinematic style has appealed to a range of covetable clients, including Coca-Cola, Gatorade, Intel, and Mercedes, as well as magazines such as *Arena, British Marie Claire, Elle,* and *Vibe.* A straight portfolio would have worked fine as a self-promo, but an extra shot of glamour and glitz worked wonders.

The Solution

Drebin's fantastic scenarios are meant to elicit intrigue. The images in his self-promo are therefore unfettered by text but gussied up with an infusion of production magic. An experimental silver-halftone technique makes each shot appear as though printed with metallic auto paint.

To achieve this effect, Dinnick & Howells creative director Jonathan Howells initially explored printing on metallic papers but abandoned the option after

reproduction trials tested poorly. He then tinkered with solid silver layers on press but found that a blanket layer of silver killed the richness of the color. In the end, the desired result was achieved with traditional handcrafting. Howells worked closely with technicians at C.J. Graphics to fine-tune the mechanics of each shot on press. All images were scanned to five channels (CMYK plus silver), but the silver was painstakingly manipulated to accentuate only certain areas of each image.

WETLAND STUDIES AND SOLUTIONS
These Boots Were Made for Talkin

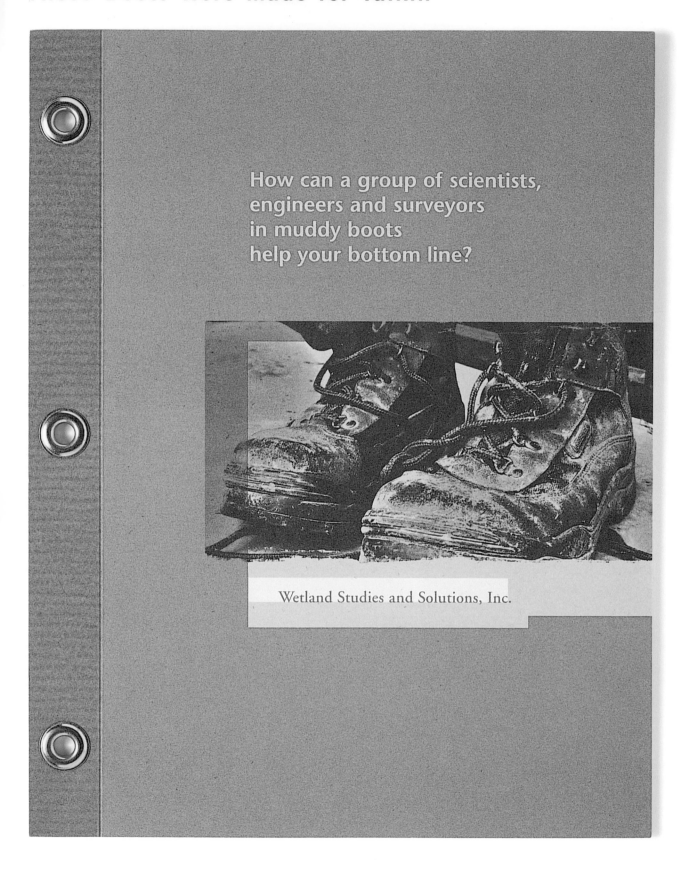

How can a group of scientists,
engineers and surveyors
in muddy boots
help your bottom line?

Wetland Studies and Solutions, Inc.

CLIENT: Wetland Studies and Solutions (WSS) is an environmental consulting firm specializing in land-use issues. **FIRM:** Hinge **CREATIVE DIRECTOR:** Doug Fuller
DESIGNERS: Doug Fuller, Liz Weaver, Greg Spraker, and Aaron Weinstein **COPYWRITER:** Eric Stewart **PRINTER:** C&R Printing

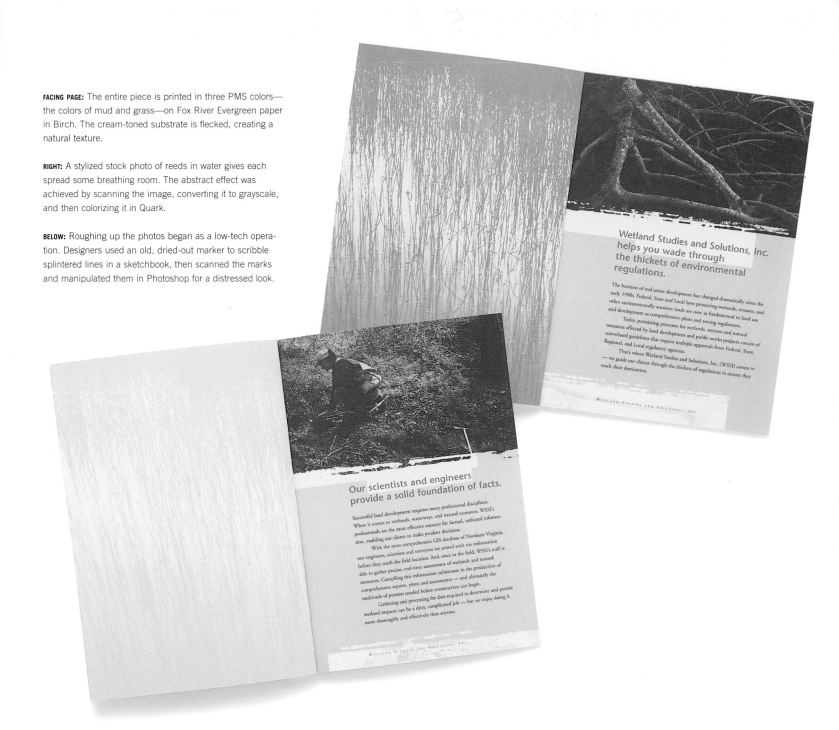

FACING PAGE: The entire piece is printed in three PMS colors—the colors of mud and grass—on Fox River Evergreen paper in Birch. The cream-toned substrate is flecked, creating a natural texture.

RIGHT: A stylized stock photo of reeds in water gives each spread some breathing room. The abstract effect was achieved by scanning the image, converting it to grayscale, and then colorizing it in Quark.

BELOW: Roughing up the photos began as a low-tech operation. Designers used an old, dried-out marker to scribble splintered lines in a sketchbook, then scanned the marks and manipulated them in Photoshop for a distressed look.

The Challenge

Hinge was brought in on the heels of another design firm that went out of business in the midst of a marketing project for Wetlands Studies and Solutions (WSS). The client was somewhat dubious, and the pressure was on to produce something brilliant. But the quality of available photography was mediocre at best. And then there was the subject. "Wetlands consulting isn't the sexiest topic. It's downright dirty," notes Doug Fuller, a partner at Hinge. "With the bulk of the matter relating to cumbersome regulatory issues, it was a challenge to give some life to this dry subject."

The Solution

As part of a larger marketing package, the brochure takes what seems to be a messy by-product of the client's work—muddy boots—and highlights it to create a real sense of personality for the firm. The boots, which are a source of pride for WSSI's president, were spotted on the client's doorstep.

"The president is an accomplished environmental scientist equally at home testifying before a government panel or getting his hands dirty doing field work," explains Fuller. Zoning in on the mud-crusted kicks helped set the tone for the design and achieve buy-in from the client.

Inside the brochure, images were reproduced in a gritty style to compensate for the fact that some were stock and others were supplied by the client. Earthy colors and clunky brass grommets reinforce WSS's image as a group of hard-working professionals making a real difference for their clients.

NORTHERN LIGHTS PHOTOGRAPHY STUDIO
Sheer Bliss

ABOVE: The original brochure didn't do justice to Eric Sartoris's skill as a shooter.

TOP: An envelope wrap and inserts printed on Gilclear Natural have the sheer elegance of a veil. The outer shell was die-cut with rounded flaps and then scored crisp.

Why Redesign?

Northern Lights Photography was using a no-frills, 8½" x 11" (21.5 cm x 27.9 cm) brochure/flyer as its staple handout for trade shows and client inquiries. But when it comes to weddings, prospective brides want frills. The studio needed a more genteel sales tool that was cost-effective and multifunctional but also romantic and beautiful.

CLIENT: Northern Lights Photography Studio specializes in weddings. **FIRM:** Emma Wilson Design Co. **DESIGNER:** Emma Wilson **COPYWRITER:** Emma Wilson
PHOTOGRAPHY: Eric Sartoris **PRINTER:** Hemlock Printing

To Have and To Hold

Format was the first issue that needed a new focus. Rather than corralling several photos, album-style, in a folded brochure, prints were reproduced individually on square cards, with easy-to-locate contact information on the back of each card. Quotations from famous poets and philosophers enhance the personalized appeal of each card.

"We realized most clients would identify with just one or two specific images, so we pushed that aspect in the design," says designer Emma Wilson.

The format encourages pending brides and grooms to dissect the package according to their tastes and to share the cards with friends, thus creating new potential clients. The loose-card format also allows Northern Lights to distribute individual photo cards à la carte at trade shows (in lieu of full-fledged brochures) to save on costs.

As a set, the cards come wrapped in a precious little package that unfurls like the petals of a flower. Tuscan gold hues and ornamental motifs create an Old World aesthetic. The name of the studio is

ethereally writ in silver on one of the flaps in Cézanne, a font resembling impressionist scrawl.

To add a touch of filigree to the vellum inserts and envelope, Wilson tapped into her personal collection of sugar, spice, and everything nice. "I keep a file of what I call graphic by-product—that is, patterns and textures I've found in old catalogs, clip art books, magazines, packaging, and junk mail," she explains. "Having these materials at my fingertips allows me to paint with found objects and textures, as if they were brush strokes."

MCARDLE PRINTING COMPANY
For the Record

(So you'll hear one broken record after another.)

CLIENT: McArdle is a full service printer in the D.C. area offering desktop publishing and image setting, web and sheetfed printing, binding, mailing, and distribution. FIRM: Grafik Marketing Communications Ltd. CREATIVE TEAM: Kristin Goetz and Judy Kirpich PRODUCTION: Heath Dwiggins COPYWRITER: Melba Black ILLUSTRATOR: Jon Flaming PRINTER: McArdle Printing Company

The world's largest wedding cake stood 9 feet tall and weighed 1,530 lbs. —including 230 lbs. of flour and 400 lbs. of marzipan and icing.

At McArdle, there's so much that goes into printing a job, the printing's just the icing on the cake.

Hartsfield International Airport in Atlanta, Georgia is the world's busiest airport, shuttling 80,162,407 passengers in a single year. We can relate, having printed 6,643 jobs on 187,598,432 sheets of paper last year alone.

The Challenge

How can a printer attract new business in a competitive environment? Actual case histories are pretty much a necessity. Fortunately, McArdle had a lot of accomplishments to be proud of—like producing seven different jobs in five days for the same customer and cranking out a seven-color die-cut job in one weekend. The trick was finding a fun way to talk about its most death-defying feats without getting mired in technical jargon and extraneous detail.

The Solution

Grafik nailed a concept that definitely broke the mold. McArdle's everyday printing triumphs were cast in the same category with the world's largest wedding cake, unprecedented mathematical calculations, and other extraordinary incidents of genius and/or insanity. Tapping into the *Guinness Book of World Records 2003,* the creative team extracted examples of superhuman achievements that could segue into McArdle selling points. For example, one spread reads: *Michael Kettman spun 28 basketballs simultaneously on May 25, 1999, but we juggle dozens of jobs every day—without ever dropping the ball.* (Yuck yuck.)

Cheekiness notwithstanding, the brochure's alternative horizontal trim size makes it a standout among the vertical crowd. Punchy type and circus colors, deftly harmonized with quirky illustrations, exude the energy of a printer that never rests until its clients are happy (and dazzled). A high-quality white paper stock ensures that bright colors are printed as bright as can be.

Was the client happy? Some might say McArdle's enthusiasm was record breaking. Grafik is now rolling out a direct-mail campaign and giveaways related to the same theme.

HOTEL 71
Convention Town Gets Unconventional

Reservations
1.800.621.4005
info@hotel71.com

Hotel 71
71 East Wacker Drive
Chicago, Illinois 60601

t 312.346.7100
f 312.346.1721

CLIENT: Hotel 71 is an upscale Chicago hotel with a particular emphasis on service and design, catering to business and leisure travelers.

FIRM: Liska + Associates, Inc. ART DIRECTOR: Steve Liska DESIGNER: Kristen Merry PHOTOGRAPHY: Rodney Oman Bradley

FACING PAGE: Close-up shots of swanky upholstery and fresh flowers offer a visual taste of the hotel's robust flavor and sleek style.

RIGHT: Hotel 71's minimalist logo is an immediate attention grabber.

BELOW: Color blocks lined up like skyscraper windows convey the hotel's key selling points in succinct capsules. Touted as "the hotel that works," Hotel 71 features cool but functional interiors with large work spaces, leather ergonomic chairs, broadband, and other choice amenities for business travelers.

The Challenge

The hotel at 71 East Wacker had been there for ages. It was a tired, old, blue-blazer-and-name-tag kind of place, but it was a landmark. Under new ownership, the space was slowly transformed into a hip, service-focused destination in the manner of Ian Schrager's fabled urban meccas—but with Midwestern flair. Renovations were completed in chunks but were far from complete when Liska + Associates was hired to build buzz for the new space among prospective guests, travel professionals, and the media.

The Solution

Hotel 71 hoped its edgy makeover would attract film, fashion, architecture, and design trailblazers, and that other guests—particularly business travelers—would soon follow. The problem was, rooms were still occupied by plumbers and electricians when it came time to create a launch brochure.

Liska's first task was to develop a flexible identity system characterized by crisp geometry and bright colors. From there, parlaying the same elements into an accordion-fold brochure made sense. On one side of the brochure, pithy selling points are captured in neat blocks of effervescent color. On the other, lusty, full-

bleed photos hint at the hotel's prime riverside real estate and sleek amenities. "We had to fake a room to get some of those shots," says art director Steve Liska. "We borrowed some materials we knew the interior architect was going to use and mocked up the corner of a room. We needed to at least communicate the essence of what the hotel was all about."

Following a soft launch in early 2003, business built into a steady crescendo. "The launch couldn't have happened at a worse time in Chicago," says Liska. "Vacancy rates were extremely high, and convention business was way down. But they've been doing great in spite of it. They are nearly always booked."

ORIVO
Starting Up a Conversation

A VOICE IN YOUR HEAD?

As a boy, Alexander Graham Bell built a talking robot and spent hours manipulating the throat of his fox terrier, trying to turn growls into words. At age 29, he successfully transmitted speech over wires, moving communication from telegraph to telephone.

A FLASH OF INSPIRATION?

A melted key atop a kite in a thunderstorm proved Benjamin Franklin's theory of electricity correct. His invention of the lightning rod, first used on ships, was one of many others that included bifocal glasses, the rocking chair and the odometer.

SOME ARE TIMELESS, SOME ARE FLEETING. They organize, clean, detect, monitor, bind, minimize, devour, close, save, render, destroy, regulate, pull, push, insert, hide, r, instruct, carry, enclose, draw, calculate, enjoy, accelerate, defend, meld, collect, notify, support, caution, release, curtail, inform. ORIVO IS ALWAYS ASKING, WHAT IS…

NEXT?

CLIENT: Orivo is a consultancy that works with manufacturers and retailers to develop new product and branding ideas. **FIRM:** Hornall Anderson Design Works **ART DIRECTOR:** Jack Anderson **DESIGNERS:** Andrew Wicklund and Henry Yiu **COPYWRITER:** John Koval **PHOTOGRAPHY:** Andrew Wicklund, plus stock

FACING PAGE: Almost all of the photos are stock, except for a few that designer Andrew Wicklund shot with a digital camera. Photos were meant to have a raw, undesigned feeling to them because the piece reads like a workbook. The paper stock (Benefit Gray Matters) and type (Helvetica) are similarly no-nonsense.

RIGHT: Orivo's brochure isn't meant so much as a capabilities piece as a conversation starter. The back of the book includes three "creativity exercises," followed by 35 pages of blank, gridded paper for brainstorming, sketching, and doodling.

BELOW: A few, well-meted gatefold pages enhance the pacing of the brochure. Needs are intimated on the outer pages and then answered inside the folded pages.

In the consumer market, ideas come in two forms: product innovation, and process innovation. There are ideas for consumer products, and ideas for getting them to market efficiently. Orivo combines creativity and practicality to define better methods, develop stronger brands and deliver exceptional products.

The Challenge

Orivo needed a word mark that was "clean, simple, timeless, confident, and established, with a European flavor." Founder David Sinegal didn't want to come across as a start-up company. But he was, in fact, launching an entrepreneurial venture. And when it came time to create a brochure, no specific case studies were available to share. This was problematic, considering Orivo's specialty—identifying market needs and figuring out how to meet them with new or revamped products—was an abstract concept that needed to be illustrated with concrete examples. What Sinegal needed was the visual equivalent of an elevator pitch.

The Solution

Building on the theme of "taking dreams into reality," the design team at Hornall Anderson created a series of vignettes and images alluding to significant eureka ideas throughout history—from Ben Franklin's experiments with electricity to the genesis of the graphite pencil. Next, a thumbnail gallery of familiar consumer goods demonstrates how even the simplest products can improve quality of life. The format is intentionally more like a sketchbook than a polished brochure.

"This piece is an idea book that shows how [Sinegal] thinks about things. It's used primarily during face-to-face encounters with potential clients," explains art director Jack Anderson. The brochure's small trim size (8" x 6" (20.3 cm x 15.2 cm)) allows information to be fed in quick sound bites, whereas a larger format would have resulted in fewer, more type-heavy pages. "This approach allowed us to control the messaging so there's one message per spread," Anderson says. "It flows like a PowerPoint presentation but doesn't look like one."

HEFFERNAN
Scale to Fit

Terry Heffernan—known in the worlds of advertising and design for his exquisite large-format still lifes—has quietly pursued his passion of photographing iconic images that capture the soul of America. All of the portraits shown were shot on location using an 8x10 camera with available light.

CLIENT: Terry Heffernan is a commercial photographer specializing in large-format still-lifes with a particular interest in Americana. He is also a film director.
FIRM: Pentagram San Francisco ART DIRECTOR: Kit Hinrichs DESIGNER: David Asari COPYWRITER: Delphine Hirasuna PHOTOGRAPHY: Terry Heffernan
PRINTING: H. MacDonald

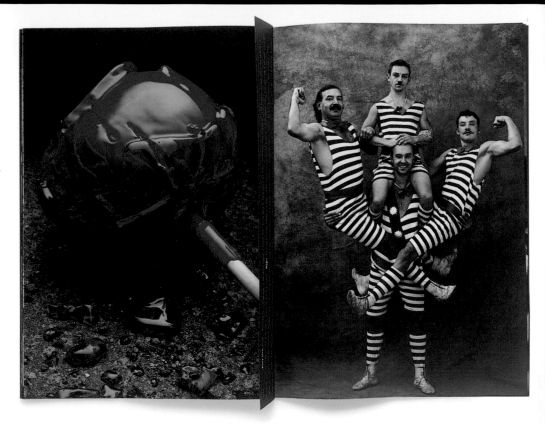

FACING PAGE AND BOTTOM RIGHT: Scale emphasizes the immaculate detail in Heffernan's deft compositions.

TOP RIGHT: Although the design is largely transparent, art direction was key in juxtaposing images to form emotional connections. The still lifes and portraits on adjacent facing pages were not shot to coincide with each other. The associations were formed later.

The Challenge

As part of an ongoing self-promotion campaign called "New American Icons," photographer Terry Heffernan wanted to combine some of his best still life photographs with a newer series of large-format black-and-white portraits shot with natural light. The goal was to generate new interest in his work, educate buyers about his range, and further key business relationships. To a large extent, the design needed to get out of the way and let the photos speak for themselves.

The Solution

"Terry's portfolio is full of large-scale platinum prints that are powerful and wonderful in their detail," says Pentagram partner Kit Hinrichs, who has worked with Heffernan for more than twenty years. "He only shoots 8" x10" (20.3 cm x 25.4 cm). To show those images in a smaller book seemed inappropriate." Hence, the brochure is a dramatic 13" x 19" (33 cm x 48.3 cm), giving the images a weighty and noble presence.

"At first we considered having no copy at all—just photography—but then it occurred to us that these aren't just images; they are interpretations," says

Hinrichs. Narrow pages of text on uncoated stock are thus saddle-stitched between the sensual, over-sized photographs, adding dimension to their meaning. Brief, yet riveting field notes make stories of migrant workers, welders, circus acrobats, and Shoeless Joe Jackson all the more poignant.

Printed in early 2002, this savory promo garnered some savory results. Many who saw it went to Heffernan's website to purchase stock photography as well as original commissioned images or film projects. Sappi McCoy, which provided the paper for the brochure, ordered an overrun of copies to use as a paper promotion.

LANGDON HALL COUNTRY HOUSE & SPA
Architectural Rendering

LANGDON HALL

Country House Hotel & Spa

CLIENT: Langdon Hall Country House Hotel & Spa is located in Cambridge, Ontario. **FIRM:** Viva Dolan Communications and Design **ART DIRECTOR:** Frank Viva **DESIGNER:** France Simard **COPYWRITER:** Doug Dolan **COPYEDITOR:** Harry Endrulat **PHOTOGRAPHY:** Ron Orenstein **PRINTER:** Bowne of Toronto

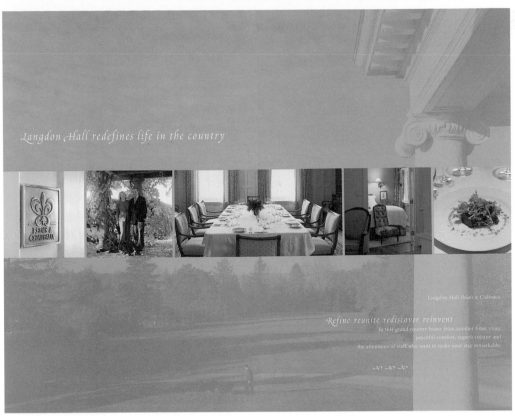

FACING PAGE: A die-cut window lends a crisp, handsome finish to the brochure cover.

TOP RIGHT AND ABOVE: A panoramic shot of a cornice backed by a magnificent lawn makes for a poetic background halftone. Meanwhile, full-color portraiture of the estate's amenities has a cinematic quality. Sumptuous images of culinary delights, verdant sanctuaries and antique spaces run in strips, like snapshots in time.

RIGHT: Seasonal imagery provides freshness to a series of small bi-fold pamphlets meant for distribution via local festivals and travel offices.

The Challenge

Langdon Hall is a member of the utterly exclusive Relais & Chateaux association of haute hotels. The graceful estate and spa is a haven for well-heeled vacationers craving peace and pampering, as well as a preferred space for small corporate affairs junkets. The proprietors needed an elegant brochure for trade shows and personal meetings, as well as a series of smaller pieces to be racked at local festivals, events, and tourism offices.

The Solution

Langdon Hall is a unique destination, so capturing a sense of place was paramount. Aesthetic details

from the turn-of-the-century manor are reflected in lush photographs but also reverberate in the architecture and tenor of the layout. The property's prolific stonework, for example, translates into a warm slate color (achieved with spot color) on the brochure cover and inside spreads. "This color worked well because we wanted to include a few halftones in the background that could accommodate reverse type," says art director Frank Viva. "We wanted to set up a rhythm. It was important to choose a color that was dark enough to knock out type, but not too heavy." A die-cut window on the cover adds dimension to the piece and serves as the genesis of a grid that makes deft and artistic use of squares and rectangles.

Quality imagery was a must, but there was also mileage to gain. Photos shot for the main brochure were easily parlayed into the smaller pamphlets, given there would be no audience crossover. Each pamphlet bears a seasonal slant, but the content is fairly generic in order to prolong shelf life. Timely dates and events are added with inserts, as needed.

The client for the project was Langdon Hall itself, but the pieces didn't go unnoticed by Relais & Chateaux. Viva Dolan was subsequently commissioned to create a brochure for the parent association.

DIRECTORY OF DESIGNERS

ALR Design
2701 Edgewood Ave.
Richmond, VA 23222
USA
804-321-6677 (phone/fax)
www.alrdesign.com
noah@alrdesign.com

And Partners
156 Fifth Ave., Ste. 1234
New York, NY 10010
USA
212-414-4700 (phone)
212-414-2915 (fax)
www.andpartnersny.com
david@andpartnersny.com

Anderson Thomas Design, Inc.
116 29th Ave. N.
Ste. 100
Nashville, TN 37203
USA
615-327-9894 (phone)
615-329-0665 (fax)
www.andersonthomas.com
anyone@andersonthomas.com

Belyea
1809 Seventh Ave.
Ste. 1250
Seattle, WA 98101
USA
206-682-4895 (phone)
206-623-8912 (fax)
www.belyea.com
patricia@belyea.com

Bløk Design
Atlixco 50B
La Condesa DF 06140
Mexico
+5255 55 53 5076 (phone)
+5255 55 53 9997 (fax)
416-203-0187 (phone Canada)
blokdesign@att.net.mx

BRAUE: Branding & Corporate Design
Eiswerkestrasse 8
27572 Bremerhaven
Germany
+0471 983 82 0 (phone)
+0471 983 82 30 (fax)
www.brauedesign.com
mail@braue.info

Campbell Fisher Design
3333 E. Camelback Rd.
Ste. 200
Phoenix, AZ 85018-2324
USA
602-955-2707 (phone)
gl@cfd2k.com

Carbone Smolan Agency
22 West 19th St.
10th Floor
New York, NY 10011-4204
USA
212-807-0011 (phone)
212-807-0870 (fax)
www.carbonesmolan.com
amanda@carbonesmolan.com

Carter Wong Tomlin Ltd.
29 Brook Mews N.
London W2 3BW
UK
+020 7569 0000
+020 7569 0001
www.carterwongtomlin.com
info@carterwongtomlin.com

Communication Visual
1627 K. St. NW, 5th Floor
Washington, DC 20006
USA
202-463-2366 (phone)
202-822-3650 (fax)
www.com-vis.com
Julie@com-vis.com

Dean Johnson Design
646 Massachusetts Ave.
Indianapolis, IN 46204
USA
317-634-8020 (phone)
317-634-8054 (fax)
www.deanjohnson.com
djd@deanjohnson.com

Dinnick & Howells
298 Markham St.
Toronto, Ontario M6J 2G6
Canada
416-921-5754 (phone)
416-921-0719 (fax)
www.dinnickandhowells.com
Email: jonathan@dinnickandhowells.com

Dotzero Design
8014 SW 6th Ave.
Portland, OR 97219
USA
503-892-9262 (phone)
503-245-3791 (fax)
www.dotzerodesign.com
jonw@dotzero.com

Emma Wilson Design Co.
500 Aurora Ave. N.
Seattle, WA 98109
USA
206-652-9928 (phone)
206-965-2246 (fax)
www.emmadesignco.com
emma@emmadesignco.com

Esdale Associates, Inc.
25430 W. Cuba Rd.
Barrington, IL 60010
USA
847-842-9300 (phone)
847-842-9308 (fax)
www.esdaleassociates.com
sesdale@esdaleassociates.com

Flood Graphic Design
3504 Ash St.
Baltimore, MD 21211-2310
USA
410-790-9400
410-235-4674
www.flooddesign.com
joe@flooddesign.com

Form
47 Tabernacle St.
London EC2A 4AA
UK
+44 020 7014 1430 (phone)
+44 020 7014 1431 (fax)
www.form.uk.com
studio@form.uk.com

form fünf
Alexanderstrasse 9b
D-28203 Bremen
Germany
+0421 70 30 74 (phone)
+0421 70 37 40 (fax)
www.form5.de
bastian@form5.de

Fuszion Collaborative
225 N. Fairfax St., 2nd Floor
Alexandria, VA 22314
USA
703-548-8080 (phone)
703-548-8382 (fax)
www.fuszion.com
john@fuszion.com

Gee + Chung Design
38 Bryant St.
Ste. 100
San Francisco, CA 94105
USA
415-543-1192 (phone)
415-543-6088 (fax)
www.geechungdesign.com
earl@geechungdesign.com

goodesign
68 Jay St. #1007
Brooklyn, NY 11201
USA
718-254-8738 (phone)
178-254-8739 (fax)
www.goodesignny.com
info@goodesignny.com

Grafik Marketing Communications, Ltd.
1199 N. Fairfax St., Ste. 700
Alexandria, VA 22314-1437
USA
703-299-4500 (phone)
703-299-5999 (fax)
www.grafik.com
info@grafik.com

Grant Design Collaborative
111 E. Marietta St.
Canton, GA 30014
USA
770-479-8280 (phone)
770-479-4384 (fax)
www.grantcollaborative.com
bill@grantcollaborative.com

Group Fifty-Five Marketing
329 Fisher Bldg.
3011 West Grand Blvd.
Detroit, MI 48202-3099
USA
313-875-1155 (phone)
313-875-4349 (fax)
www.group55.com
jgutierrez@group55.com

Heller Communications, Inc.
16 Wooster St. #2
New York, NY 10013
USA
212-625-3300 (phone)
212-937-2406 (fax)
www.hellercommunicationsinc.com
info@hellercommunicationsinc.com

Hinge
4230-O Lafayette Center Dr.
Chantilly, VA 20151
USA
703-378-9655 (phone)
703-378-9657 (fax)
www.studiohinge.com
doug@studiohinge.com

Hornall Anderson Design Works
1008 Western Ave.
Ste. 600
Seattle, WA 98104
USA
206-467-5800 (phone)
206-467-6411 (fax)
www.hadw.com
info@hadw.com

i.e. Design
2250 E. Imperial Highway
Ste. 200
El Segundo, CA 90245
USA
310-727-3500 (phone)
310-727-3515 (fax)
mail@iedesign.net

i.e. Design, Inc.
150 West 25th St.
Ste. 404
New York, NY 10001
USA
212-255-1515 (phone)
212-255-3102 (fax)
www.ie-design.com
beth@ie-design.com

Iridium, A Design Agency
134 St. Paul St.
Ottawa, Ontario K1L 8E4
Canada
613-748-3336 (phone)
613-748-3372 (fax)
www.iridium192.com
ideas@iridium192.com

Kolegram Design
37 Boulevard St-Joseph
Hull, Quebec JBY 3V8
Canada
819-777-5538 (phone)
819-777-8525 (fax)
www.kolegram.com
mike@kolegram.com

KROG
Krakovski nasip 22
1000 Ljubljana
Slovenia
+386 41 780 880 (phone)
+386 1 4265 761 (fax)
edi.berk@krog.si

Liska + Associates Inc.
515 North State St., 23rd Floor
Chicago, IL 60610-4322
USA
312-644-4400 (phone)
312-644-9650 (fax)
www.liska.com
liska@liska.com

Lloyds Graphic Design & Communication
17 Westhaven Place
Blenheim
New Zealand
+64 3 578 6955 (phone/fax)
lloydgraphics@xtra.co.nz

Methodologie
808 Howell 87
Seattle, WA 98101
USA
206-623-1044 (phone)
206-625-0154 (fax)
www.methodologie.com
annet@methodologie.com

Minale Bryce Design Strategy
56 Little Edward St., Spring Hill
Brisbane, Queensland 4000
Australia
+61 7 3831 4149 (phone)
+61 7 3832 1653 (fax)
www.minalebryce.com.au
jbryce@minalebryce.com.au

Mortensen Design Inc.
416 Bush St.
Mountain View, CA 94041
USA
650-988-0946 (phone)
650-988-0926 (fax)
www.mortensendesign.com
gordon@mortdes.com

Pentagram Design
387 Tehama St.
San Francisco, CA 94103
USA
415-896-0499 (phone)
415-896-0555 (fax)
www.pentagram.com
info@sf.pentagram.com

Planet Propaganda
605 Williamson St.
Madison, WI 53703
USA
608-256-0000 (phone)
608-256-1975 (fax)
www.planetpropaganda.com
dana@planetpropaganda.com

Radford Wallis LLP
The Old Truman Brewery
Studio k1-006
91 Brick Lane
London E1 6QN
UK
+020 7377 5258 (phone)
+020 7377 5260 (fax)
www.radfordwallis.com
aw@radfordwallis.com

Radley Yeldar Design Consultants
326 City Rd.
London EC1V 2SP
UK
+44 020 7713 0038 (phone)
+44 020 7278 5672 (fax)
www.ry.com
info@ry.com

Rick Johnson & Company Advertising
1120 Pennsylvania NE
Albuquerque, NM 87110
USA
505-266-1100 (phone)
505-262-0525 (fax)
www.rjc.com
info@rjc.com

SEA Design
70 St. John St.
London EC1M 4OT
UK
+020 7566 3100 (phone)
+020 7566 3101 (fax)
www.seadesign.co.uk
bryan@seadesign.co.uk

sparc
1735 North Paulina
Ste. 502
Chicago, IL 60622-1195
USA
773-772-1600, x22 (phone)
773-772-3800 (fax)
richardcassis@hotmail.com

Sussner Design Co.
212 3rd Ave. N.,
Ste. 505
Minneapolis, MN 55401
USA
612-339-2886 (phone)
612-339-2887 (fax)
www.sussner.com
derek@sussner.com

THIRST
117 S. Cook St. #333
Barrington, IL 60010
USA
847-842-0222 (phone)
847-842-0220 (fax)
www.3st.com
gina@3st.com

Turner & Associates
487 Bryant St., 2nd Floor
San Francisco, CA 94107
USA
415-344-0990 (phone)
415-344-0991 (fax)
www.turnersf.com
info@turnersf.com

Two Twelve
902 Broadway
Floor 20
New York, NY 10010-6002
USA
212-254-6670 (phone)
212-254-6614 (fax)
www.twotwelve.com
shaun@twotwelve.com

**Viva Dolan Communications
and Design Inc.**
99 Crown's Lane,
Ste. 500
Toronto, Ontario M5R 3P4
Canada
416-923-6355 (phone)
416-923-8136 (fax)
www.vivadolan.com
info@vivadolan.com

Vrontikis Design Office
2707 Westwood Blvd.
Los Angeles, CA 90064
USA
310-446-5446 (phone)
310-446-5458 (fax)
www.35k.com
pv@35k.com

Williams and House
7 Towpath Ln.
Avon, CT 06001
USA
860-675-4140 (phone)
860-675-4124 (fax)
www.williamsandhouse.com
info@williamsandhouse.com

ABOUT THE AUTHOR

Jenny Sullivan is a design writer in the D.C. area and principal of JenPen, LLC, a writing and consulting firm serving agencies, nonprofits, corporations, and publishers. As a regular contributor to *HOW* magazine, she writes about design currents, rising talent, small-business issues, and far stranger topics. Her work has also appeared in *I.D.* magazine, *Washingtonian, The Artist's Magazine, PR News, Arrive,* and Adobe.com. In 2001, she served as guest editor of *I.D.*'s annual Interactive Media Design Review.

Sullivan holds a B.A. in English literature and studio art from Kenyon College. In her spare time, she watches her paintbrushes collect dust.

ACKNOWLEDGMENTS

Many thanks to:

The inspired and inspiring designers who shared their talents and insights for this endeavor;

My pals at *HOW* magazine, who, for the past 10 years, have given me countless opportunities to fall in love with design over and over;

Kristin Ellison, my trusted and cool-headed editor at Rockport;

Gordon MacKenzie, who believed I could do this long before I ever believed it;

And most of all, to baby and Sean, who put up with many late nights, pizza dinners, and minor meltdowns during the making of this book.